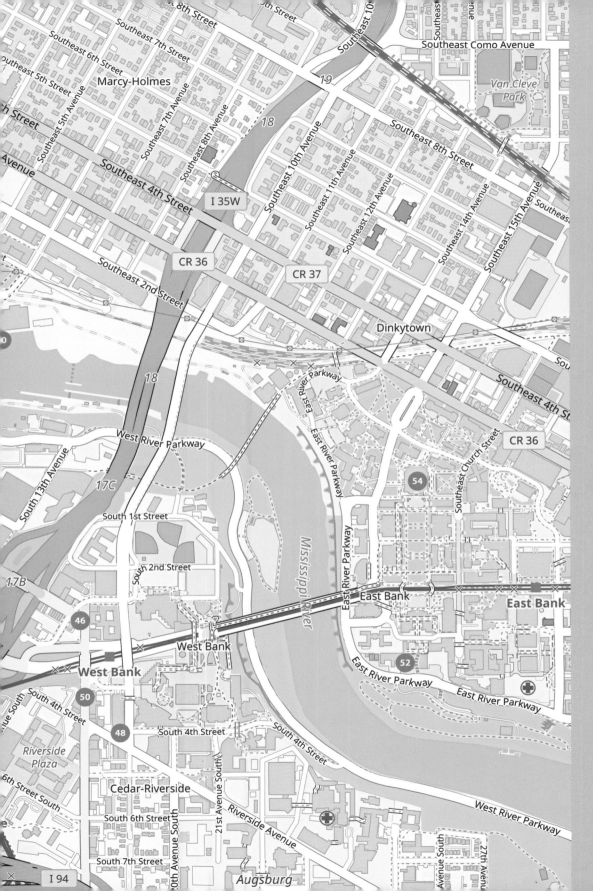

C000182535

MINNEAPOLIS

You can find most of the sites
in Minneapolis on this outline

Numbers in red circles refer to the pages where sites appear
in the book.

MINNEAPOLIS–ST. PAUL

THEN AND NOW®

First published in the United Kingdom in 2018 by
PAVILION BOOKS
an imprint of Pavilion Books Company Ltd.
43 Great Ormond Street, London, WC1N 3HZ, UK

This book is a revision of the original *Minneapolis–St. Paul Then and Now* first produced in 2001 by Salamander Books, a division of Pavilion Books Group.

ISBN: 978-1-911216-98-8

Repro by Rival Colour Ltd, UK
Printed in Singapore

10 9 8 7 6 5 4 3 2

AUTHOR ACKNOWLEDGMENTS
I owe thanks for priceless help, advice, and support for this book to Emily Parks, Judith Martin, Paula Pentel, Mark and Mike Brauer, Bob Roscoe, Anna Botz, Anne Piper, Sue Rich, Andy Sturdevant, and Craig, Elizabeth, and Linda Lindeke.

Dedicated to Barbara, who instilled in me from an early age a love of local history and, most especially, Saint Paul.

PICTURE CREDITS
The publisher wishes to thank the following for kindly supplying the photographs that appear in this book:

All Then photographs are courtesy of the Minnesota Historical Society, with the exception of the following:

Getty Images: 10, 12, 14, 20, 24, 26, 28, 34, 42, 80, 86, 94, 96, 98, 106, 110, 140, 142.
Library of Congress: 36.
Simon Clay: 40 top.
National Register of Historic Places: 126.

All Now photographs were taken by Karl Mondon, with the exception of the following:

Getty Images: 11.
Simon Clay: 63 top, 109 top, 123.
Pavilion: 69, 85, 91.

Endpaper maps are courtesy of OpenStreetMap contributors (www.openstreetmap.org)

MINNEAPOLIS–ST. PAUL
THEN AND NOW®

BILL LINDEKE

PAVILION

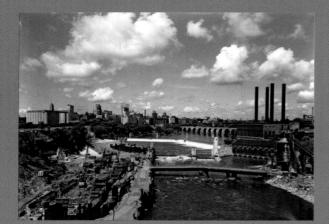

St. Anthony Falls, 1955 p. 10

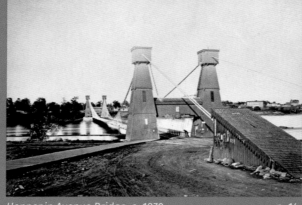

Hennepin Avenue Bridge, c. 1870 p. 14

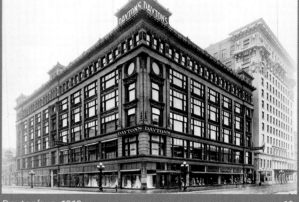

Dayton's, c. 1910 p. 16

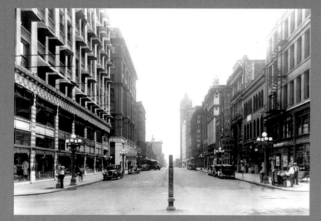

Newspaper Row, c. 1930 p. 24

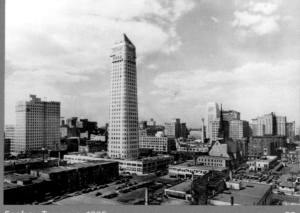

Foshay Tower, c. 1935 p. 28

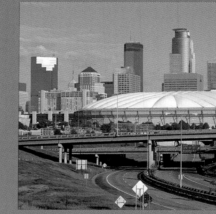

Metrodome, 2001 p. 40

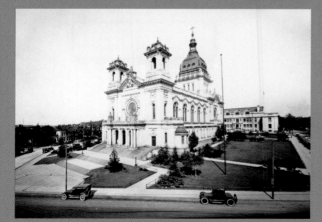
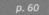

Basilica of St. Mary, c. 1920 p. 60

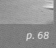

Hennepin and Lake, 1959 p. 68

Lake Calhoun, 1911 p. 70

Seven Corners, 1906 p. 76

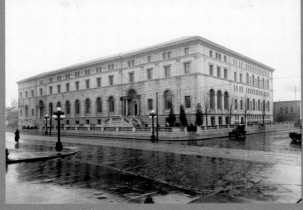

St. Paul Central Library, 1920 p. 78

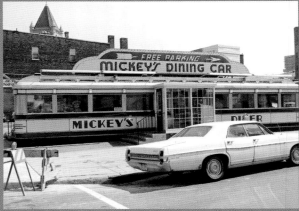

Mickey's Diner, c. 1973 p. 84

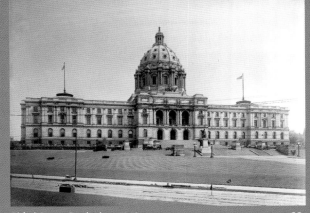

Third State Capitol, c. 1910 p. 88

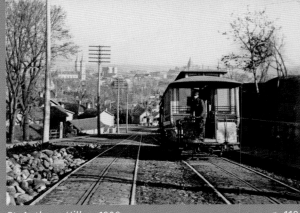

St. Anthony Hill, c. 1900 p. 110

Commodore Hotel, 1925 p. 114

St. Paul Central High School, 1915 p. 130

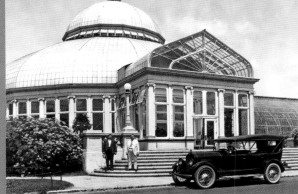

Como Conservatory, 1925 p. 134

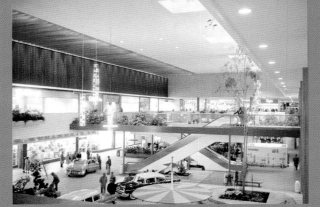

Southdale Mall, 1956 p. 142

INTRODUCTION

Minneapolis and St. Paul, Minnesota's Twin Cities, grew up around the meeting of two great rivers. Before Europeans arrived, the native Dakota people called this river confluence "Bdote," or the "meeting of the waters," and the site was sacred. As European explorers and settlers arrived in greater numbers with the fur trade, the river junction became an ever more important meeting place.

Today we know these rivers as the Minnesota and Mississippi, and in early state history they were lifelines of opportunity. Their intersection, today called Mendota, is home to some of the earliest white historical sites in the Twin Cities. From this point, the Mississippi stretches upstream through a deep gorge curving toward St. Anthony Falls, around which Minneapolis grew. Beyond the falls, the Mississippi stretches northward to its origin at Lake Itasca, deep in the heart of Minnesota's northern pine forests.

From Mendota the Minnesota River extends upstream, south and west into the fertile prairies and farmland that were once home to the Dakota people. The geology of the expansive valley, lined on both sides by bluffs, stems from its role in the ice age, where it served as the outlet for a glacial lake stretching deep into Canada. And downstream, the Mississippi River famously flows for hundreds of miles, widening and winding south into Wisconsin, Iowa, Illinois, Missouri, and beyond, as it bisects and connects the United States on its way to the Gulf of Mexico.

Despite their mercurial nature, the rivers' patterns have constantly shaped the geography of Minneapolis and St. Paul. Industries have formed, flood-prone homes have been erased from the map, and the rivers themselves designated a national park. Meanwhile, the Twin Cities evolved into a sprawling and diverse northern metropolis, home to universities, corporations, theaters, museums, and many millions of people.

The historic photos in this book capture the heyday of these two river cities. Most are from the period of rapid growth between the 1880s and the 1920s, when the valley was a magnet for settlers pouring into Minnesota in search of opportunity. The urban environment has changed since the early days, but thanks to a combination of passion, neglect, and preservation, many parts of the old city can still be found. Historic buildings, old streets, and entire neighborhoods remain hidden in plain sight, scattered amongst the waves of new construction, forming the canvas for everyday life in the Twin Cities.

Though joined at the hip, each of the Twin Cities has a unique story to tell. St. Paul, the older twin, began in 1838 as a trading post downstream from Fort Snelling, the military base constructed at the rivers' confluence. Famously, the city was first called Pig's Eye, named for its first European resident, Pierre "Pig's Eye" Parrant. Parrant was a cantankerous trader with a lazy eye who sold booze to Indians, soldiers, and refugees from British settlements to the north. Holing up in a bluff cave close to today's downtown, Pig's Eye epitomized the rough early days of St. Paul.

As riverboats began frequenting Pig's Eye's growing town, it was soon rechristened "St. Paul" by a French Catholic priest named Lucien Galtier, tasked with civilizing the unruly fur traders. At the navigable limit of the Mississippi, as St. Paul grew it became a vibrant trading center. Its downtown nestled amongst seven bluffs, St. Paul thrived during the riverboat days, growing and shrinking along with the speculative economy. When the railroad arrived in the 1870s and 1880s, St. Paul continued to grow, anchoring the Great Northern Railway that led into the Pacific Northwest.

Today St. Paul remains hillier and more traditionally Catholic than its twin city. It serves as home to the bulk of the state government, many museums and civic institutions, and is a cultural center for the entire state.

Minneapolis, predominantly west of the Mississippi, was not officially settled until 1851, when a dubious treaty allowed expansion into historic Dakota land. The city grew up around St. Anthony Falls, the largest waterfall anywhere on the Mississippi. Through the early years, the 60-foot falls powered a bewildering

complex of timber and flour mills that employed thousands and fueled an industrial boom.

Minneapolis's early civic culture centered on industrial production, shaped by speculative Yankee industrialists who bought land and built the city's first neighborhoods. Minneapolis's early years were centered on the combination of industry and speculation, but by the early 20th century, Minneapolis and St. Paul entered a more refined era. In St. Paul, the construction of the third state capitol building in 1904 was a monumental enterprise, and along with the nearby cathedral, the buildings became a symbol of broad horizons. Minneapolis invested heavily in a peerless park system that connected the lakes and riverfront into a public asset that remains at the core of the city's identity.

During the Great Depression and World War II, both cities struggled with overcrowding and widespread disinvestment. Yet soon after the war, city leaders launched themselves into a period of massive change, drawing on large pools of federal funding that fueled suburban housing development while remaking the central core. The streetcars were removed and replaced with buses, urban renewal projects commenced in both downtowns, and central neighborhoods were cleared for freeways or parking lots. The decimation of much of old Minneapolis and St. Paul began in earnest.

Particularly hard-hit were the run-down districts around each downtown, home to both the working class and the region's most diverse and walkable streets. Elsewhere, flood-prone neighborhoods, like St. Paul's West Side or Minneapolis's Bohemian Flats, were obliterated. And African-American and ethnic communities, like St. Paul's Rondo or Minneapolis's Near North Side, were leveled with their residents displaced. Both cities are still struggling to remedy the impacts of those changes.

Partly in reaction to the relentless post-war upheaval, a historic preservation movement emerged. While, too late for many areas, architects, historians, and activists began saving historic buildings, starting

with small-scale projects on the peripheries of each downtown, like St. Paul's Irvine Park and Lowertown, or Minneapolis's Nicollet Island and Milwaukee Avenue. At the same time, the post-war decades saw rapid suburban growth, fueled by an intricate network of incentives and programs. The suburban story mirrors that of most American cities, where the post-war housing crisis, automobile subsidies, and federal incentives for greenfield development fueled growth on the fringes of the old city. Without geographic barriers to expansion, the Twin Cities metro area rapidly expanded, and today newer suburbs dominate its political and economic landscape.

Suburban growth strained the limits of the Twin Cities' political leadership to such an extent that, in 1967, the state legislature passed a regional governance structure that remains unique in the country. Called the Metropolitan Council, an appointed board controls and shapes sewer expansion, planning, and transit within the seven-county urbanized region. Along with other region-wide revenue and tax-base sharing programs, these reforms allowed the region to function efficiently, despite the complexity of having so many independent municipalities within the metro area.

Only since the millennium have the core cities of Minneapolis and St. Paul begun growing again, as changing tastes around housing and transportation are rejuvenating the old city. Today, with a rich cultural scene, dynamic non-profits and corporations, many educational institutions, and affordable cost-of-living, the Twin Cities area is a growing and diverse place that millions call home.

And yet, if you ask most people about the Twin Cities, the chances are good that they are associated with only one thing: the cold weather. And it's true that Minneapolis–St. Paul is one of the world's largest cities at such an extreme and continental climate. Far from the moderating effects of the ocean, the region's famously volatile summers and long, cold winters have shaped both the civic imagination and the urban landscape in many ways.

On one hand, the extreme winters have fostered a culture of escapism, like each downtown's elaborate skyway system of second-story bridges that seamlessly connect office buildings and parking lots into a glass-enclosed network. The system's construction began in the early 1960s, and accelerated during the construction booms of the 70s and 80s. Other notable architectural winter hacks include the now-demolished enclosed Metrodome sports stadium in downtown Minneapolis, and the region's many indoor malls, including the 1992 Mall of America in suburban Bloomington.

On the other hand, the extreme winters have been embraced. St. Paul's annual Winter Carnival celebration has taken place each January since 1886, an early effort by civic boosters to reframe the city's frosty image. In the early years, builders erected an annual "ice palace" crafted of blocks taken from a nearby lake. Along with carving contests, sledding and skating, and a series of parades, the carnival offered defiance in the face of the seemingly endless wintertime.

In the 21st century, the Twin Cities continue to change and evolve. Most notably, the region is becoming more diverse as new Americans and immigrants move into Minnesota. For example, Minneapolis and St. Paul are home to some of the country's largest populations of Hmong—mostly from Laos and Thailand—and Somali refugees, and both groups fit into the diverse landscape of people who have moved to the region from all over the world. Throughout the years, Minneapolis–St. Paul remains a land of opportunity and hope for people of all stripes, who share a geographically and culturally unique place in the Upper Mississippi River valley.

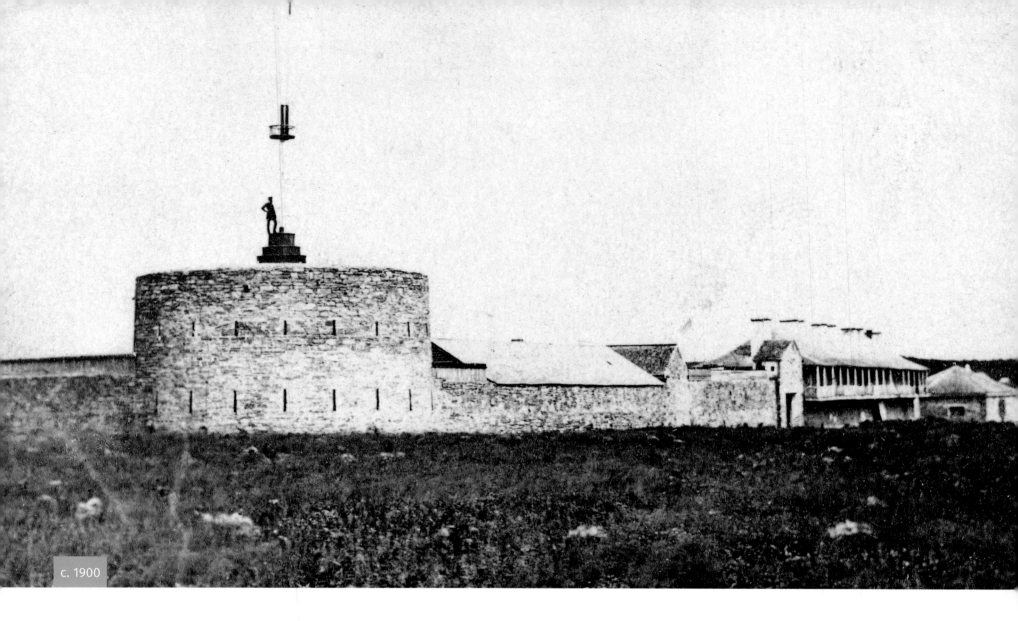

c. 1900

FORT SNELLING
The first major American military fort in the northwest region

ABOVE: The history of urban development in the Twin Cities begins at Fort Snelling, the first site of permanent American settlement in the area. Located equidistant from the two downtowns, from this point St. Paul and Minneapolis grew through the next two hundred years. Originally known as Fort St. Anthony, this old U.S. Army base was erected in 1820 as a way to protect the U.S. western frontier from the British. The first permanent American settlement in the area, the fort also cemented the relationship with the indigenous Native American people, who knew the site as "Bdote"—a Dakota word meaning "where two waters join." Built high on the bluff where the Minnesota and Mississippi rivers meet, in the early days the fort served as a military and logistical headquarters for the burgeoning fur trade. Located close to the well-used Coldwater Spring, the fort became a central place for the collection, disbursement, and trade of goods. Most tragically, during the Dakota–U.S. War of 1862, the fort and its surrounding grounds operated as an internment camp for Dakota awaiting forced exile to western reservations. This photo, taken in the early 1900s, shows the fort before it fell into decline.

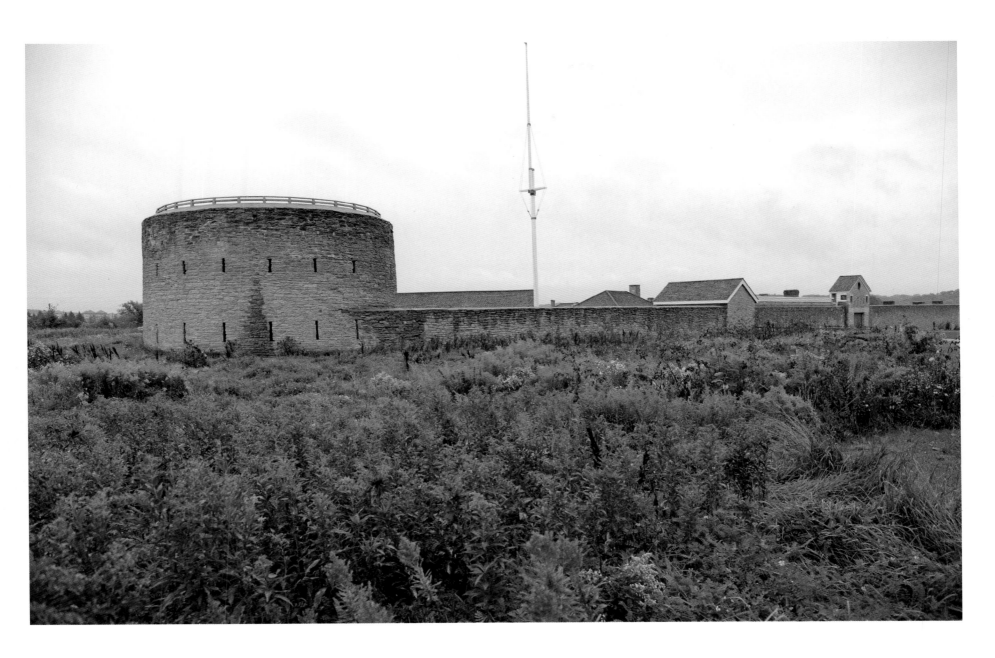

ABOVE: In the 20th century, Fort Snelling fell into ruin and was finally decommissioned in 1945. The round tower at the center of the photograph is the only surviving structure from the original 19th-century complex. Yet after a painstaking reconstruction effort begun by preservationists and historians in the late 1960s, the rest of the buildings have been rebuilt to appear as they might have looked in the 1850s. Today this National Historic Landmark is run as a museum by the state's historical society, complete with reenactors that entertain and inform tourists and school groups. The Minneapolis–St. Paul International Airport sits less than a mile away, and multiple freeways run past the walls of the restored fort, which still look down on the river confluence, just as they did almost two centuries ago.

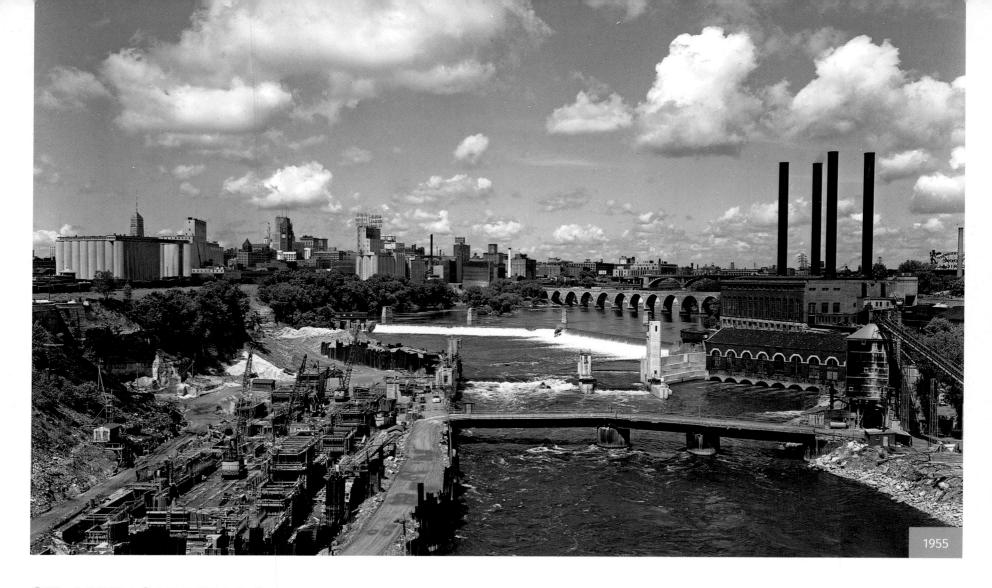

1955

ST. ANTHONY FALLS

The largest waterfall anywhere on the Mississippi River

ABOVE: Originally a Native American portage site and the birthplace of Minneapolis, the Falls of St. Anthony (called *kakabikah* or "split rock" by the Ojibwe, or *owahmenah* or "falling waters" by the Dakota) are the still-beating heart of the city. They fueled the early industrial growth of Minneapolis, and their 50-foot drop still offers the largest waterfall anywhere on the Mississippi River. The most dramatic section, Upper St. Anthony Falls, is hidden behind the Stone Arch Bridge in this view. Before 1852 only the east side of the falls (right side of the photograph) were open for settlement. After a treaty with Dakota tribes, Minneapolis was settled on the west side of the falls, and by 1872 the two cities—St. Anthony and Minneapolis—had merged. For the next four decades, competing flour mills faced off across the waterfall, powering Minneapolis's booming industrial growth. Each year, the waterfall itself, an unruly series of rapids formed from a shelf of soft sandstone, would slowly erode and move upstream. Following a partial collapse of the rock, in 1869 city engineers created a concrete apron to stabilize the waterfall and fix it in place. This image, from 1955, shows the construction of the lock and dam at Lower St. Anthony Falls. It was one of a pair of dams built downtown during the post-war period in an effort to boost riverfront industry. Notably, the construction of the upper lock involved replacing segments of the iconic Stone Arch Bridge, shown curving over the Mississippi behind the University of Minnesota heating plant (the building with the smokestacks at right). Grain elevators are visible on the west bank (on the left), with the Foshay Tower rising behind them.

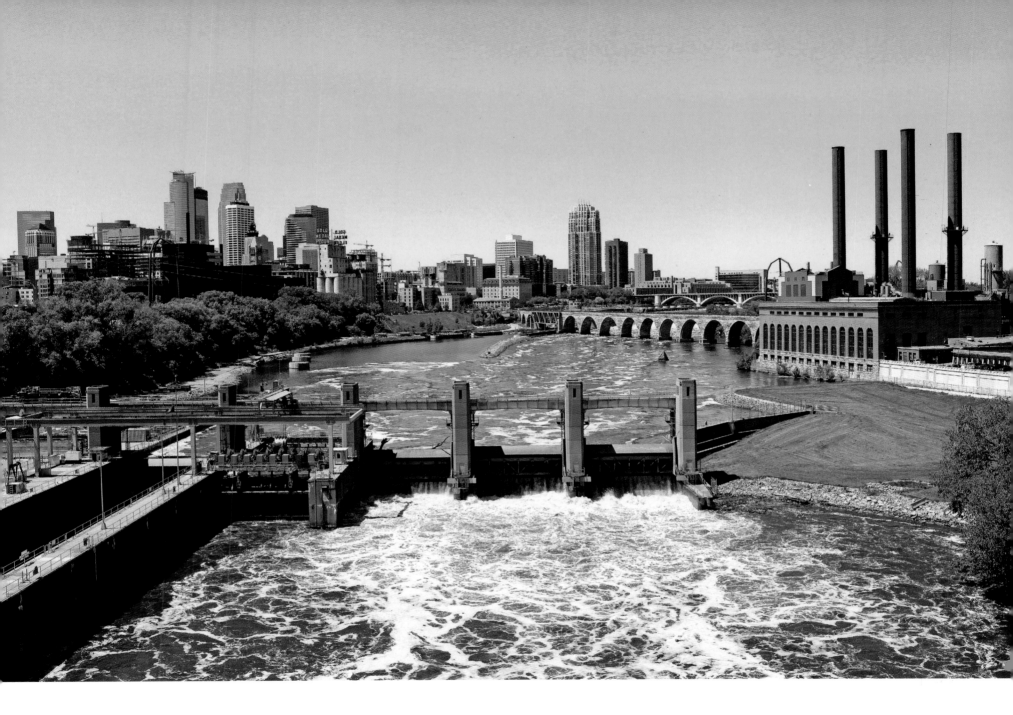

ABOVE: The rapids seen in the earlier image were subsumed by the Lower St. Anthony Falls Lock, which was completed in 1956. Sadly for city planners, the downtown locks shown here never catalyzed much in the way of river traffic, and by the 1980s city planners had begun transforming the river district into a thriving mixed-use residential area. Today, much of the surrounding industrial area has become parkland. The grain elevators, like the rail yards behind them, have been demolished and replaced with mixed-use developments. The Gold Medal Flour sign remains visible on the downtown riverfront, and the skyline has grown to dominate the remaining pre-war buildings. Meanwhile, the river locks themselves were recently closed to barge and boat traffic in an attempt to halt the migration of invasive fish. Some environmentalists have suggested removing the locks in an attempt to return the Mississippi and the falls back to a more natural state.

STONE ARCH BRIDGE

The second oldest rail crossing anywhere on the Mississippi River

BELOW: Shown here around 1900 and built for James J. Hill's Great Northern Railroad in 1881, the Stone Arch Bridge is the second oldest rail crossing anywhere on the Mississippi River. Built over a span of two years out of granite and limestone, the bridge was a massive undertaking for Hill's burgeoning western railroad. Initially dubbed "Hill's folly" for its ambitious attempt to skirt the complex St. Anthony Falls, the rail connection into downtown proved to be a huge success, as well as a beautiful addition to the Minneapolis riverfront. Visible along the western riverbank in the background are the row of industrial milling and warehouse structures which would have been running at peak capacity all through the day and night.

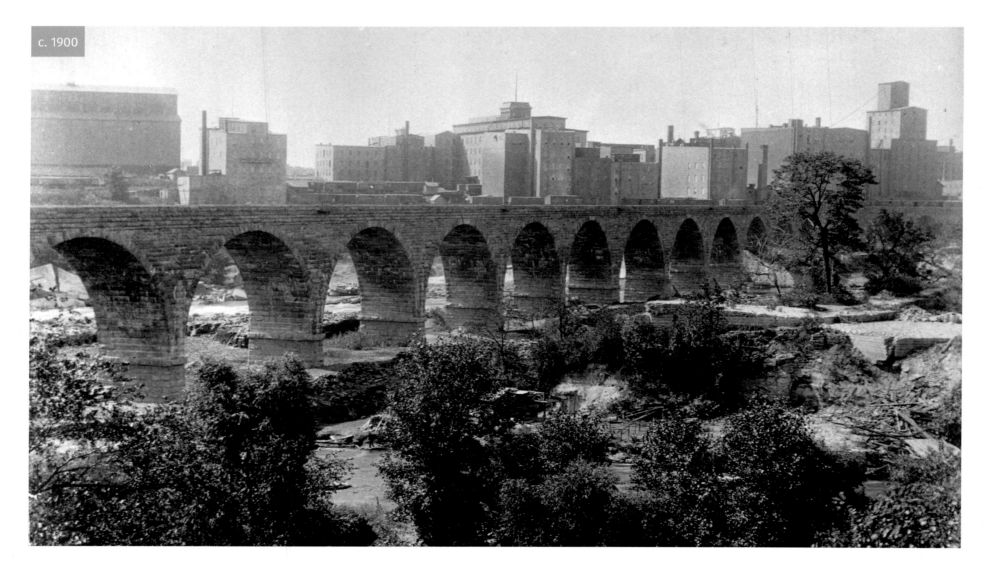

c. 1900

BELOW: Today the same view of the Stone Arch Bridge is obscured by trees that have regrown along the riverbanks, and in some ways the once-industrial area around the river now more closely resembles an earlier pastoral era. Hill's Stone Arch Bridge carried railroad cars over the river until the late 1970s, before the tracks were mothballed along with the downtown rail terminal. It was purchased by the state in 1992, to be converted into a bicycle and pedestrian-only connection over the Mississippi River. Offering stunning views of St. Anthony Falls, today the Stone Arch Bridge has become a popular route for tourists, bikers, joggers, and wedding photographers. Parks occupy the former industrial land on the river bluffs on either side of the bridge, and crowds gather along it each year on the Fourth of July to watch fireworks burst high over the downtown riverfront. The blue-and-yellow Guthrie Theater building, which was designed by French architect Jean Nouvel and is meant to invoke the city's industrial past, is framed by one of the bridge's arches.

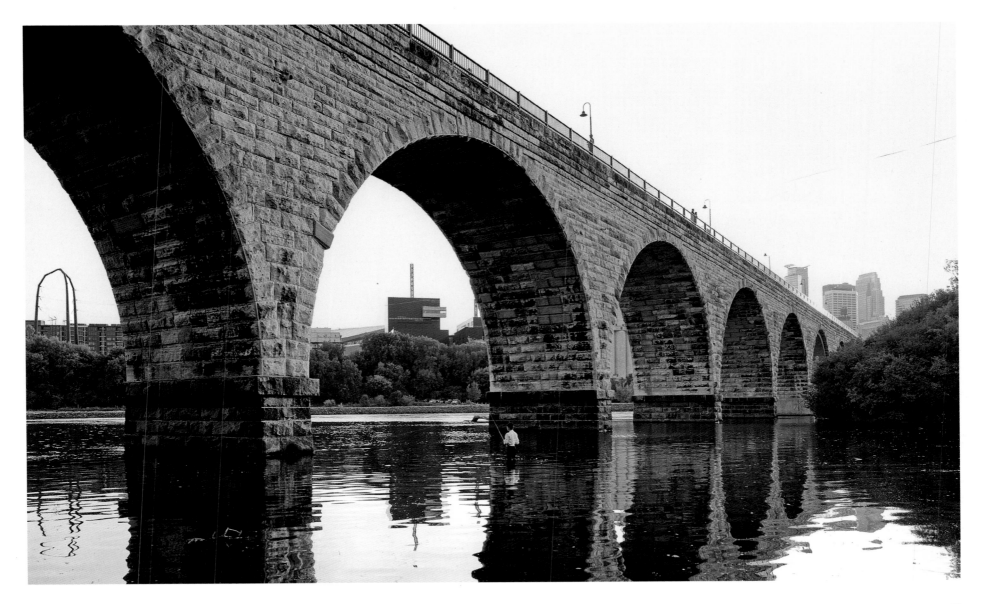

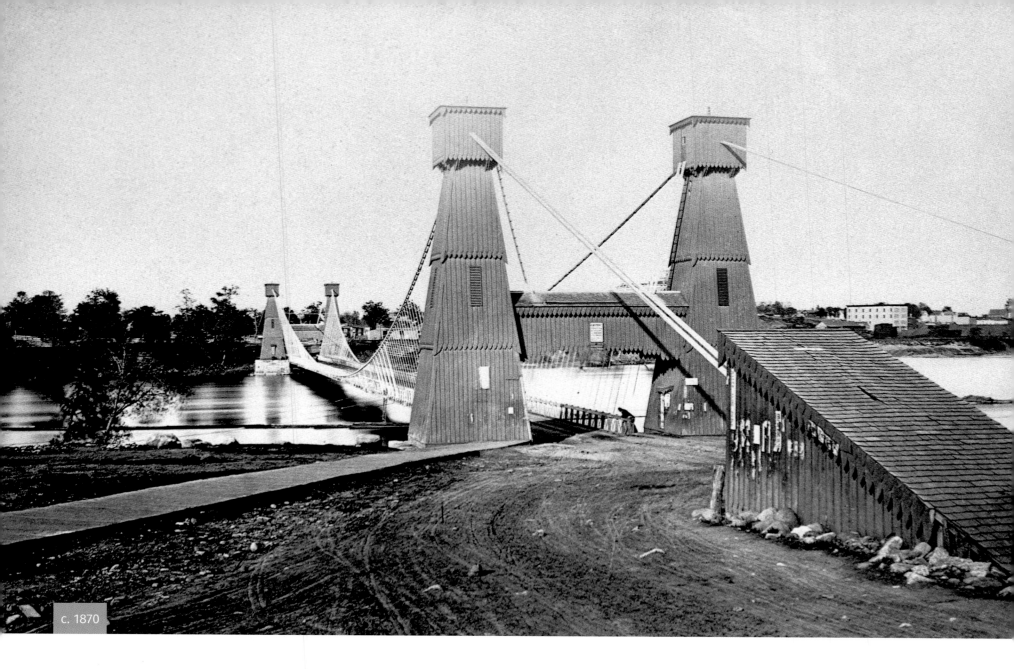

c. 1870

HENNEPIN AVENUE BRIDGE

The first permanent bridge across the Mississippi

ABOVE: Built in 1855, the Hennepin Avenue Bridge was the first crossing of the Mississippi River. Taking advantage of Nicollet Island, just upstream from the St. Anthony Falls, the original bridge shown here was a narrow link between the cities of St. Anthony on the east bank and Minneapolis on the west bank. With traffic booming, the wooden suspension bridge quickly proved obsolete. A larger suspension bridge was constructed in 1876, and a third, even larger arch bridge in 1891. The leafy residential portion of Nicollet Island is shown in the background, with the industrial buildings of the St. Anthony riverfront rising on the river's edge.

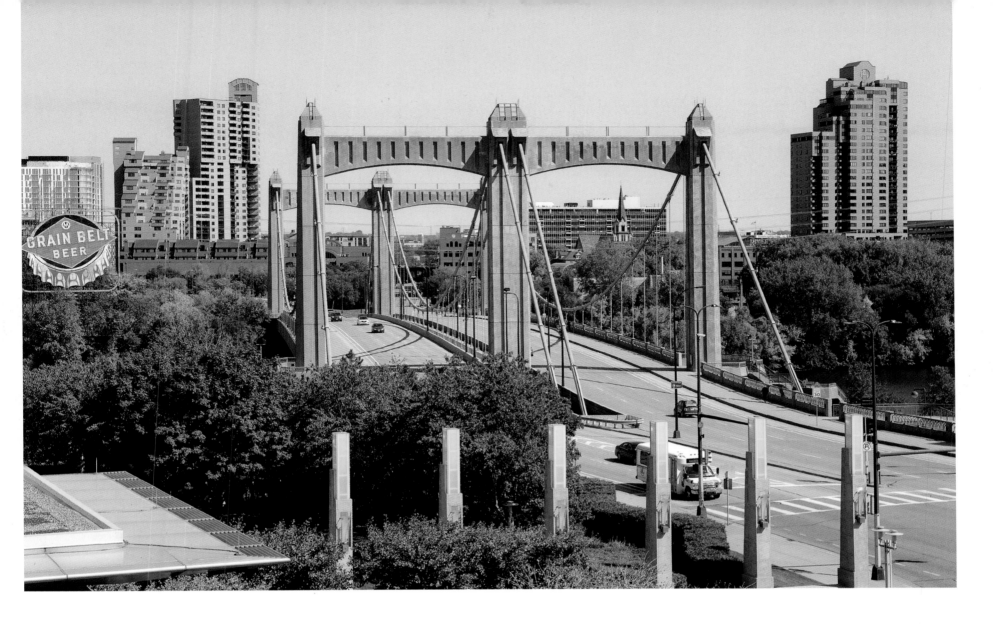

ABOVE AND RIGHT: The current Postmodernist Hennepin Avenue Bridge was built in 1990, its functionally unnecessary suspension cables an homage to the original structures. The 1870s suspension footings are still visible, excavated underneath the current bridge. Instead of industrial activity, today Nicollet Island is used for restaurants and events, while also home to dozens of historic homes and a Catholic high school. The Grain Belt sign, bearing the logo of a famous local beer once brewed just upriver in Northeast Minneapolis, has been catching the eye of northbound drivers since 1950. The St. Anthony skyline is now dominated by high-rise condominiums. Meanwhile, the river has become much cleaner that it was during the industrial era, and kayakers, like the ones shown in the photo on the right, are a frequent sight during warm weather.

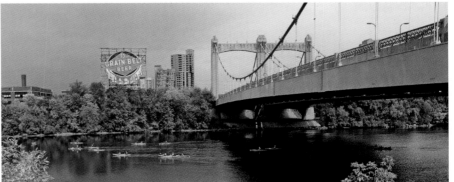

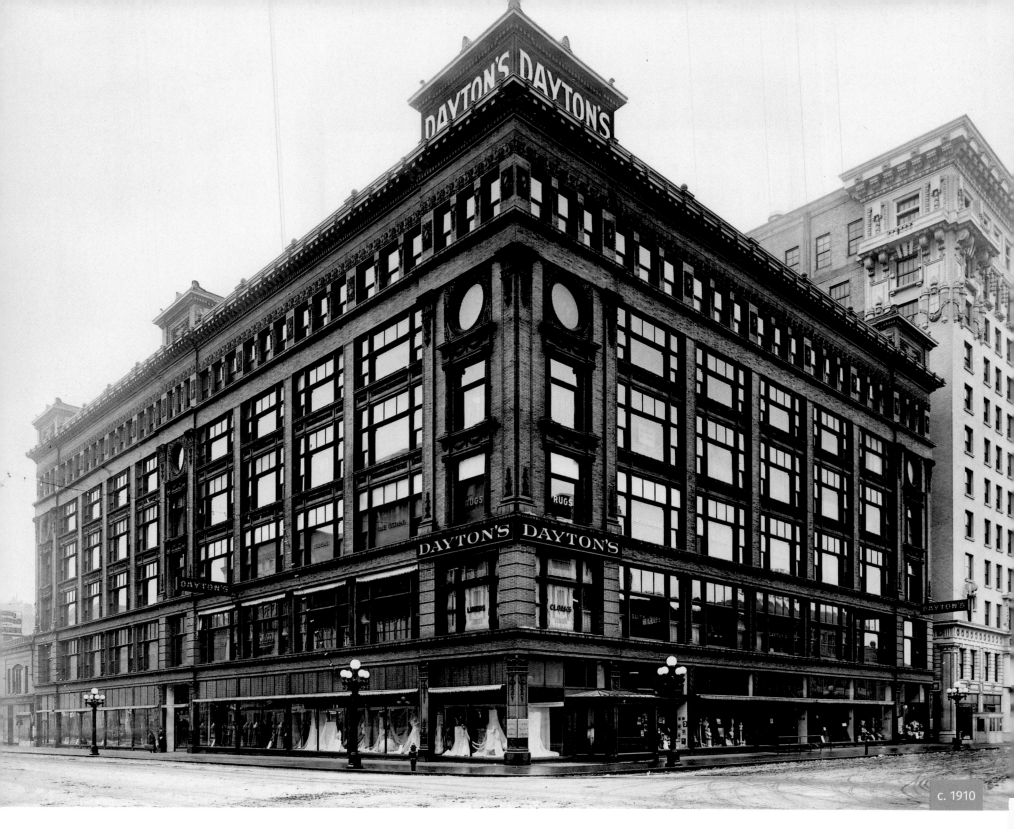

c. 1910

16

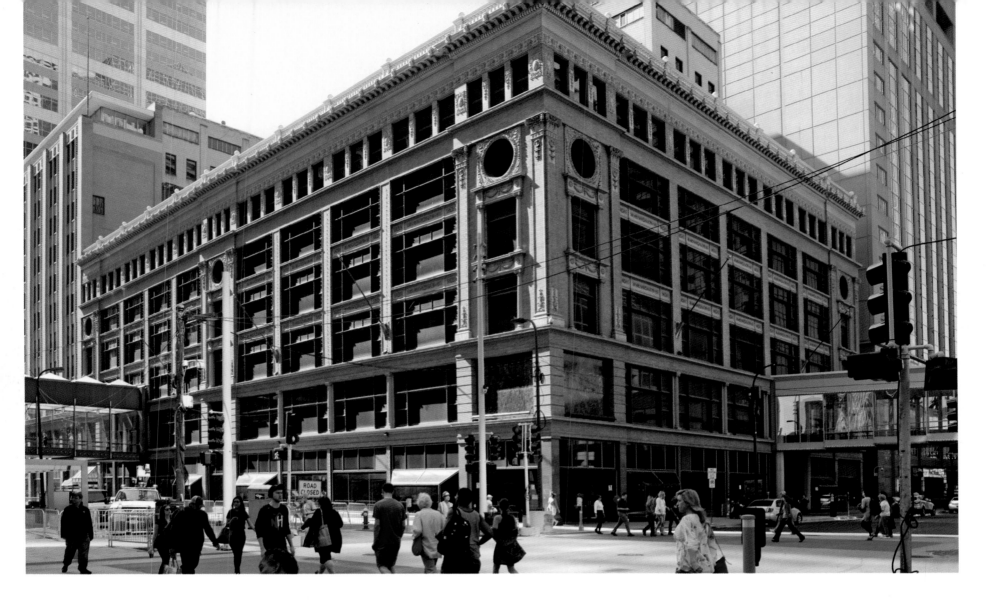

DAYTON'S
The department store finally closed its doors in 2017

LEFT: For much of the 20th century, downtown Minneapolis was the retail heart of the city. Along with Donaldson's, Power's, Penney's, and a few others, Nicollet Avenue and Marquette Street were the prime places for shopping, and for much of that time, the most popular department store was Dayton's. Built in 1902, the six-story Dayton's department store, on the corner of Nicollet Avenue and Seventh Street, offered seasonal sales that quickly became famous in booming Minneapolis. The new department store was a destination for people who would take the streetcars downtown to shop for the latest consumer goods.

ABOVE: The store continued to grow through the 20th century, eventually becoming the flagship of a chain of retailers that would form the Target Corporation in 1965. Each Christmas, the sixth floor of the store would host a series of themed holiday dioramas that attracted children from around the state. However, as retail tastes changed and shoppers moved to the suburbs, and later online, large-scale retail in downtown Minneapolis waned. In 2006 Dayton's was bought by Macy's, and the store finally closed for good in 2017. Today the building is being remodeled as a mixed-use office and retail complex that will attempt to draw a new kind of consumer to downtown Minneapolis. Outside its doors, the remodeled Nicollet Mall pedestrian and transit street forms a spine of retail and offices through the heart, including the headquarters of the Target Corporation just a few blocks to the south. The enclosed pedestrian footbridges on either side of the building are part of the city's skyway system, which was established in the early 1960s.

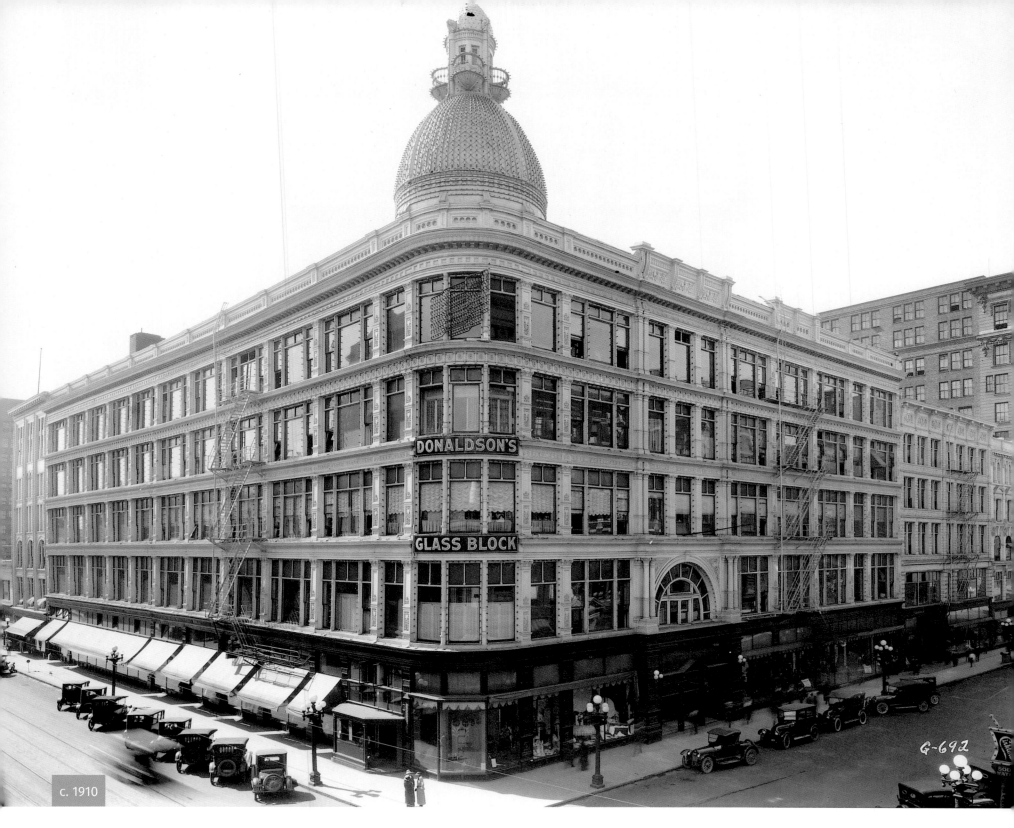

c. 1910

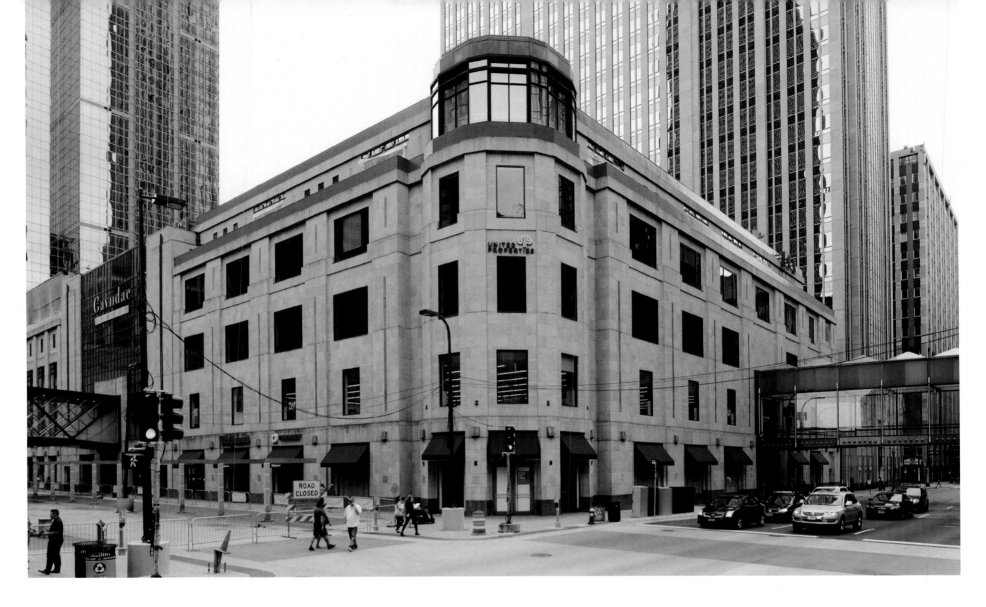

DONALDSON'S
The famous Glass Block was destroyed by fire in 1982

LEFT: Donaldson's Glass Block department store, which took its name from its extensive use of windows, was founded by Scottish immigrants in 1884. Dominating the corner of Seventh Street and Nicollet Avenue, it was one of the largest retail hot spots in the city. During holiday season in particular, people would flock to the store using the then-new electric streetcar system. Dayton's arrived on the opposite corner of the intersection in 1902 and the two department stores would compete against each other for many years to come. In this photo taken around 1910, automobiles have just begun to appear downtown, and shoppers are parked at angles on Nicollet Avenue.

ABOVE: Today nothing of the old Donaldson's building remains. During the 1980s, the brand merged with Carson Pirie Scott and moved into a new urban mall on Nicollet Avenue, before disappearing from Minneapolis altogether. Famously, while the 19th-century Donaldson's building was being demolished in 1982, it became the site of a dramatic fire that broke out on Thanksgiving night. The fire engulfed the entire block and destroyed Donaldson's. The site of the old department store was filled by Gaviidae Common, a Postmodernist four-story urban mall, and the 57-story Wells Fargo Center, designed by Cesar Pelli. The former Donaldson's block is also the site of Minneapolis's first skyway connection. The second-story pedestrian footbridge was built in 1962 across Marquette Street, connecting the Wells Fargo building with the Northstar Center. Along with the 1960s efforts to construct a pedestrian and transit mall along Nicollet Avenue, the skyway system was intended to bolster the downtown retail core in an era of fierce suburban competition, and has met with mixed success.

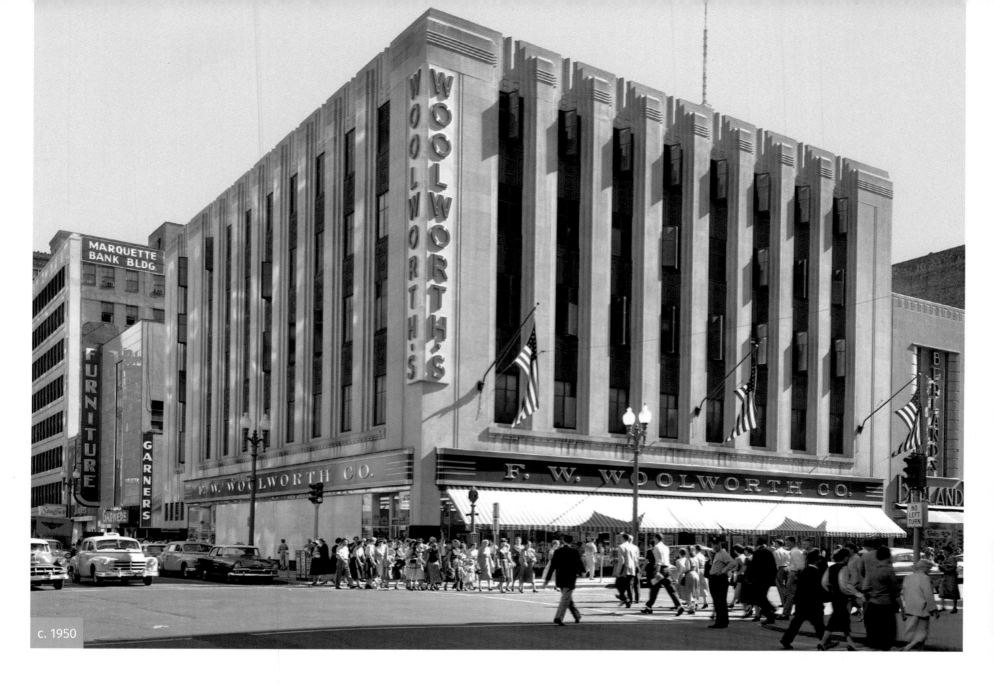

c. 1950

WOOLWORTH'S
Now home to the Philip Johnson-designed IDS Center

ABOVE: For almost a century, the corner of Seventh Street and Nicollet Avenue has been the heart of downtown Minneapolis's retail district. Built in 1937 in the middle of the Great Depression, the Art Deco five-story Woolworth's building designed by Larson and McLaren was the cutting edge of retail. It was even air-conditioned year-round, a novelty at the time. Shown here around 1950, and located across the street from Dayton's, the store cemented Nicollet Avenue as the center of the regional shopping district.

20

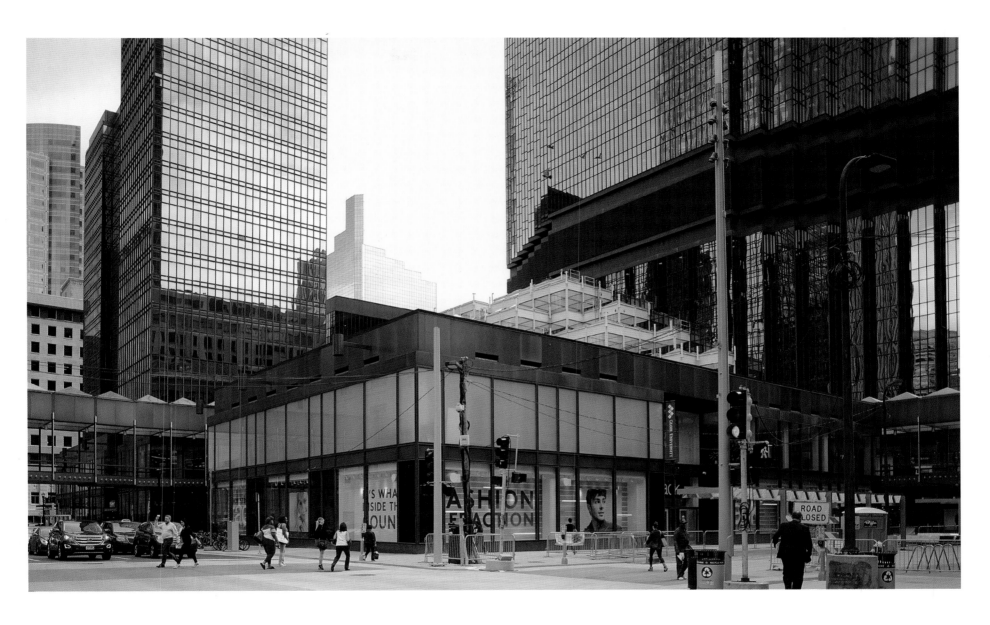

ABOVE: Woolworth's lasted until the late 1960s, when construction of the city's first major Modernist skyscraper, the IDS Center (named for a financial services company), began. At 57 stories tall, the shiny Philip Johnson-designed glass-and-steel tower, visible along the right edge of the photo, dwarfed the rest of the skyline, almost double the size of the Foshay Tower. The building, which opened in 1973, features a massive indoor atrium, the "Crystal Court," which tied together the nascent tendrils of the city's second-story skyway system, allowing office workers and shoppers to transcend the sometimes-cold Minneapolis sidewalks. In the mid-1960s, Nicollet Avenue was closed to regular vehicle traffic and redesigned as a pedestrian and transit mall, and in 2017 the mall was updated with fresh concrete pavers, new trees, and other placemaking features. While the region's retail activity no longer centers on the corner of Seventh and Nicollet, the IDS Center remains the tallest building in Minnesota. The IDS Center's two-story indoor plaza, which occupies the former Woolworth's site, is a bustling hub of activity connecting the skyway to the street.

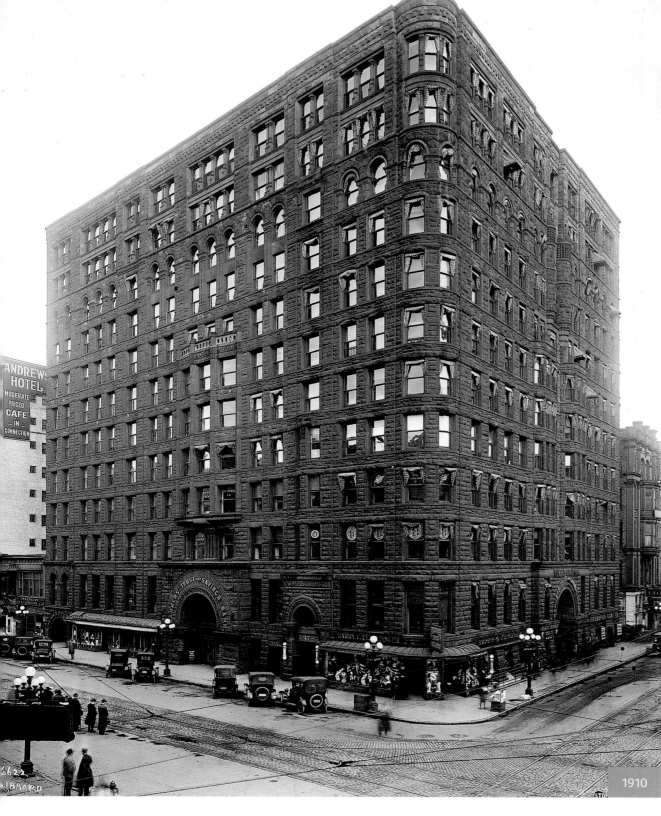

1910

LUMBER EXCHANGE BUILDING

A rare example of an early "skyscraper"

LEFT: Built in 1886 on Hennepin Avenue and Fifth Street, the Lumber Exchange Building was Minneapolis's tallest structure for a time. A Richardsonian Romanesque "skyscraper" with thick red granite walls, the building housed many of the lumber companies that plied their trade in wood from the northern pine forests. In the late 19th century Minneapolis was the home of a huge seasonal labor market, which brought itinerant workers from around the country into Minnesota for work. Each winter teams of lumberjacks headed north to harvest the pines, and each spring the felled trees flowed south down the river and into the waiting mills and railroads. Along with the grain and flour exchanges, the lumber exchange was an icon of Minneapolis's early days as a commodities and industry hub. The top two stories, with bricks that contrast with the granite (visible in the photograph opposite), were added in a later expansion.

RIGHT: Most of the skyscrapers of this era have been lost to progress and change, and today the Lumber Exchange Building is the oldest American 12-story building outside New York City. The building was listed on the National Register of Historic Places in 1983 and today is home to a mix of offices and restaurants. The building sits next to the Warehouse District light rail station along Fifth Street; the catenary wires are visible extending over the intersection. Facing Hennepin, the exchange looks out at the last remnants of the city's once-booming red-light district. Then as now, Hennepin Avenue is the crossroads of Minneapolis. While the area is no longer a hub of industry commodities trading, the Lumber Exchange has found new life as a home for the city's diverse economy.

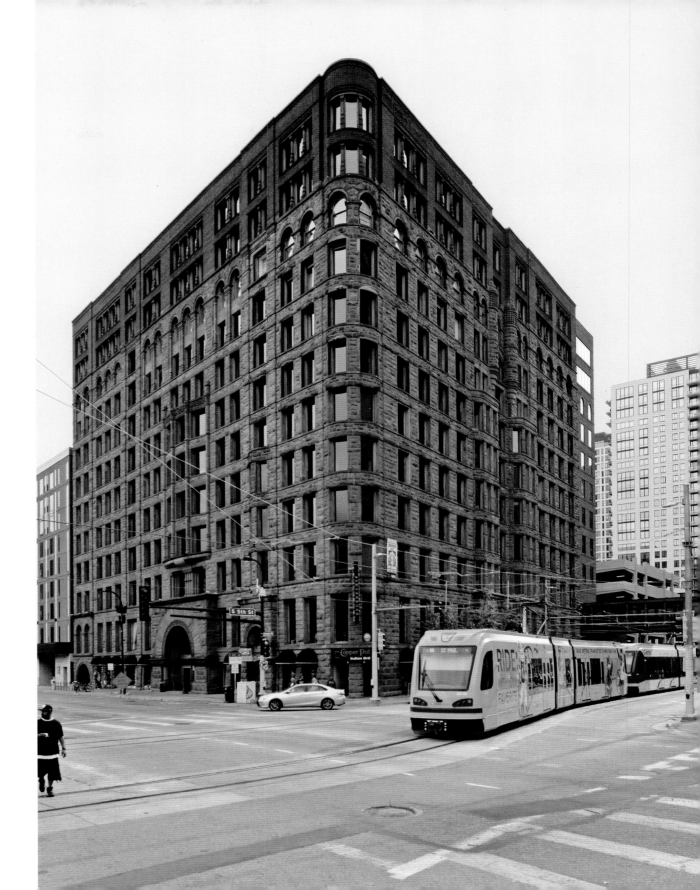

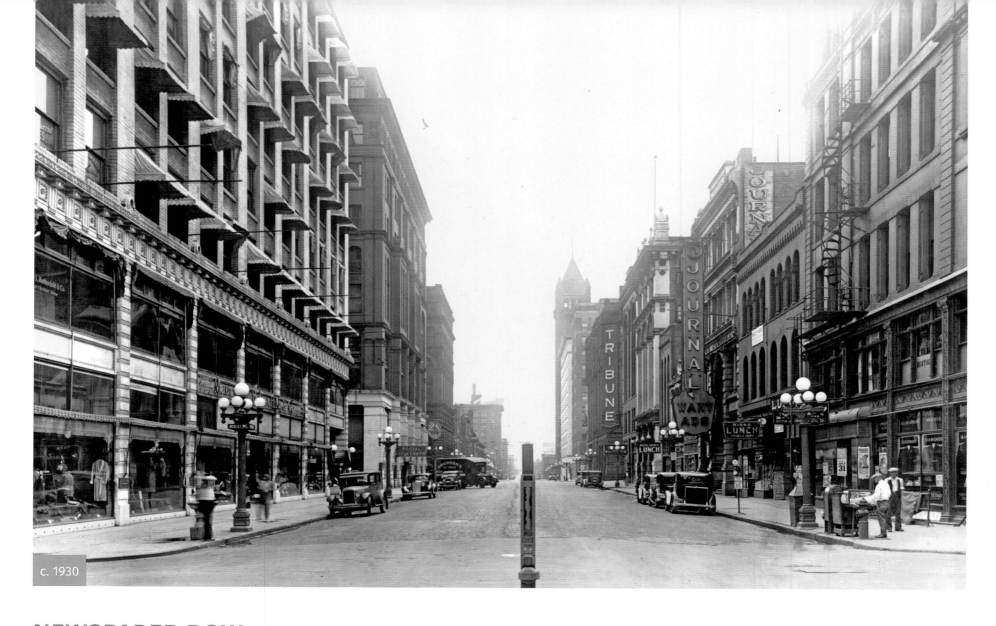

c. 1930

NEWSPAPER ROW

Fourth Street was at the heart of Minneapolis's booming newspaper industry

ABOVE: Most of the buildings shown on this stretch of Fourth Street—part of Minneapolis's vaunted "Newspaper Row"—date to the late 1880s, when the newspaper industry was booming right alongside the Twin Cities. By the early 1900s the corner of Fourth Street and Nicollet Avenue was the center of Minneapolis's newspaper industry. Signs for the *Tribune* and the *Journal* can be seen affixed to the buildings on the right, while the tower of the Minneapolis City Hall punctuates the distance. Within these few blocks were centered a dozen newspapers and printers operating in many different languages. There was the *St. Paul Globe*, the *Minneapolis Tribune*, the *Minneapolis*

Journal, the *Saint Paul Pioneer Press* (branch office), the *Penny Press*, the *Minneapolis Time*, the *Svenska American Posten*, and others. In front of different buildings, bulletin boards with breaking headlines would attract crowds, and likely as not there was a continual din of rumor, innuendo, and other information bubbling over the street. Journalists, businessmen, columnists, and all manner of the well-connected and ink-stained would hang around the row and the restaurants nearby.

ABOVE: City Hall remains today, but there is nothing left of the old Newspaper Row. The *Tribune* moved east out of the district in 1947, and even its building, which housed the merged *Star Tribune*, has been demolished for a new public park. Meanwhile, nothing from 19th-century Nicollet Avenue remains. Instead, the corner of Nicollet and Fourth is a mix of office and apartment buildings, the latest of which, visible on the left, boasts balconies that recall the awnings of old Newspaper Row. The covered footbridge in the foreground will connect this 30-story development with the public/private skyway system.

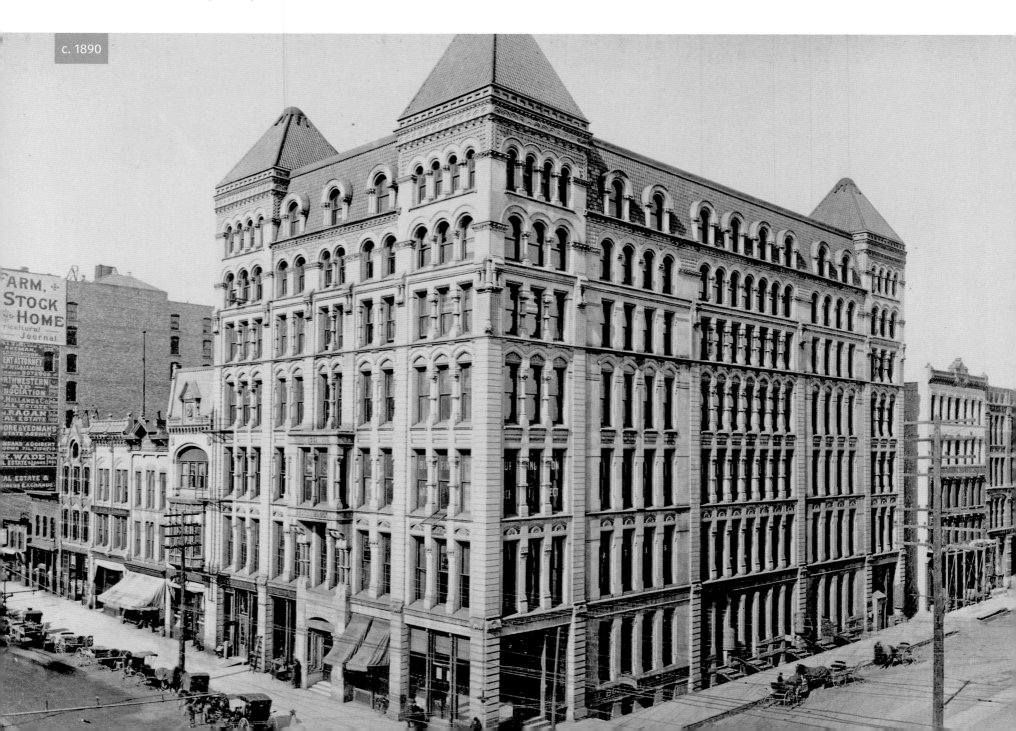

BOSTON BLOCK

Built in a decade of rapid expansion

c. 1890

LEFT: When the Boston Block was under construction in 1880, Hennepin Avenue was a well-worn dirt road and the scale of the new building signaled a new era for downtown Minneapolis. Designed by ambitious architect Leroy Buffington, who pioneered the use of steel beams within Victorian stone construction, the building reflected the early move toward Romanesque architecture that was coming into fashion at the time. With its four turrets and imposing bulk, the building changed the tone in Minneapolis at the beginning of an economic boom that would last throughout the 1880s. The building suffered a fire in 1887 and was remodeled soon afterward. Shown here in 1892, Buffington had his offices located in the office tower. By that point he had also designed a number of other Minneapolis and St. Paul landmarks, including the Pillsbury A-Mill, the second State Capitol building, and the first St. Paul Union Depot.

RIGHT: According to period accounts, the light-colored facade of the Boston Block did not age particularly well, and after a few decades the building had become dingy. By the 1940s the building was marked for demolition and it was torn down in 1943, a prelude of things to come in the area after the war was over and federal urban renewal dollars arrived. Today the old Boston Block is all but forgotten, and the area is now home to a mix of residential and office buildings. The site is occupied by an unremarkable senior housing tower, with concrete walls adjacent to the Hennepin Avenue sidewalks.

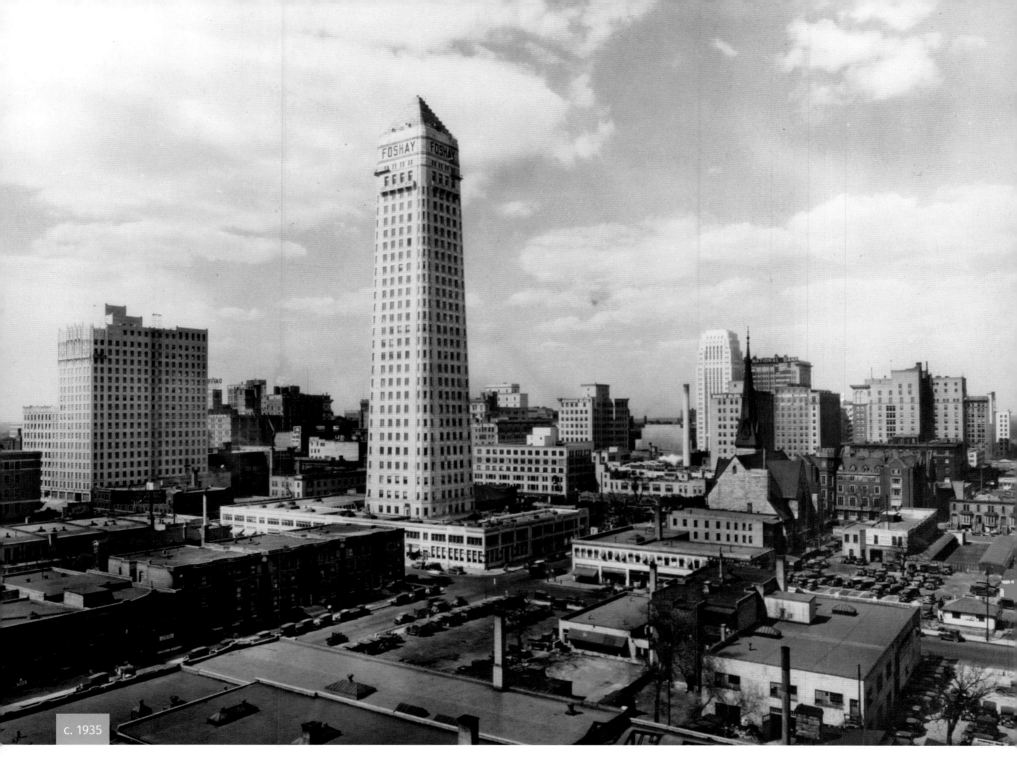

c. 1935

FOSHAY TOWER

The tallest building in Minneapolis for over 40 years

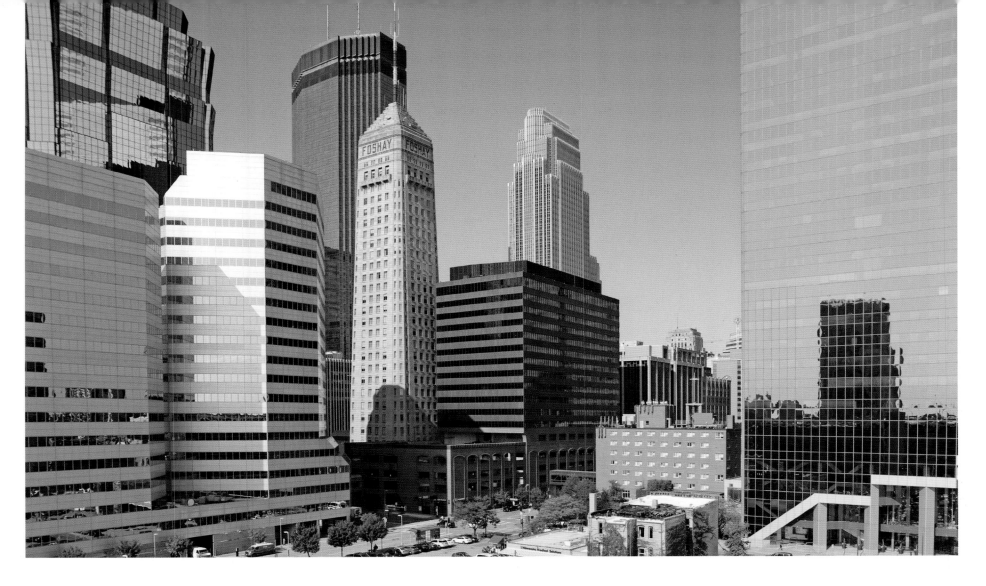

LEFT: Easily one of Minneapolis's iconic buildings, the 32-floor Foshay Tower was the tallest building in Minneapolis for over 40 years. Erected in 1929, and designed to look like the Washington Monument, the skyscraper was funded by an infamous schemer, Wilbur Foshay, who finished the Art Deco tower just before the stock market crashed. The opening ceremony for the building saw Foshay's name in lights and featured a commissioned march by the composer John Philip Sousa. Soon afterward, Foshay went bankrupt and was convicted for mail fraud, and Sousa never got paid for his composition. Yet the tower that bears Foshay's name defined the downtown skyline for almost half a century.

ABOVE AND RIGHT: Apart from the small ivy-covered apartment building visible in the foreground parking lot, few of the pre-war landscape remains in this part of the city. Throughout the post-war decades, the old buildings were largely cleared for parking lots and large-scale office buildings. Today the Foshay Tower is a prestigious boutique hotel, with a small museum, a skydeck open to the public, and a hotel bar on the top floor offering striking views of the city. Restaurants and office space line the first floor on Marquette and Ninth, on the edge of the downtown core. The Art Deco details of the interior—including the mail slots, elevators, and marble hallways—are a stunning reminder of Minneapolis's architectural and design heritage.

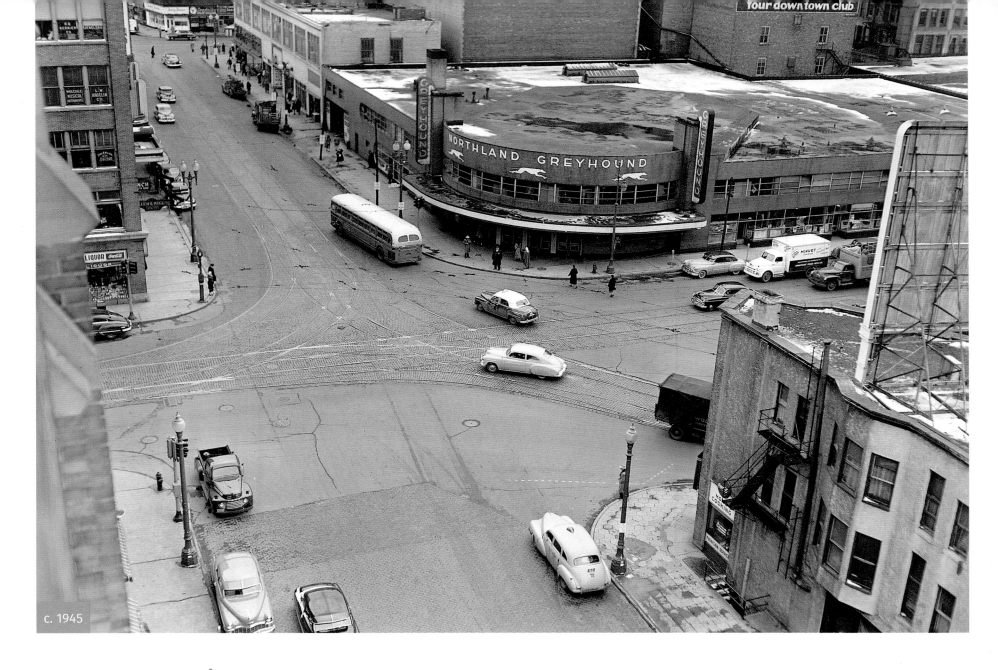

c. 1945

BUS STATION / FIRST AVENUE

A key location in Prince's film *Purple Rain*

ABOVE: One block behind the city's traditional theater district, First Avenue was the edge of the downtown Minneapolis core for decades. This bus station dates to the mid-1930s, and served as the downtown bus depot for many years. Opened as the Northland Greyhound, the bus station included a café, barbershop, and cigar store. The Greyhound company began 200 miles north of Minneapolis in Hibbing,

Minnesota, as a regional bus service. This picture, taken soon after World War II, shows the streetcar tracks and a bus waiting to depart. In that era, the mixed-use fabric of the warehouse district was full of cheap apartments, hotels, offices, and many warehouses. During the day and night, streets filled with people from all walks of life.

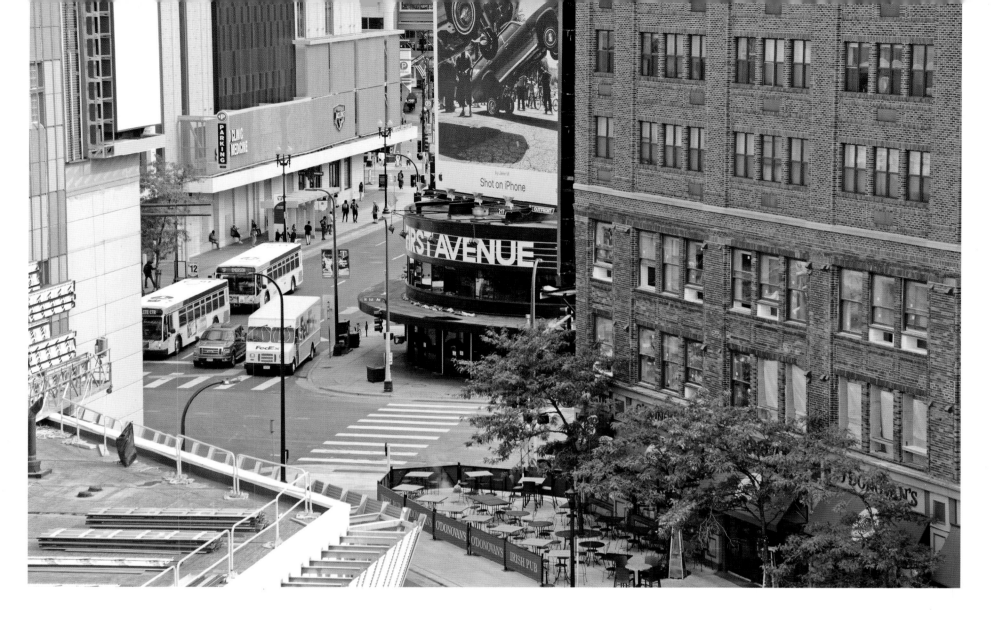

ABOVE AND RIGHT: During the 1970s and 1980s, Hennepin Avenue and the nearby "warehouse district" along First Avenue were the heart of a thriving local arts and music scene. The empty bus station, which closed in 1968, was converted to a nightclub called Uncle Sam's in 1972, and renamed First Avenue in 1981 when it began focusing on rock and R&B music. During the next few decades, the nightclub became the legendary venue for hundreds of rock acts, including the early rise of local artists like Prince, the Replacements, and Hüsker Dü. Today First Avenue still anchors the Minneapolis music scene. Its exterior wall is covered with stars representing the different bands that have played there, including a unique gold star for Minneapolis's late rock icon, Prince.

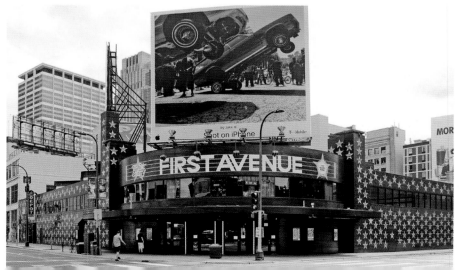

BRIDGE SQUARE / GATEWAY PARK
The only remnant of the City Beautiful-inspired park is its flagpole

BELOW: Arguably no spot in Minneapolis has seen more transformation than the intersection of Nicollet (on the left) and Hennepin Avenue (on the right). Once dubbed Bridge Square, after the Hennepin Avenue Bridge over the Mississippi, the large triangular plaza was ground zero for 19th-century gatherings, parades, demonstrations, and public life. Minneapolis's first City Hall, built in 1873, sat on the square, as did many of the city's most famous hotels. This photo shows the building in the mid-1880s. As the 20th century progressed, the area declined economically while the economic and cultural center of downtown moved away from the industrial riverfront.

1885

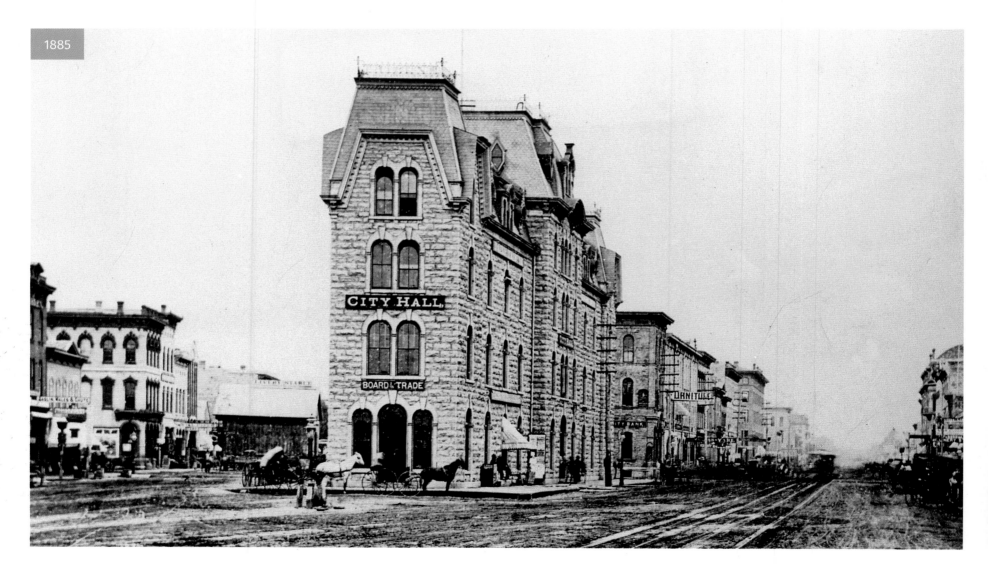

BELOW: By 1900 the new City Hall was under construction a half-mile away, and by 1920 old Bridge Square was the site of the city's first large-scale urban renewal project. The then-obsolete City Hall was torn down, and the site was cleared to create a City Beautiful-inspired Gateway Park. The name came from its location, which was seen as a gateway to the nearby train depots. Once the post-war infusion of federal urban renewal dollars came to town, old Bridge Square/Gateway Park became the starting point for the largest slum-clearance project in the country. During the early 1960s, over a dozen blocks of Minneapolis's oldest building stock were leveled for surface parking lots, bare grassy plazas, and Modernist architecture. Today, after 50 years of inattention, the area's surface parking lots are finally receiving an influx of new development. The only remnant of old Gateway Park is the flagpole, visible in the foreground. It still stands at the spot that once marked the intersection of Nicollet and Hennepin.

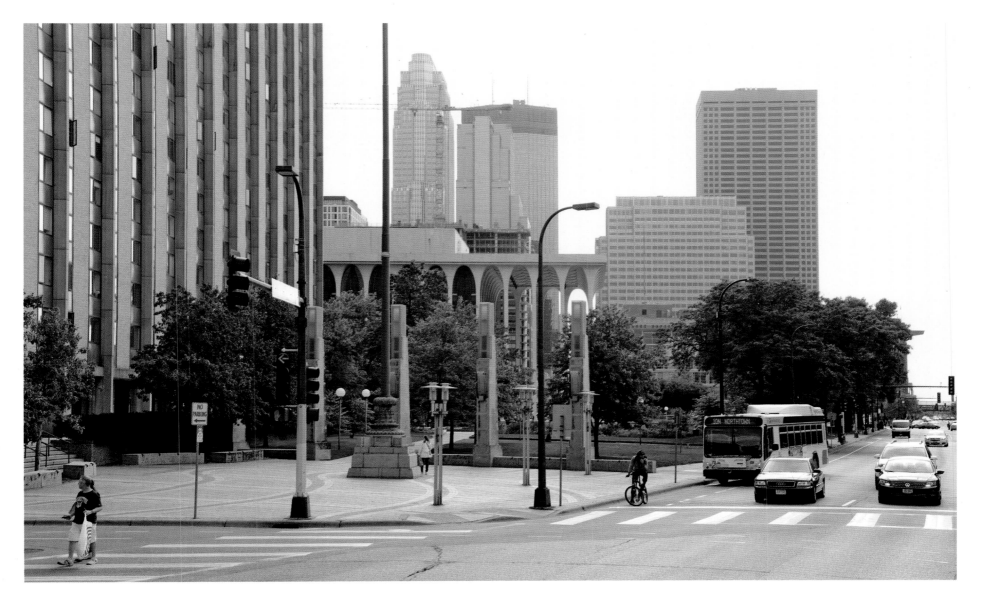

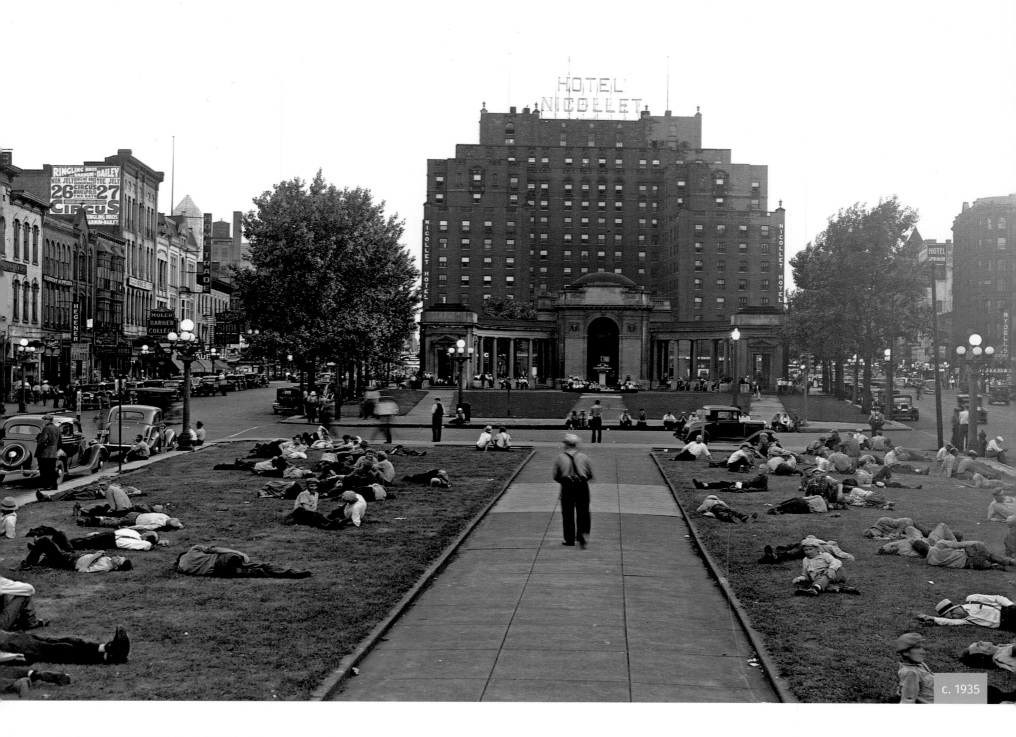

c. 1935

GATEWAY PARK AND HOTEL NICOLLET

A gathering place for Minneapolis's itinerant labor market during the Great Depression

LEFT: Because of its unsavory reputation, Bridge Square became the site of Minneapolis's first attempt at urban renewal. Following a City Beautiful Beaux Arts script, planners erected a new park at the square called Gateway Park. Its columns and arched pavilion are visible in the background, and the park itself stretched like a triangle outward with a tall flagpole at its apex. The name Gateway referred to the proximity of train stations, which made the neighborhood the "gateway" of Minneapolis. Despite the hopes for change, by the 1930s, when this photo was taken, Gateway Park had fallen into the grips of the Great Depression. Its proximity to Minneapolis's infamous skid row, one of the largest in the nation, made it an ideal hangout for the city's itinerant labor market. Men looking for seasonal or day-labor work would hang out in the park waiting for jobs or drinking at any of the dozens of nearby establishments that occupied the land between the downtown and the grimy Mississippi. The Hotel Nicollet, built in 1924 and rising behind the park, was an expansion of the original Nicollet House Hotel that had occupied the site since 1858.

ABOVE: By the mid-1950s, armed with federal urban renewal dollars, Minneapolis leaders declared the site ground zero for a massive slum clearance effort. Every existing building between the park and the river was razed to the ground, replaced by parking lots and a small handful of Modernist office complexes, each surrounded by well-manicured private plazas. The white pillars just visible at the left of the frame belong to one of those Modernist office buildings, an elegant insurance building built by Minoru Yamasaki in 1965. The Hotel Nicollet was placed on the National Register of Historic Places in 1987, but it was demolished in 1991 and replaced by a surface parking lot. Minneapolis's new central library building, designed by Cesar Pelli, occupies the focal point at the center of the frame, while the old grounds of the park and hotel remain a surface parking lot to this day.

c. 1910

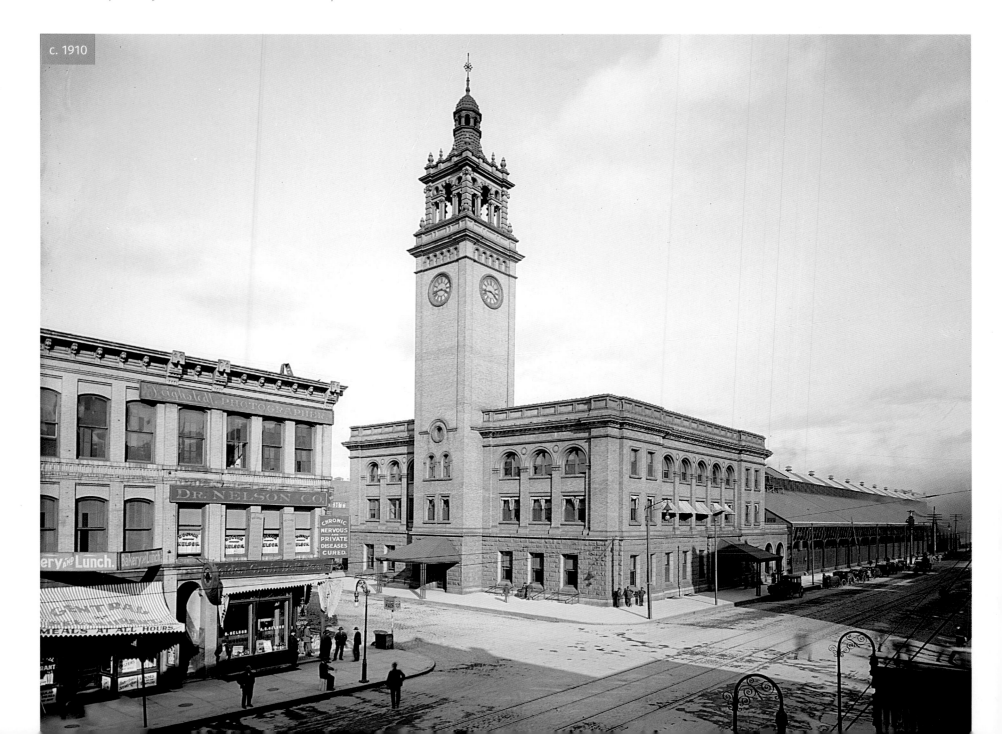

LEFT AND RIGHT: Built in 1899, the Chicago, Milwaukee, St. Paul, and Pacific Railroad—also known as the Milwaukee Road—was once a key line serving the Twin Cities, and its Minneapolis depot was one of three that served the city. At its peak, it offered service to and from Chicago in under seven hours via its famous Hiawatha train. The station was the focal point for the massive rail yard that extended into the mill district, and the depot served as a disembarkation point for untold thousands of people setting foot in Minneapolis for the first time. The photo on the right shows the depot minus its cupola in 1948, when it also served the Rock Island and Soo lines.

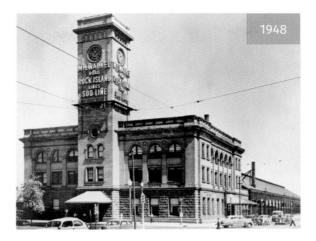

1948

BELOW: Minneapolis's other great train depot, the Great Northern, was torn down in 1978 for the new Federal Reserve bank, but the Milwaukee Road building has survived. The depot was closed in 1971 and placed on the National Register of Historic Places in 1978. After lying vacant for many years, it was renovated and reopened as a hotel in 2001. For decades, the train yard and platform structure housed a popular indoor skating rink, though it shuttered for good in 2015. Like the northeast side of the river, the former industrial riverfront area has become a hot location for housing redevelopment.

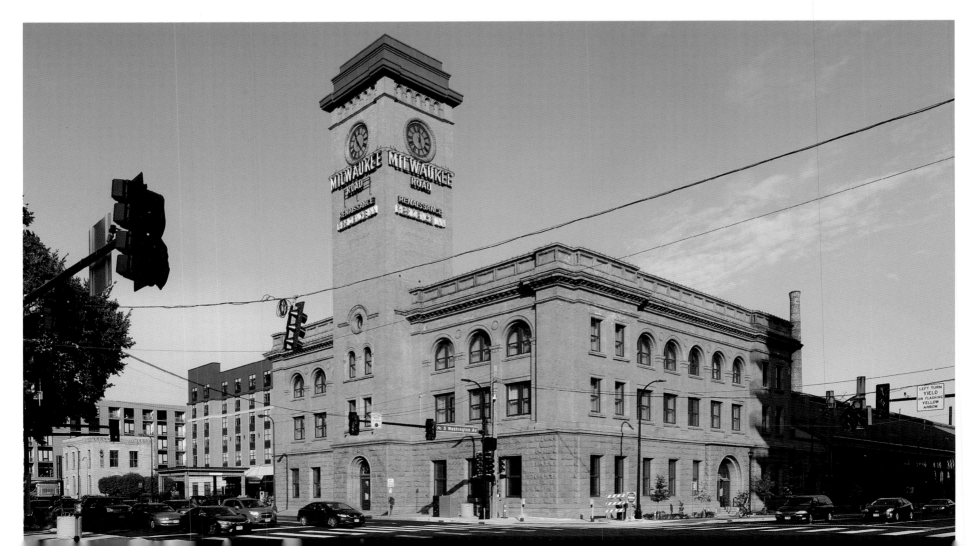

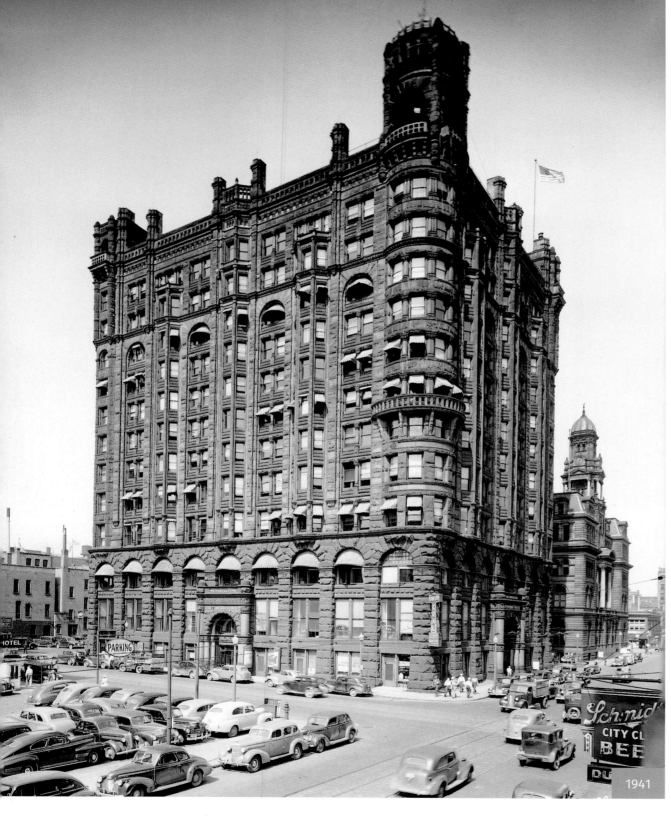

1941

METROPOLITAN BUILDING

The lamentable loss of this architectural landmark is still mourned today

LEFT: Built at Third Street and Second Avenue in 1890 for the Northwest Guaranty Loan Company, the Metropolitan Building was once Minneapolis's tallest and most glamorous skyscraper. With massive granite-and-sandstone walls and Richardsonian Romanesque architecture, capped with a small turret, the office tower defined an era in late 19th-century Minneapolis. The interior of the building contained a massive atrium, lined with ornate railings, early elevators, and topped in a glass roof. With a publicly accessible rooftop deck, it was the tallest and most interesting of the buildings in the old Gateway district. This image dates to the 1940s, about a decade before the city decided to demolish the neighborhood.

RIGHT: There's a clear architectural consensus that the demolition of the Metropolitan Building in 1962 was one of the biggest tragedies in downtown Minneapolis history. Because it stood within the seedy Gateway, by the post-war period the once-stately Metropolitan had become run down. It was demolished for reasons of "slum clearance" along with the rest of the neighborhood. If the building had survived another few years into the preservation era, the Metropolitan might be one of the city's most desirable office spaces. Instead, in 2010 its stone remains were discovered in an abandoned farm field, and have been reused in landscape architecture projects around the city. The site of the old Metropolitan is occupied by a 1980s-era office building, part of a quiet business-oriented area of the city, and connected seamlessly into the city's downtown second-story skyway network.

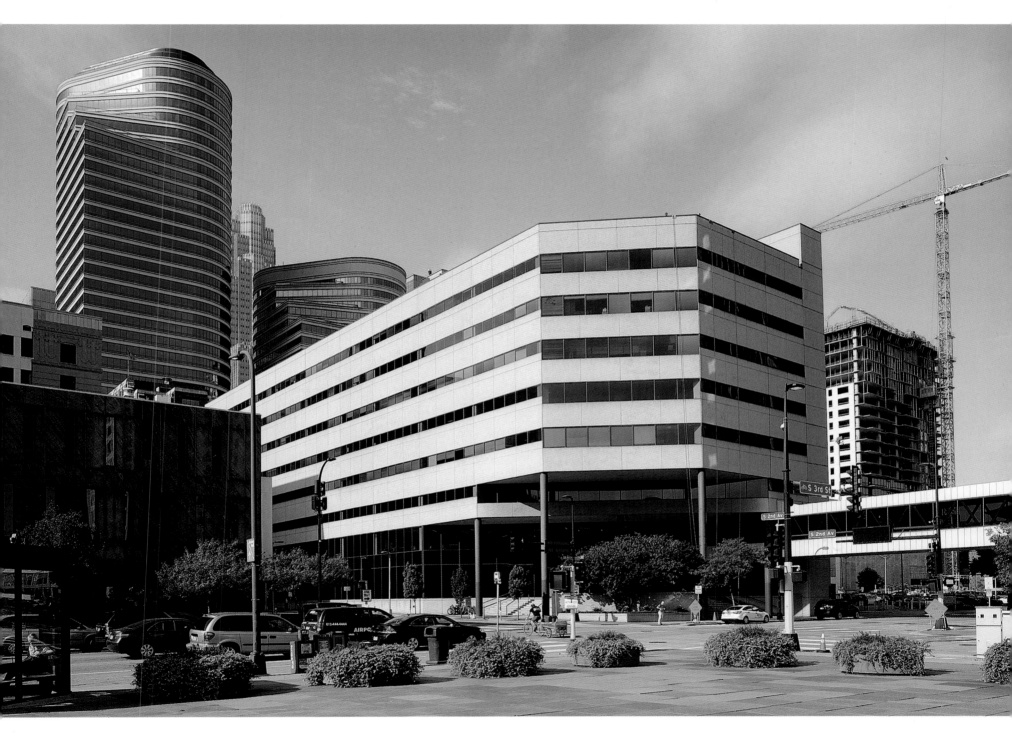

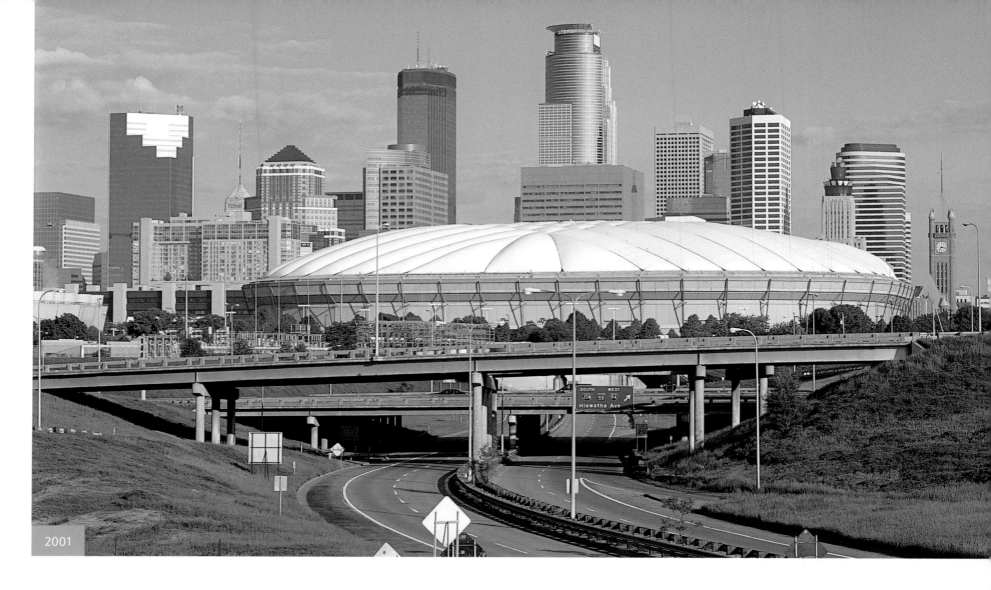

2001

METRODOME / U.S. BANK STADIUM

Its air-supported fiberglass fabric roof made the Metrodome a modern marvel

ABOVE AND RIGHT: When the Hubert H. Humphrey Metrodome was built in 1982, it was a modern marvel. Named for a former Minneapolis mayor, vice president, and nationally famous politician who had died a few years earlier, and costing $55 million, the new stadium was intended to consolidate many of the region's sports in a climate-controlled and centrally located place. Built on old industrial property at the eastern edge of downtown, the 60,000-seat building used 250,000 cubic feet of air pressure per minute to inflate a fiberglass fabric roof, creating a climate-controlled environment year-round. Notably, when exiting through some of the doors following games, the dome would "blow" its spectators forcibly out into the Minneapolis sidewalks. For over 30 years, the building was home to World Series games and Super Bowls, and the Twins, Minnesota Vikings, Minnesota Strikers (soccer), and University of Minnesota Golden Gopher football and baseball teams played their regular games at the Metrodome.

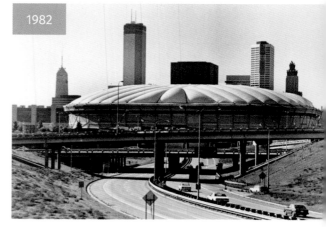

1982

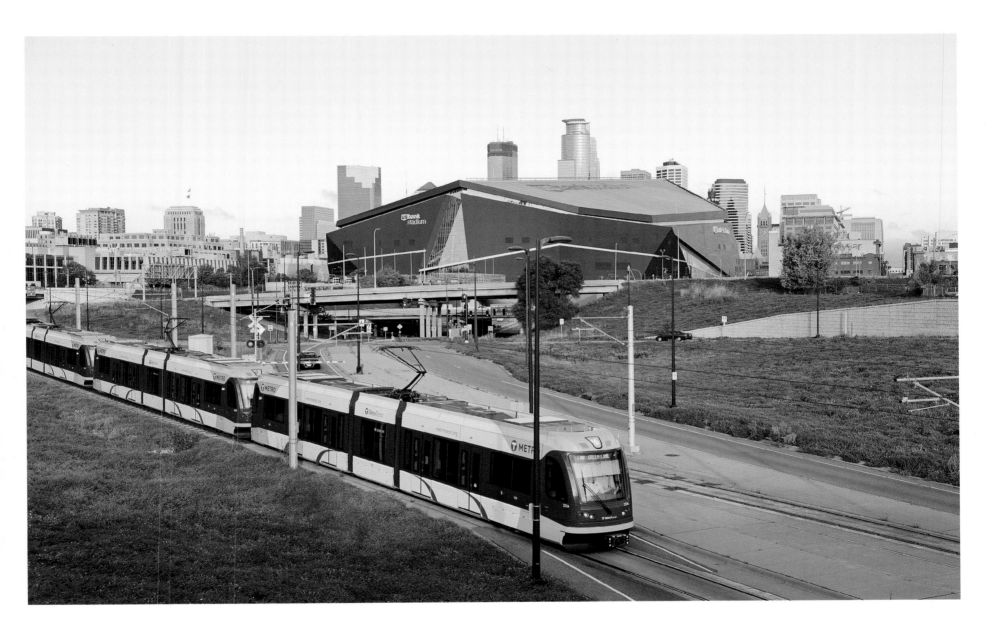

ABOVE: Since 2010, a stadium construction boom has taken place in the Twin Cities, and local sports teams gradually began moving to new homes. With help from taxpayers, the Twins built a new ballpark at the other edge of downtown and the University of Minnesota built a new football stadium back on campus. When the Minnesota Vikings garnered state funds to build a new billion-dollar stadium, the Metrodome was torn down in 2014 and eventually replaced with a new facility. Now called U.S. Bank Stadium, the new building is designed to reflect the city skyline and evoke the design of a Viking ship. Along with a new public/private park next to the stadium gates, and a pair of light rail lines (the Green Line is pictured here), the new stadium has helped spur redevelopment of the eastern side of downtown Minneapolis.

Eventually

WASHBURN CROSBY CO., INC.
OF GENERAL MILLS, INC.

GOLD MEDAL FLOUR

c. 1905

WASHBURN-CROSBY FLOUR MILL AND RAILYARD
Minneapolis's downtown mills produced 20 percent of the nation's flour supply

LEFT: At its peak in 1916, the downtown Minneapolis flour mills produced 20 percent of the national flour supply. This view, taken about 10 years earlier, shows the Washburn-Crosby flour mills, the city's largest, when they were operating at full capacity and employing around a thousand people. The mills, along with their accompanying rail yards, were built along a series of underground canals and occupied massive amounts of land between the river and Washington Avenue. The mills were topped with great neon signs advertising Washburn-Crosby's signature brand, Gold Medal Flour. Their persuasive slogan was "Eventually you'll try Gold Medal Flour, why not now?" The similar array of Northeast Minneapolis industrial buildings, on the far side of the Mississippi, are visible along the horizon. Most notable is the lost Industrial Exposition Building on the right, whose great turret was the tallest building in Minneapolis at one point, and played host to the Republican National Convention in 1892.

ABOVE: No more flour mills remain in Minneapolis. After a series of mergers, the Washburn-Crosby Company, now General Mills, moved to suburban Golden Valley and became a major food corporation. The "A" Mill, here obscured by new developments, was the oldest and largest mill on the west side of the river before being abandoned in 1965. It was nearly burned down by squatters in 1991, and while only some of the walls remained, today the mills have been restored as a mixed-use building that is home to the Mill City Museum, a popular and family-friendly attraction that offers tours of the old structure. Meanwhile, the massive rail yard has been completely removed, and over the last few decades has become a thriving residential neighborhood with high-end apartments and condominiums. Old grain elevators rise over the new neighborhood, and a neon sign (just out of frame to the right) still blinks "Gold Medal Flour" like clockwork through the night. Likewise, the North Star Blankets neon sign, today a defunct brand, can be seen in both images at the left of the frame. The old blanket factory, originally built in 1864, has been converted to loft-style condominiums.

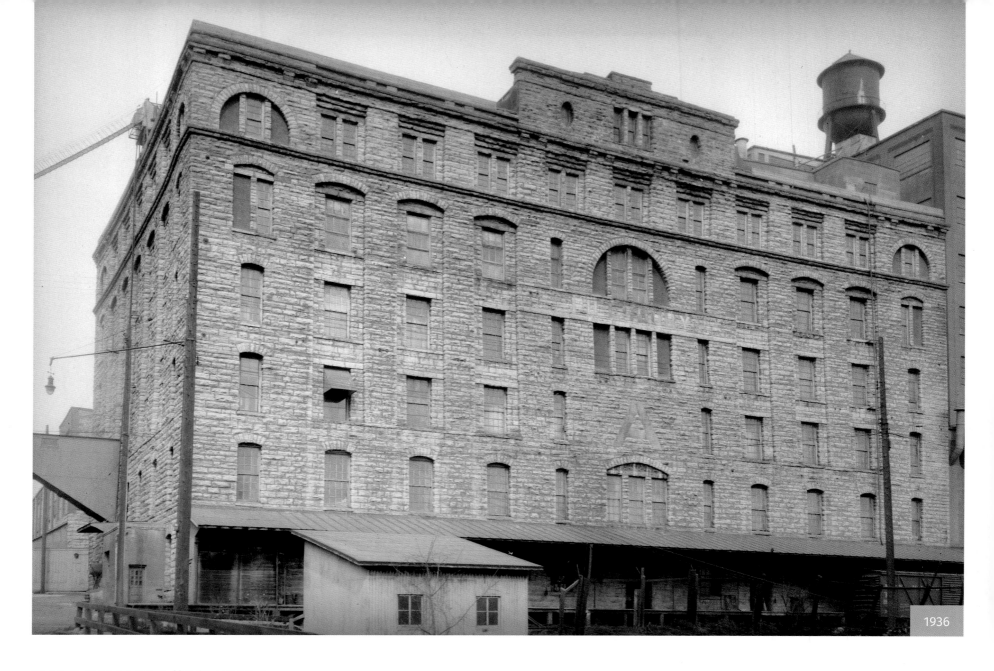

1936

PILLSBURY "A" MILL

Pillsbury was the biggest flour-producing company in the world

ABOVE: The northeast side of the Mississippi River where the Pillsbury "A" Mill stands is home to some of the oldest buildings in Minneapolis. The "A" Mill itself on St. Anthony's Main Street is the largest and oldest intact example of the dozens of mills that lined, and were powered by, the St. Anthony Falls. Pillsbury's mill, built from distinctive gray Platteville limestone, dates to 1881 and at its peak in the early 1900s, processed over three million pounds of flour a day. Once electrification became commonplace, Minneapolis's milling industry faded in importance, and the old mills were demolished or fell into ruin. This photo dates from 1936, when the downtown milling was already in decline.

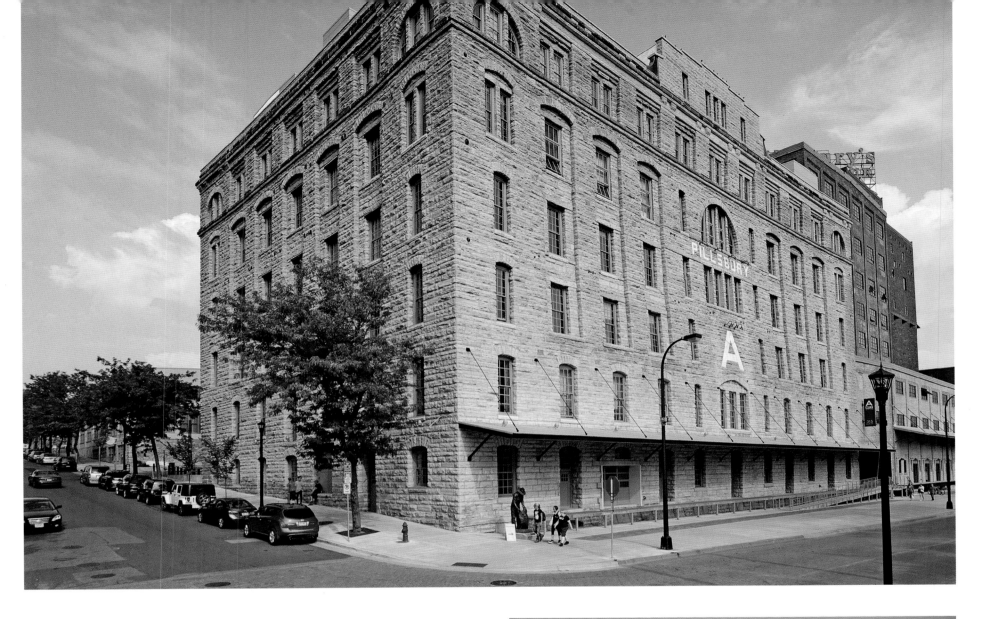

ABOVE AND RIGHT: The Pillsbury Company was bought by General Mills in 2001 and "A" Mill remained in operation until 2003. In the most historic part of the complex, large steel beams were affixed to the exterior of the building to stabilize the deteriorating stone walls. A few years afterward, the complex was sold to a developer and, with the help of federal preservation tax credits, underwent a painstaking restoration. Today the riverfront in old St. Anthony has experienced a resurgence, and is a hotbed of apartments, cafés, and condos. In 2016 the A-Mill Artist Lofts opened its doors as a restored housing complex, a centerpiece of the new neighborhood. Its old industrial nooks have transformed into apartments, studios, creative art spaces, and the like. The refurbished neon signs sit atop the old mill structures while next-door St. Anthony Main is a mixed-use office complex boasting a series of riverside cafés alongside the restored 19th-century buildings.

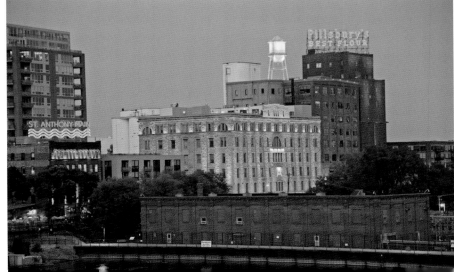

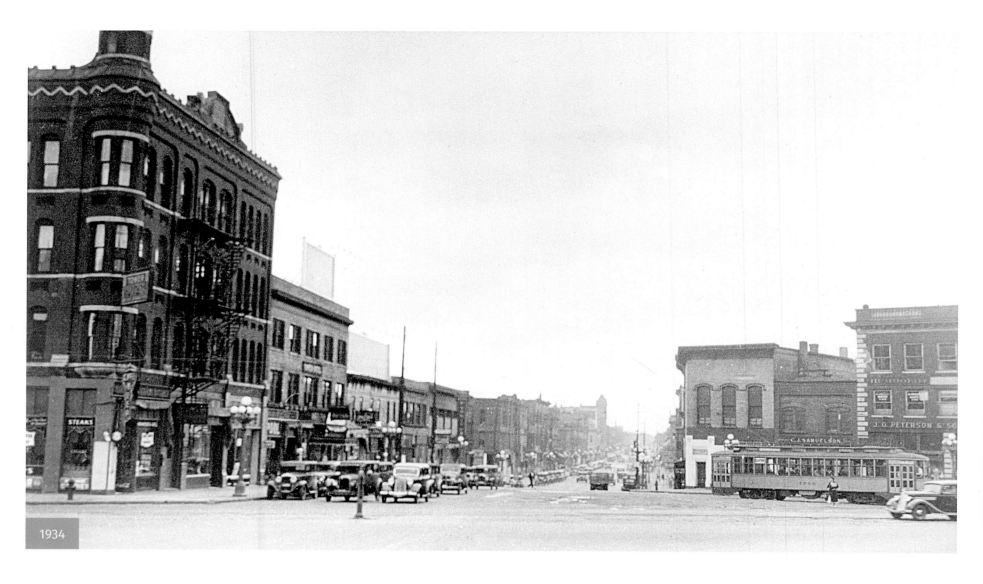

1934

SEVEN CORNERS

Created by the convergence of two grid systems at the edge of downtown

ABOVE: Minneapolis's complex Seven Corners intersection marked the very edge of downtown, the point where the industrial area transformed into a thick nest of working-class housing and a great many bars. Toward the river, a ramshackle neighborhood called Bohemian Flats, named for the eastern European immigrants who settled there, frequently flooded. Meanwhile, Cedar Avenue, at the center of the frame, ran south and was lined with immigrant shops full of goods and wares peddled in a dozen tongues. Across the Washington Avenue Bridge sat the University of Minnesota campus, home to thousands of students. In the 1930s, when this image was taken, the Seven Corners intersection was a prime streetcar hub thriving with activity.

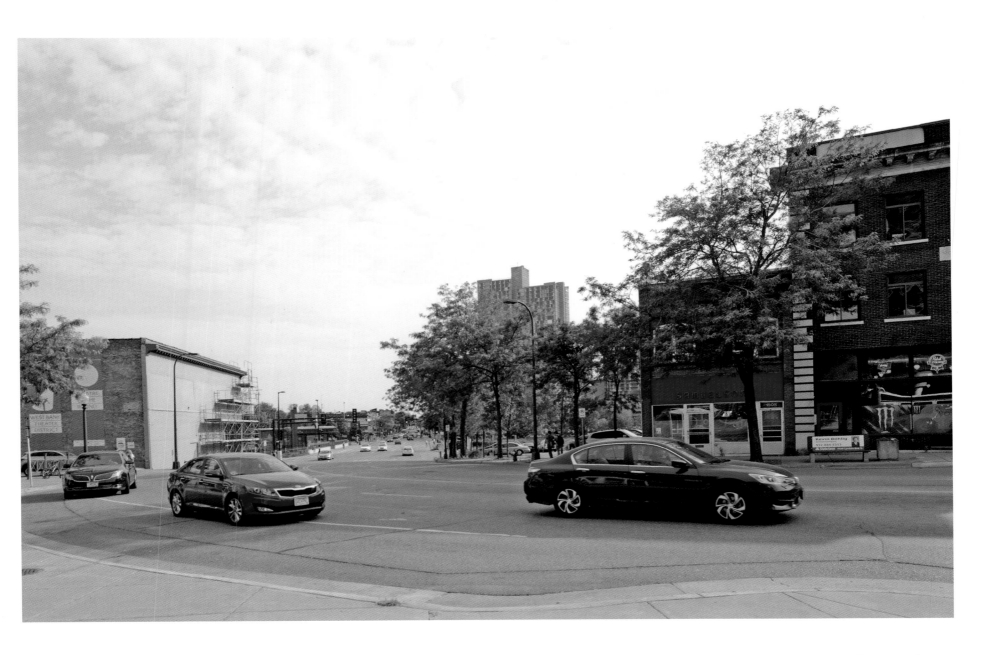

ABOVE: Today the area is separated from downtown by a series of freeways, including the Interstate 35W bridge, which tragically fell into the river just blocks from this spot in 2007. Likewise, the surrounding West Bank neighborhood has been radically changed. The flood-prone river flats are gone, and the growth of the University of Minnesota campus in the 1960s has occupied much of the old residential area.

Meanwhile, a massive early 1970s urban renewal project culminated in the erection of a series of tall Modernist towers that loom over the trees. Though the majority of the old 19th-century buildings are gone, a few blocks have persisted and continue to offer a mix of apartments, shops, and bars and restaurants. Then as now, the thriving neighborhood is home to thousands of Minneapolis's newest immigrants.

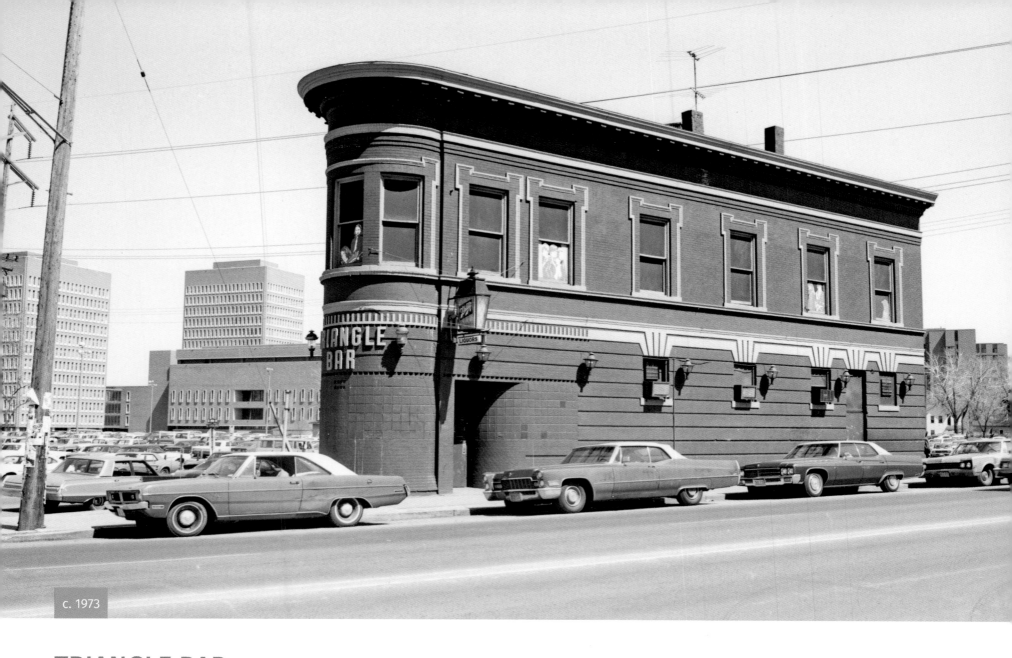

c. 1973

TRIANGLE BAR
One of the many bars that served the Cedar-Riverside neighborhood

ABOVE: In 1889 Minneapolis's mayor George Pillsbury passed some of the country's strictest blue laws, designed to keep the city's many leafy suburban neighborhoods free of moral degradation associated with drinking. Bars were banned from most of Minneapolis, but the Cedar-Riverside neighborhood, and a few other areas close to the river, were the exceptions. The paradoxical result was that these working-class enclaves became synonymous with seedy bars, which concentrated in these specific neighborhoods. The distinctive Triangle Bar on Riverside Avenue was just one of dozens that lined the streets here, offering all manner of temptations to the workers from the nearby industries. The square buildings visible to the left of the bar are the first buildings of the University of Minnesota West Bank campus, and were less than 10 years old when this early 1970s photo was taken.

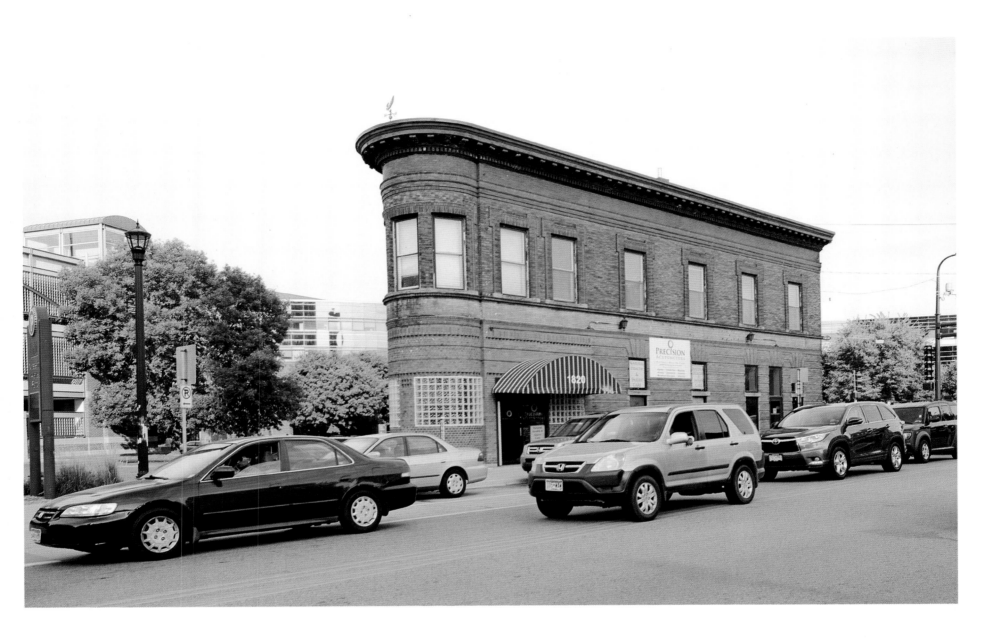

ABOVE: Today the old Triangle Bar has become a quiet acupuncture studio, but many of the surrounding old bars have survived. During the 1970s and 1980s, the West Bank neighborhood was the center of a thriving counter-cultural scene, as nearby places like Palmer's, the 400 bar, the Cedar theater, and the Viking bar became musical hot spots. The University of Minnesota has continued to expand, and campus classrooms and parking lots abut the old urban fabric.

CEDAR AVENUE

The area is now home to one of the largest East African communities in the United States

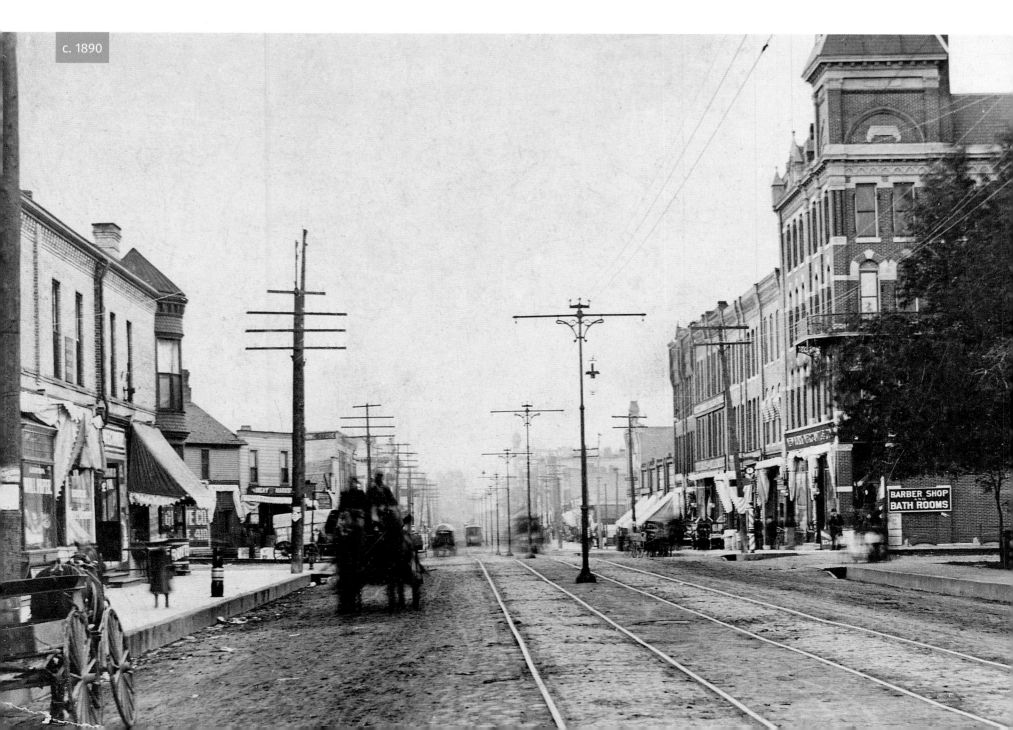

c. 1890

BARBER SHOP
AND
BATH ROOMS

LEFT: In this photo from around 1890, Cedar Avenue is still unpaved. Streetcars run from downtown along the center of the street, while horse-drawn carriages occupy the rest of the width. Many of the carriage riders would have been selling or collecting wares to distribute around the city. Dania Hall, a large Danish settlement building, is visible at the right, advertising bath houses and barber services to the men. The hall was also famous for its dances, where new immigrants could meet one another.

BELOW: While some of the historic buildings on Cedar Avenue have survived, Dania Hall was lost to fire in the year 2000; a common fate for century-old working-class buildings. The old shops on the left side of the street have become a well-known dive bar, where West Bank denizens listen to folk and rock music. A Holiday Inn sits in the focal point of the frame. Today the area is home to one of the largest Somali and East African communities in the United States, and many of the restaurants and shops reflect the international nature of the neighborhood. The old telephone poles have been replaced with trees, offering shade to strollers during warm summer days.

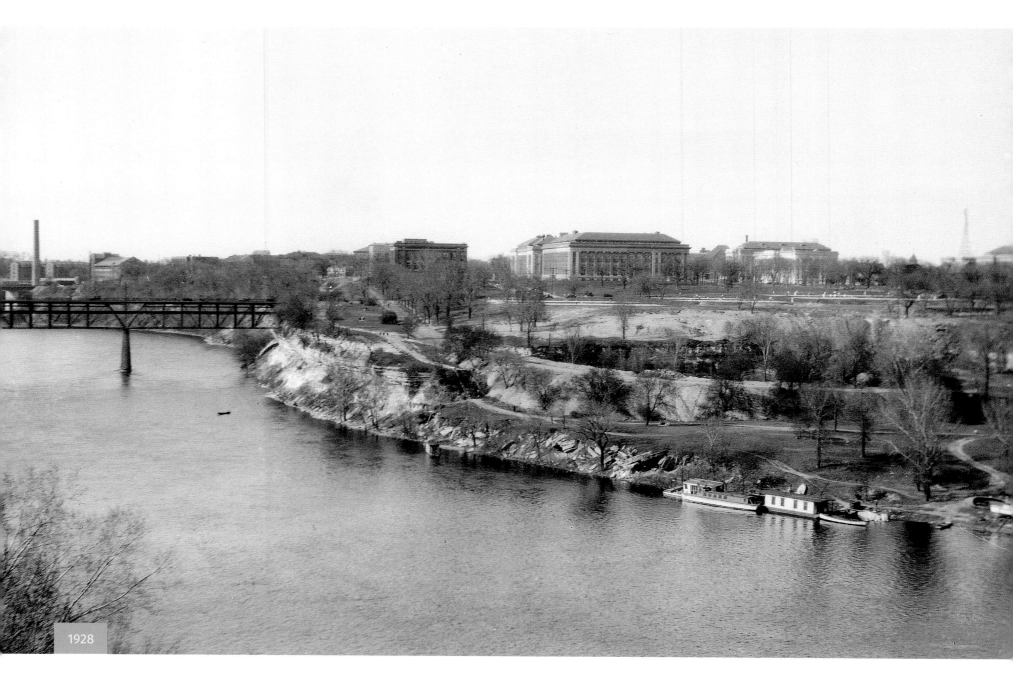

1928

UNIVERSITY OF MINNESOTA EAST BANK

The University of Minnesota is older than the state itself

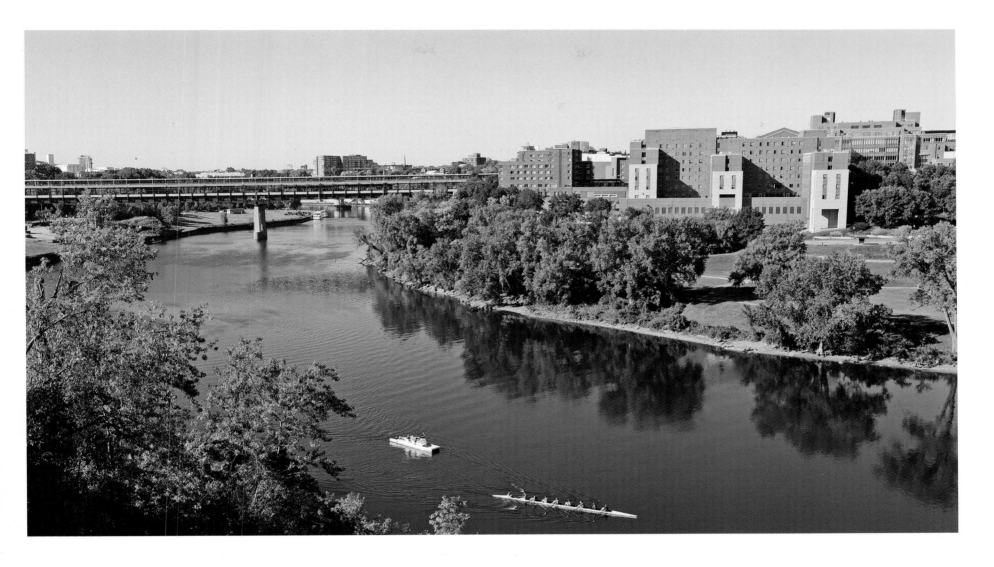

LEFT: As any school administrator will tell you, the University of Minnesota is older than the state itself. The school began in 1851 as part of President Lincoln's land grant university system that spread higher education through the burgeoning Midwest. As the school grew during the late 19th century, the campus expanded southward to form the large City Beautiful-style Northrop Mall designed by landscape architect Cass Gilbert. Meanwhile, the St. Paul campus, located a few miles away in the St. Anthony Park neighborhood, focuses on agricultural sciences. This photo dates to 1928, and shows Smith Hall (the Chemistry Department building) and Walter Library at the center of the frame, with the main campus mall to the right. The Washington Avenue Bridge extends from the bluff over the river at the left of the frame.

ABOVE: The university has continued to grow through the 20th century, expanding over the Mississippi and into the Cedar-Riverside neighborhood during the 1960s. In this photo, the Northrup Mall is obscured by the new Coffman Union campus center and other university offices that are located along the river. The new Washington Avenue Bridge, which dates to 1965 when the campus expanded to encompass both sides of the river, features a pedestrian and bicyclist-only top deck, and cars and a light rail train running below. During warm months, the university's rowing teams (pictured) use the river to train for regattas.

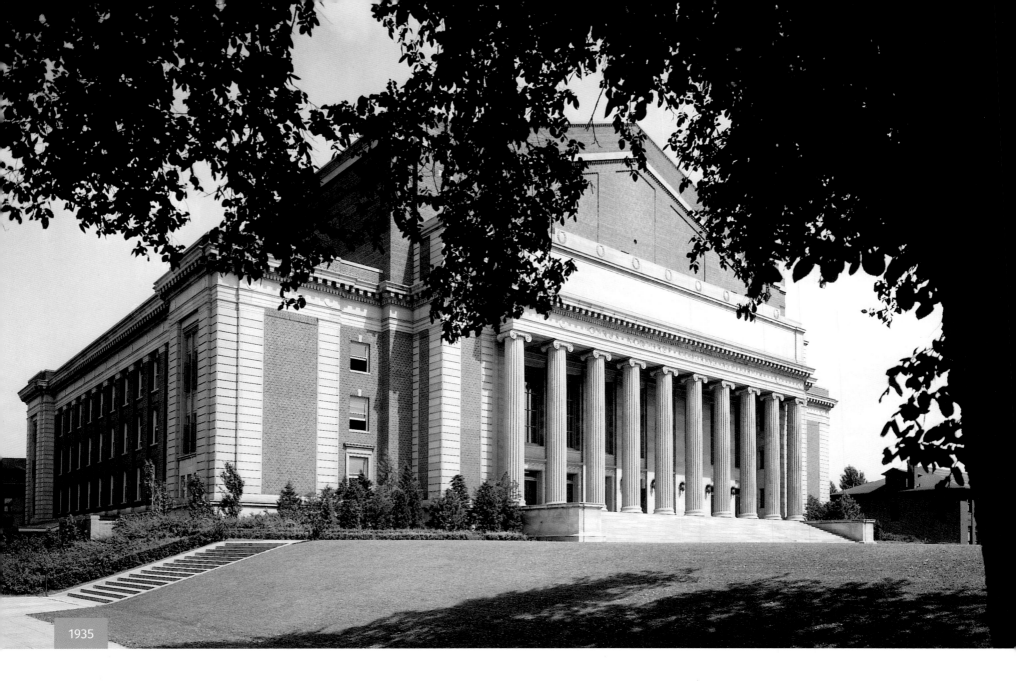

1935

NORTHROP AUDITORIUM

At the heart of the university's City Beautiful-inspired mall

ABOVE: The University of Minnesota's Northrop Auditorium anchors one end of Northrop Mall, the central public space of the Minneapolis campus. When it was built in 1929, the Clarence Johnston-designed auditorium was large enough to hold almost 5,000 people, which amounted to the entire student body at the time. The auditorium and mall were named after the University of Minnesota's second president, Cyrus Northrop. Northrop Mall is lined with City Beautiful-inspired Neoclassical buildings and later Modernist structures, including one of the campus libraries, the main administration hall, the student union, and the physics building.

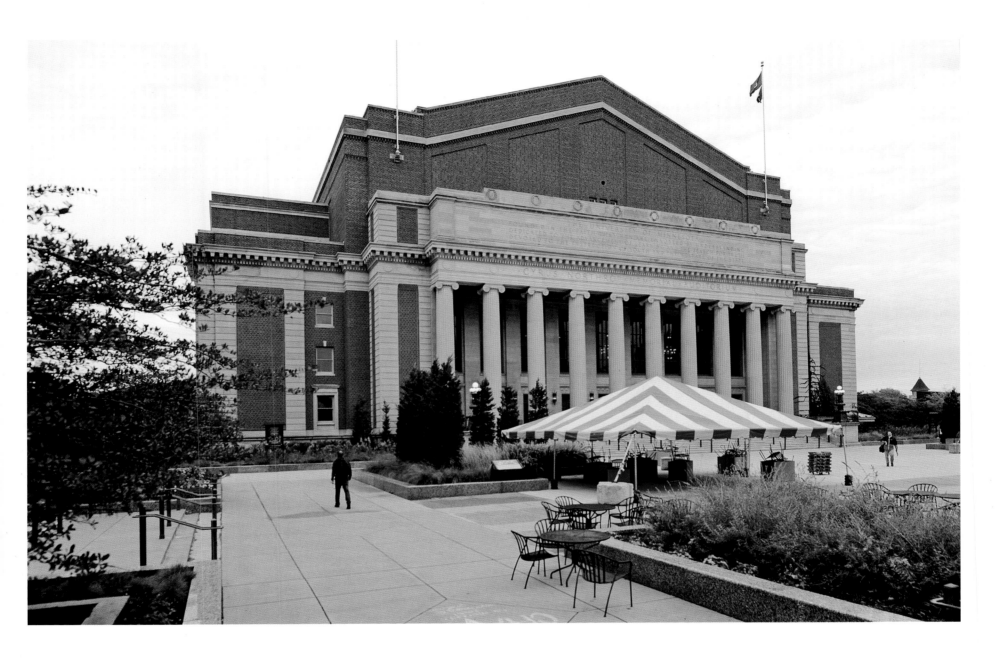

ABOVE: Today the remodeled Northrop Auditorium is still used for concerts and the mall remains the heart of campus life. These days, however, it cannot hold the student body, which has grown to about 50,000, including graduate and undergraduate schools. During warm months, the auditorium steps are full of picnic tables and occasional outdoor cafés. The adjoining sidewalks serve as a kind of "speakers' corner" for campus groups, while the open grass hosts frisbee, soccer, or cricket games, weather permitting. Over the years, the auditorium has been home to the Minneapolis Symphony Orchestra and the Metropolitan Opera. Its sprung stage, designed by George Balanchine of the New York City Ballet, has been used by the Royal Danish Ballet, American Ballet Theatre, and the Joffrey Ballet.

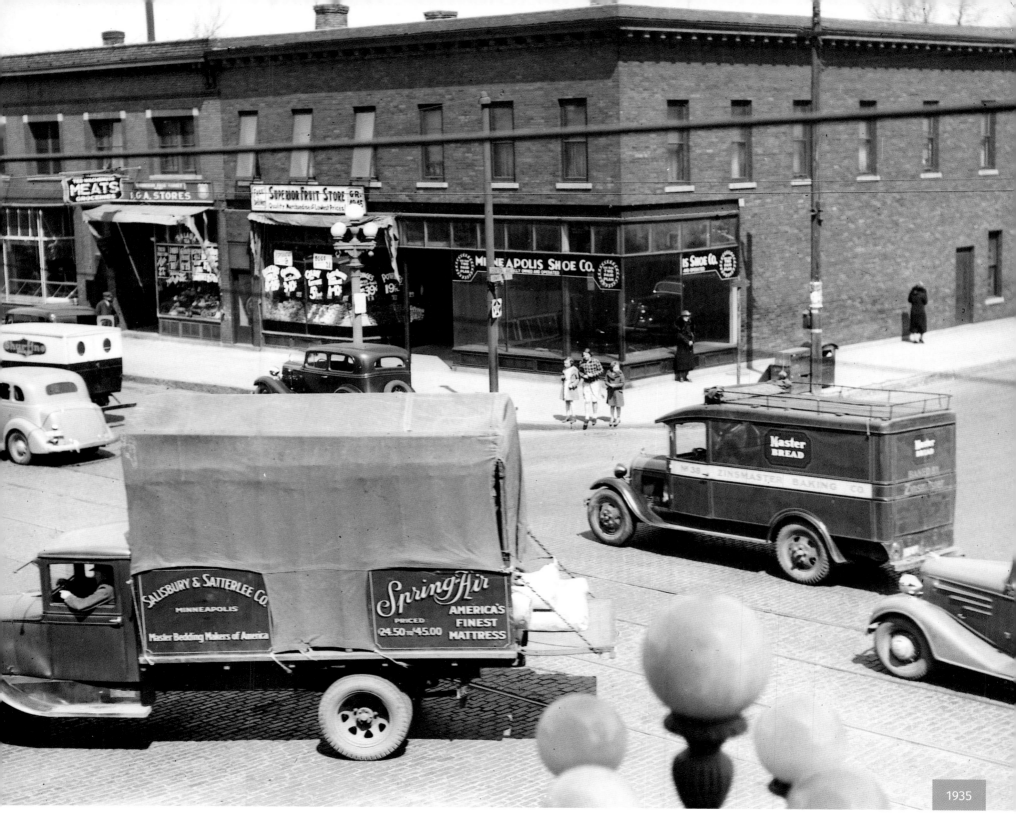

SUPERIOR FRUIT STORE

MINNEAPOLIS SHOE CO.

Master BREAD

ZINSMASTER BAKING CO.

SALISBURY & SATTERLEE Co. MINNEAPOLIS

Spring-Air

PRICED
$24.50 to $45.00

AMERICA'S FINEST MATTRESS

Master Bedding Makers of America

1935

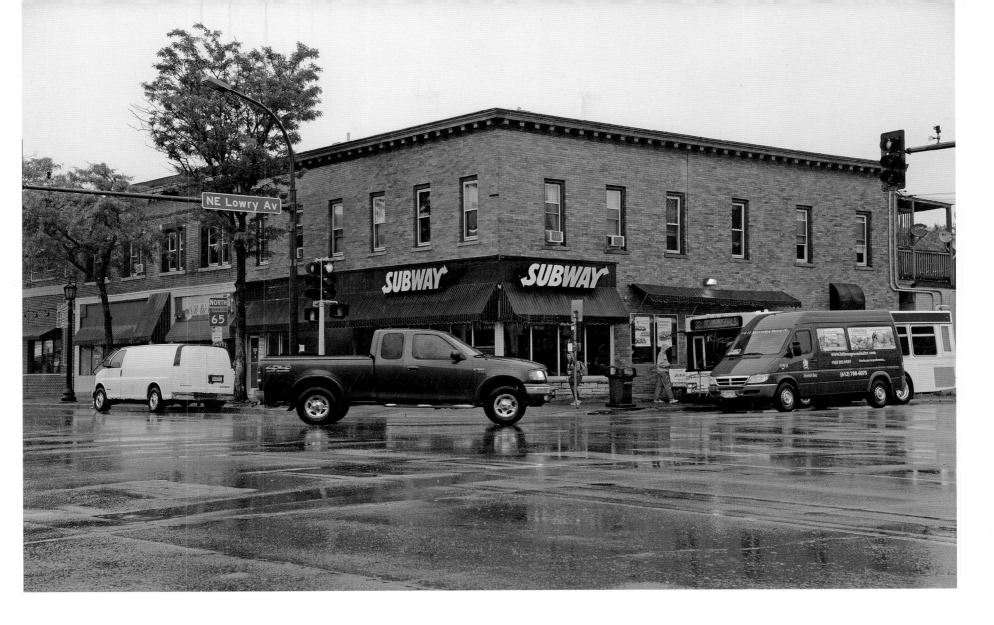

CENTRAL AVENUE AT LOWRY
The "main street" of Northeast Minneapolis

LEFT: Minneapolis's Northeast neighborhood lies on the eastern side of the Mississippi River, and has long been an eclectic mix of industry, cultural diversity, and quiet residential homes. Central Avenue, running north from the Third Avenue Bridge, forms the de facto main street of the neighborhood. Lined with small mixed-use buildings and apartments sitting alongside the railroads and factories, by the 1930s, when this photo was taken, the street was a thriving corridor of industrial activity. Then and now, Northeast was famous for being settled by eastern European and other immigrants, including Lebanese, Greek, Polish, and German communities.

ABOVE: Today Northeast remains thriving and diverse. Many of the old industrial areas have transformed into an arts district, with historic factories converted into studios, craft breweries, and housing. Meanwhile, the area's working-class housing stock remains accessible to immigrants from all over the world, and Central Avenue is where you will find restaurants and stores offering cuisine and wares from dozens of countries, including many Central American and Middle Eastern nations. Central Avenue still serves as the main street for the neighborhood, the century-old buildings still housing shopkeepers and apartment dwellers, just as they did when they were first built.

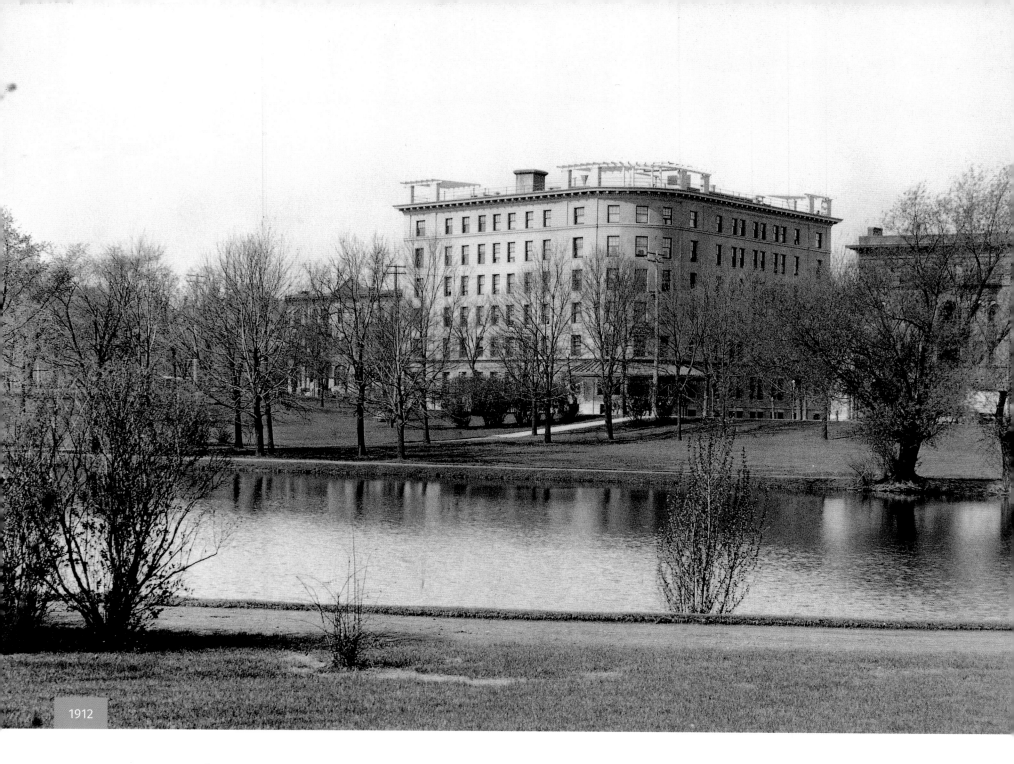

1912

LORING PARK

The first spot in the city to receive electric lights

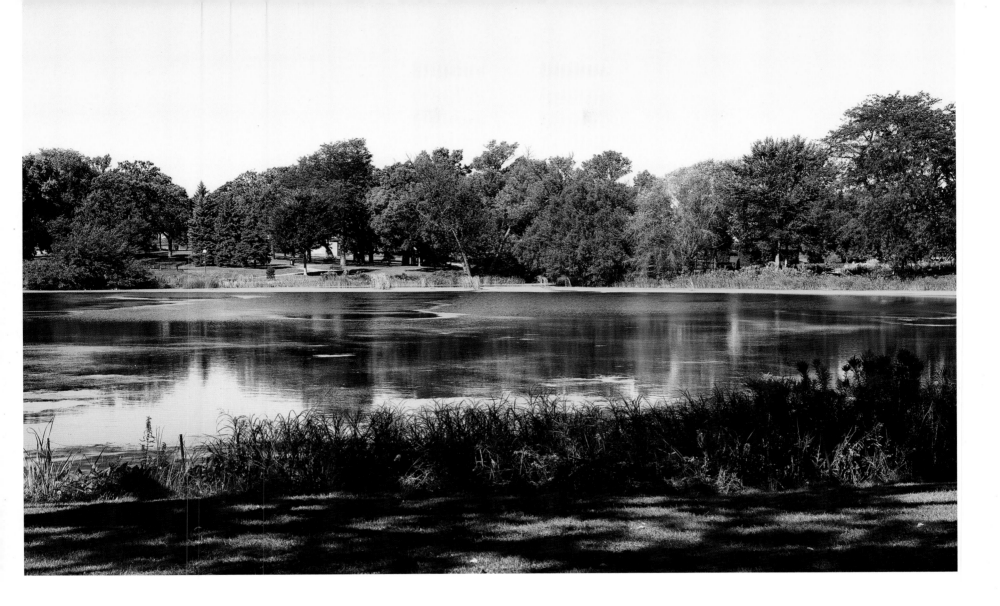

LEFT: Originally named Central Park, Minneapolis's Loring Park sits on the southwest edge of downtown and was one of a number of bourgeois parks that were created during the booming 1890s. Originally a wetlands, famed Minneapolis parks architect Horace Cleveland drained the bog into the Loring Lake, named for the first president of the city's park system. By the turn of the century, the park was lined with mansions, wealthy apartment homes, and landmark civic buildings, including the Minneapolis Women's Club (at the right of the frame), the Basilica of St. Mary, and St. Mark's Episcopal Cathedral. The pond was the first spot in the city to receive electric lights, which were used for ice skating in the wintertime. The central building is the Hotel Plaza, which was built in 1906 by architect-entrepreneur Walter Keith.

ABOVE: Then as now, the park remains a civic hot spot and a well-trod center of Minneapolis public life. Though the Interstate 94 freeway and tunnel was rammed along the edge of the area in the 1960s, in many ways the Loring Park neighborhood feels much as it might have during the late 19th century. While the Hotel Plaza was demolished to make way for the I-94, other 19th-century buildings still line the south side of the park, including the Women's Club (hidden by trees) and all of the historic churches. Added to the mix are a number of new apartment buildings, the Minneapolis Community and Technical College, and the Walker Art Center and Minneapolis Sculpture Garden, which connects to the park via a Postmodernist footbridge. The park hosts a number of annual festivals, including the Minneapolis Pride celebration. Many summer evenings, movies and music are screened on the grass, which also features shuffleboard, basketball, and tennis courts. The small pond still serves as a home to wetlands and wildlife.

BASILICA OF ST. MARY

The first church given basilica status in the United States

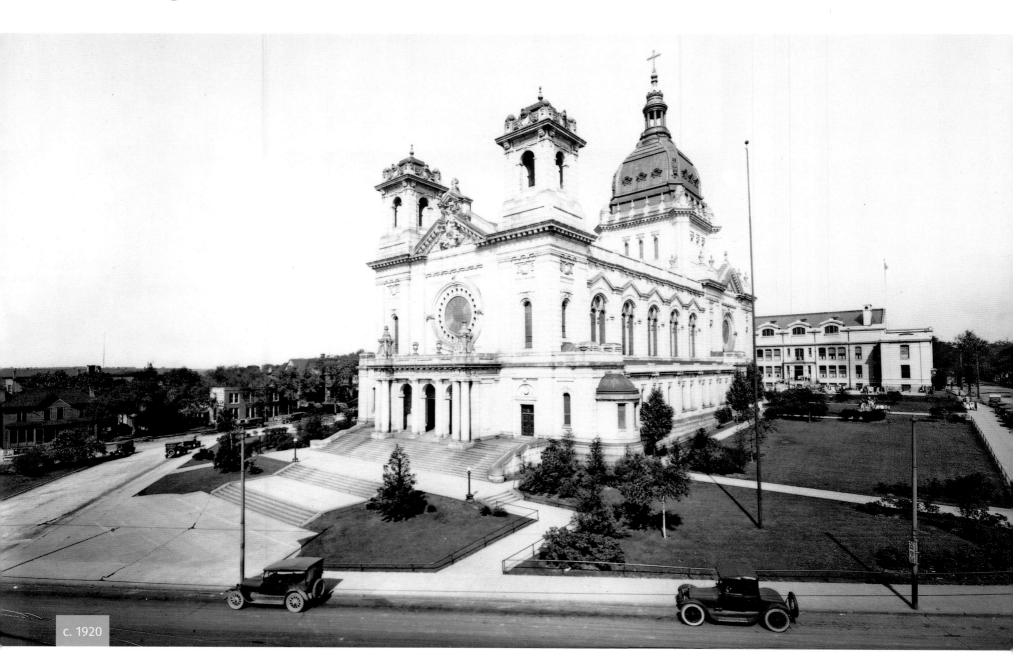

c. 1920

LEFT: Designed by the Franco-American architect Emmanuel Louis Masqueray, who also designed St. Paul's Cathedral, the massive basilica (or "pro-cathedral") was built during the early 20th century by then-local archbishop John Ireland. The cathedral opened in 1914 and was established as a minor basilica by Pope Pius XI in 1926, making it the first basilica in the United States. The basilica marks the beginning of a cluster of landmark churches that ran along the intersection of Lyndale and Hennepin Avenues, which formed a bow-tie intersection here called the "bottleneck" because it was a traffic choke point. The Basilica of St. Mary, St. Mark's Episcopal Cathedral, and the Hennepin United Methodist Church created a quasi-civic square, marked on an edge by a massive parade grounds used for public gathering.

BELOW: The area was irrevocably altered by the construction of Interstate 94 in the mid-1960s, which curved along the edge of the bottleneck through a massive tunnel before emerging by the base of the basilica and becoming an elevated freeway. From certain vantage points, the freeway is barely visible, and an observer might get a sense of the original unencumbered grandeur of the building. From others, the Beaux-Arts church is almost completely obscured by overpasses. The church grounds annually host a music festival, and the tower's bells hourly ring through the nearby Loring Park. Meanwhile, the old parade grounds next door have become part of the Walker Art Center and Minneapolis Sculpture Garden, which is open to the public free of charge.

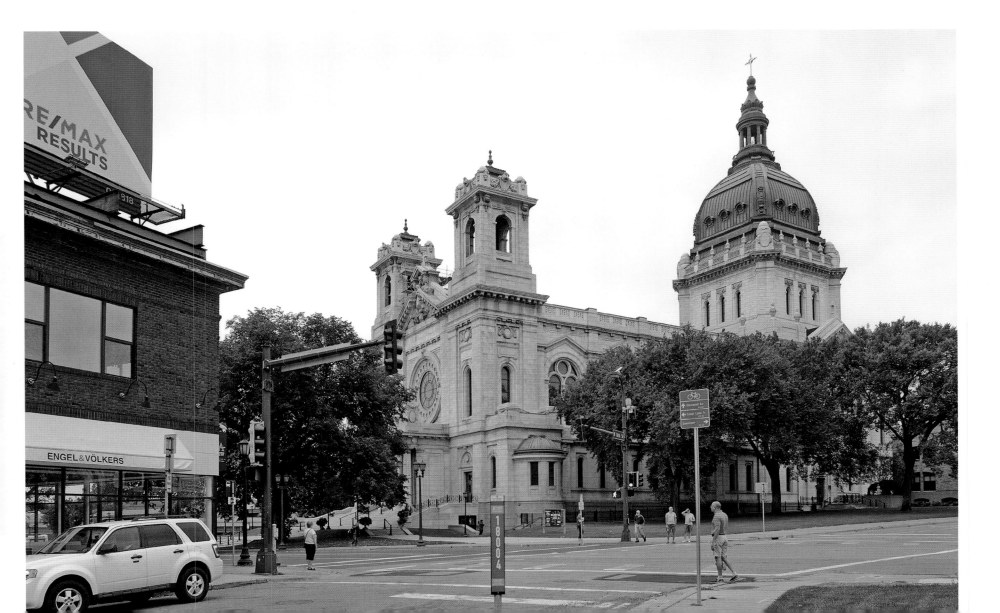

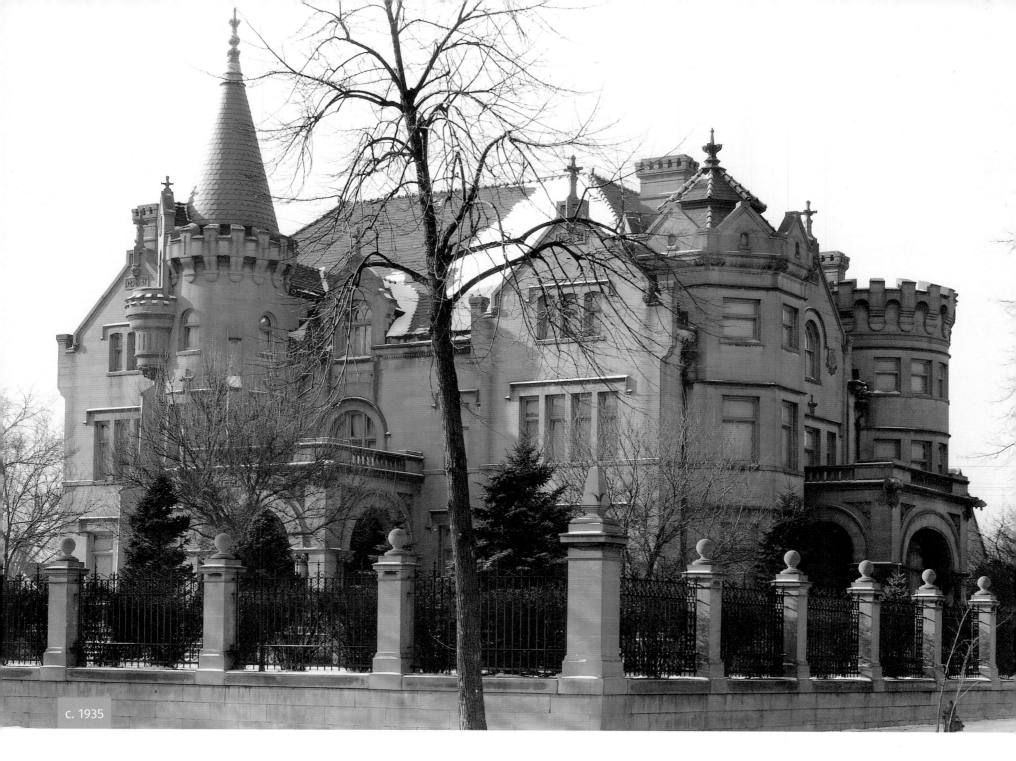

c. 1935

TURNBLAD MANSION / AMERICAN SWEDISH INSTITUTE

Neighboring mansions were razed in the 1960s to make way for the Interstate 35W

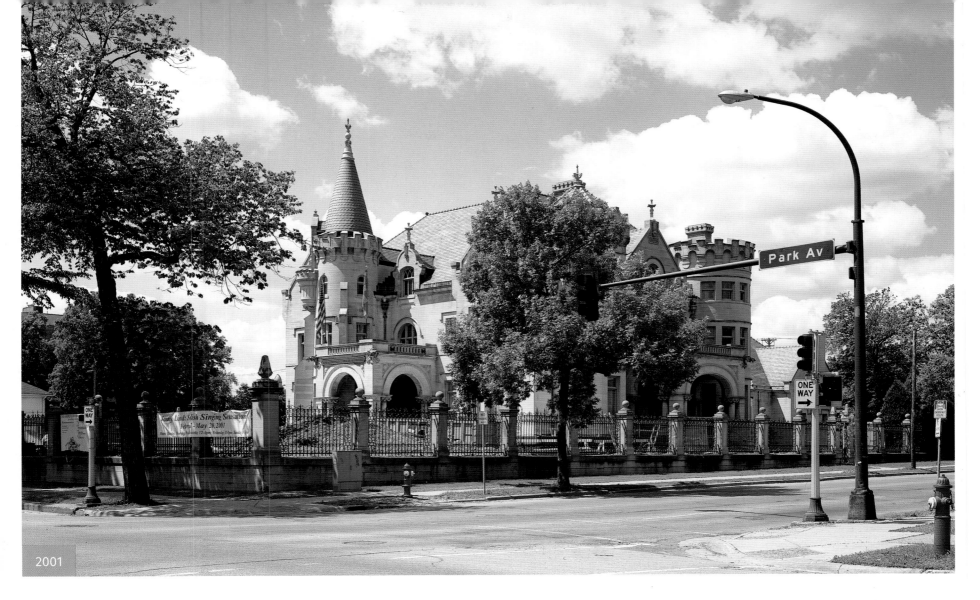

2001

LEFT: At the turn of the century, South Minneapolis's Park and Oakland Avenues were leafy addresses on the fringe of the booming city, and a prime spot for showcasing newfound wealth. The Turnblad Mansion was one such place, built by a Swedish immigrant who made a fortune publishing a Swedish-language newspaper called the *Svenska Amerikanska Posten*. The castle-like mansion had 33 rooms with painted plaster sculptures decorating the ceilings and intricately carved oak, walnut, and mahogany. Turnblad's mansion was one of many that lined this posh address through the early years of the 20th century.

ABOVE AND RIGHT: Today the building is home to the American Swedish Institute, and the old mansion has been rehabbed to showcase Swedish-American history, art, and design. Many of the other former mansions did not fare so well, as nearby Park and Portland Avenues were widened into high-speed roads and Interstate 35W was plowed through the neighborhood during the 1960s. The Institute, however, is thriving and hosts events and periodic shows. Museum-goers can tour the Turnblad Mansion and learn about the history of Minneapolis's immigration-fueled age of industrial glory.

2017

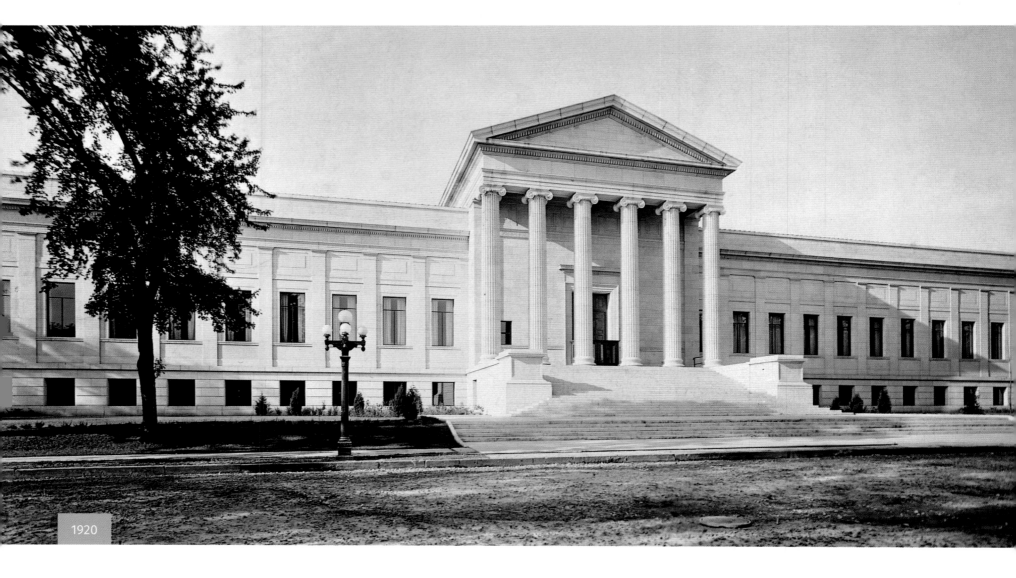

1920

MINNEAPOLIS INSTITUTE OF ARTS (MIA)

The museum's collection has grown from 800 works of art to more than 89,000 objects

ABOVE: The Neoclassical Minneapolis Institute of Arts building dates back to a 1911 architectural competition won by famed firm McKim, Mead, and White. The original designs called for a much larger building to house the growing museum collection, combined with a planned Parisian-style City Beautiful boulevard that was a key part of Minneapolis's first-ever comprehensive plan in 1917. The boulevard was to stretch from the museum steps diagonally through the street grid, terminating in a large civic plaza at the edge of downtown. The classical columns and marble steps face the block-large Fair Oaks park, named for the mansion that once occupied the site, home to milling mogul William Washburn's massive home.

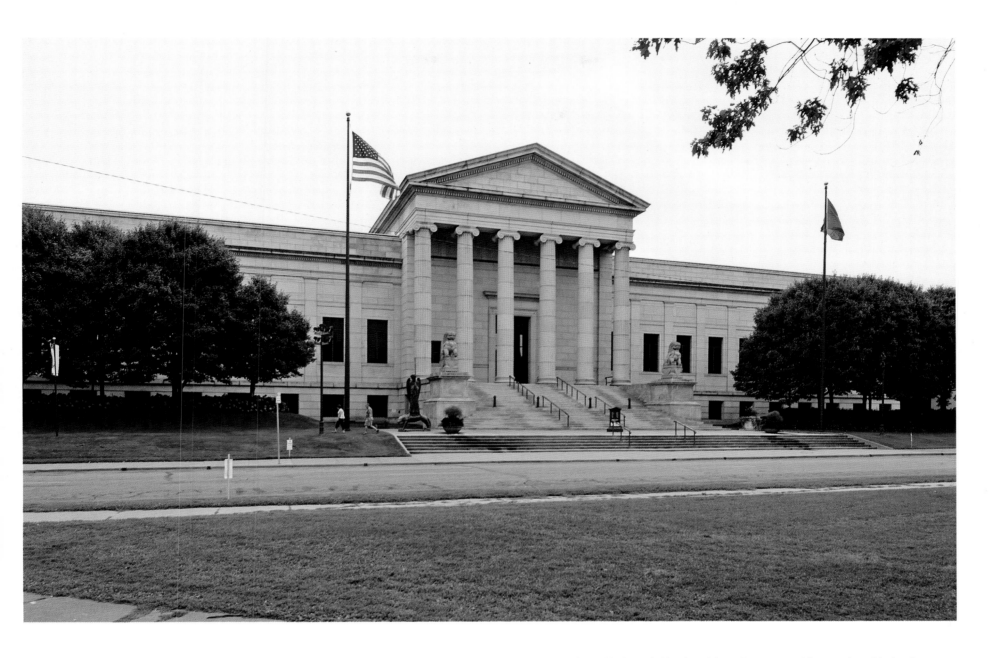

ABOVE: For many reasons, including World War I, the planned boulevard was never completed. But the MIA building remains a centerpiece of Minneapolis's arts and cultural scene, and the museum has seen a few additions that represent different waves of architectural trends. The museum's collection now includes more than 89,000 objects that span 5,000 years of world history. Many of the mansions in the surrounding Whittier neighborhood have been turned into various kinds of institutional housing or office space, including group homes for people experiencing poverty. MIA's immediate neighbors include the Children's Theatre Company and the Minneapolis College of Art and Design.

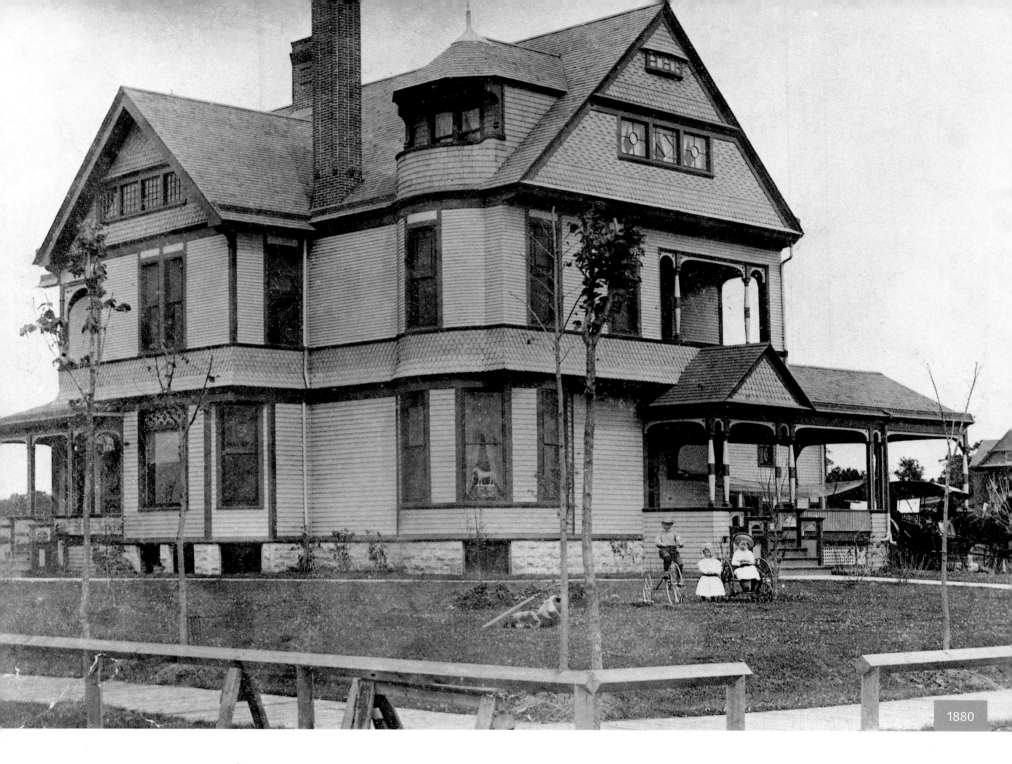

1880

SMITH HOUSE / TEMPLE ISRAEL

The site is now home to one of the largest Jewish congregations in the United States

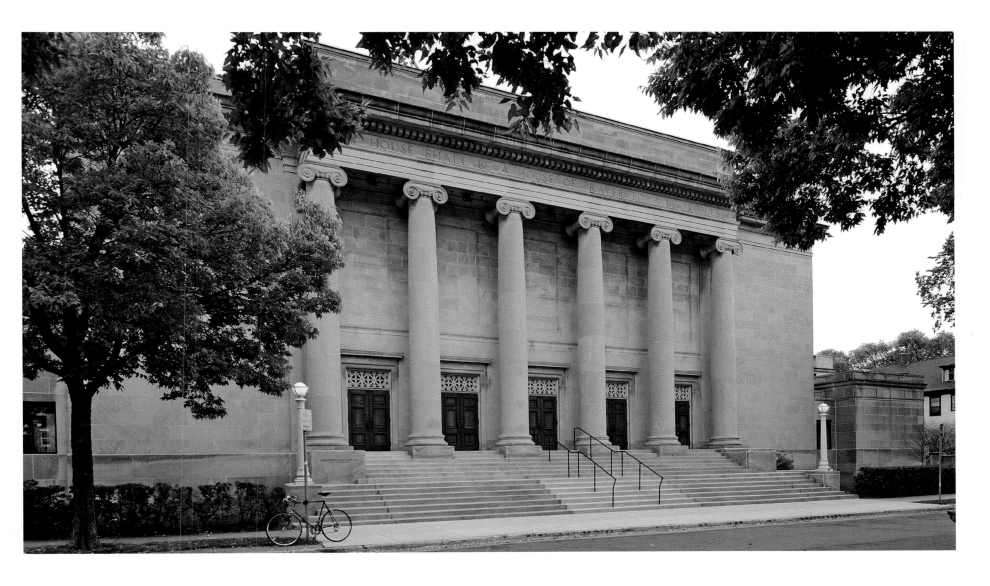

LEFT: Originally built as the residence of businessman Charles A. Smith, this house at 2324 Emerson Avenue was, for a few years, home to the first Jewish congregation in Minneapolis: Shaarai Tov (Hebrew for "gates of goodness"). In 1914 the house was sold to the congregation for $14,000. The large home was converted into classrooms and offices for the 350 families in the congregation. The city's Jewish community originally was concentrated in the Near North Side, due to racially restrictive covenants that limited where Jews could purchase homes. This photo dates to 1880, when the building was the Smith family home.

ABOVE: Constuction began on a new building on the site, named Temple Israel, in the 1920s and it was dedicated in an inaugural service in 1928. During the 1950s, Minneapolis was dubbed the "capital of anti-Semitism" because of its social conventions restricting Jewish membership in city clubs and institutions. The temple still stands today, its pillars done in the Greek Renaissance style. The congregation is one of many that thrive in Minneapolis, St. Paul, and nearby suburbs such as St. Louis Park. The temple has seen many additions—including a library, art galleries, and a gymnasium—and remains a landmark overlooking busy Hennepin Avenue in the Uptown neighborhood.

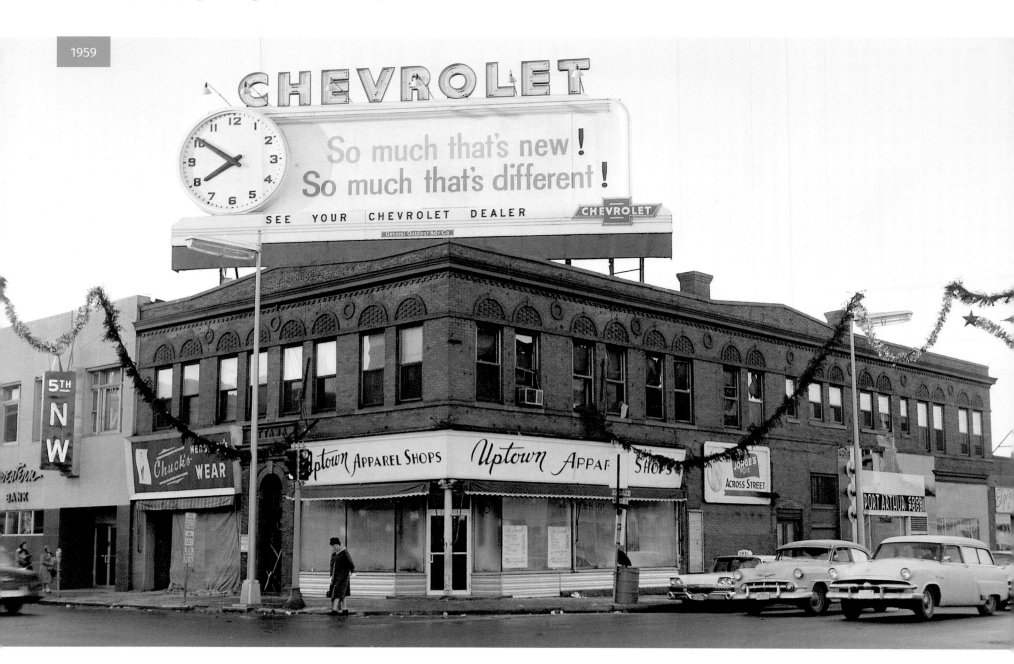

1959

LEFT: The corner of Hennepin and Lake Street was for a long time an important streetcar juncture, where westbound and southbound lines intersected near the isthmus between Lakes Calhoun and Harriet. (Thus the name Lake Street.) The resulting street corners boasted a thriving commercial and retail environment bursting with small-scale mixed-use buildings that served the residential areas surrounding it. They became the commercial hot spot of the dense communities in south Minneapolis and around the lakes. Businesses shown here, from left to right, are the Fifth Northwestern Bank, Uptown Apparel Shops, and the Port Arthur café, known for its Chinese cuisine.

BELOW: Then as now, Lake Street serves as the key commercial spine running east and west through Minneapolis, connecting the chain of lakes to the Mississippi River. Like many of the old mixed-use buildings on this corner, the retail in the old photograph has evolved, as a diverse mix of counter-cultural hot spots has transformed into a booming area for development, shopping, and nightlife. Today the Victoria's Secret store is just one of a dozen chain and high-end shops that line the intersection, including the city's only Apple Store just to the south. Across the street sits Calhoun Square, an indoor shopping mall dating to 1983 that was immortalized in a Prince song of the same name. A block to the north, what was once an abandoned set of railroad tracks has become the Midtown Greenway, a popular bicycling and recreational path that attracts people from all over the metro area.

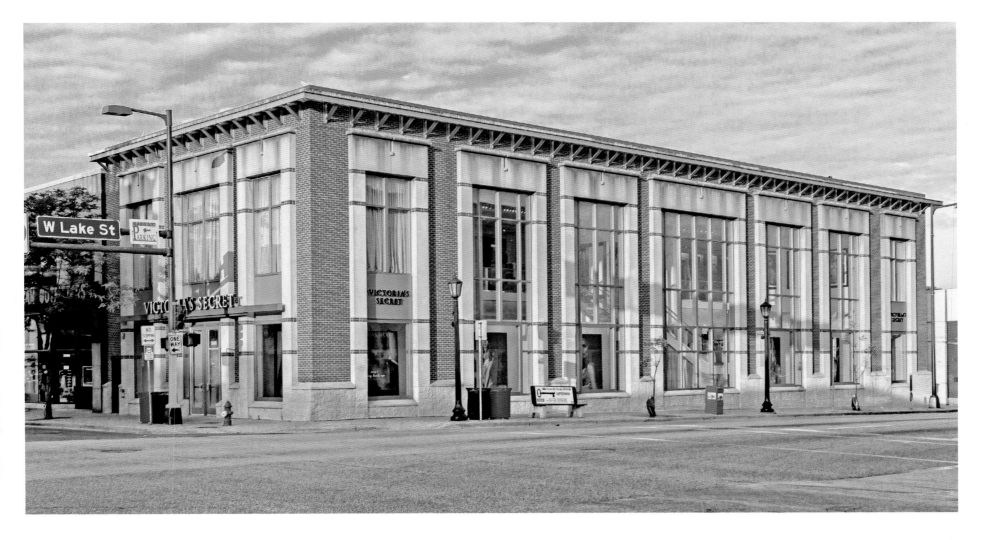

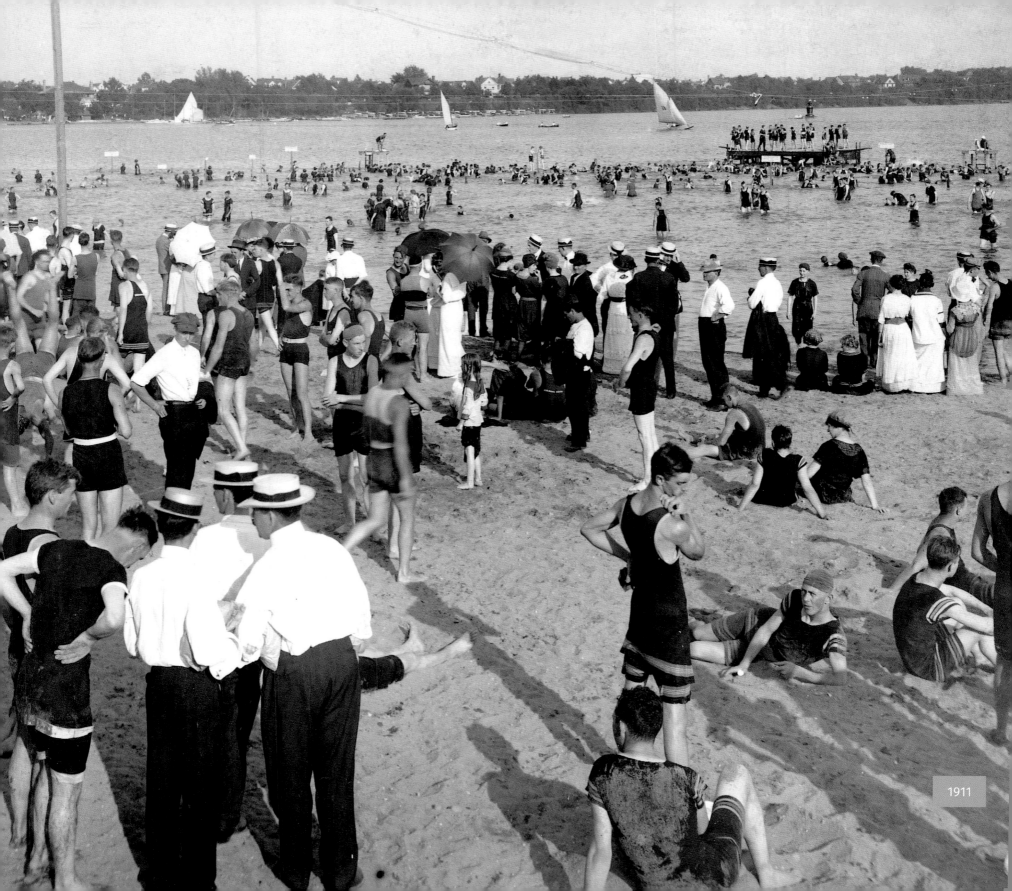

1911

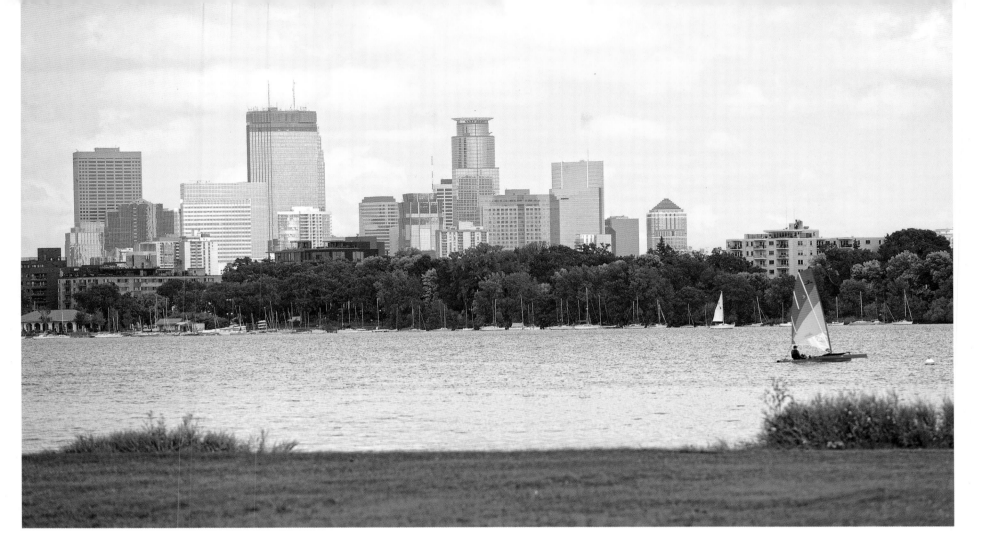

LAKE CALHOUN / BDE MAKA SKA

Once home to one of the few permanent Dakota villages

LEFT: Minneapolis's official motto is "City of Lakes," and if you glance at a map, it's easy to see why. A chain of lakes runs in an arc through the south and west part of the city, and Lake Calhoun has long been the most popular and well-frequented of these year-round attractions. The shores of the lake had once been home to one of the city's permanent Dakota villages, but all the native communities were exiled from the region following the U.S.–Dakota War of 1862. During the summertime, the lakes' many beaches offered much-needed recreation to the public, while boating and the public parkland that surrounded it provided a natural balm in the midst of the old city. This photo from 1911 shows the popular beach that sits on the south side of the lake.

ABOVE: Shown here from the south shore, with the Minneapolis downtown skyline in the background, Lake Calhoun remains the most popular lake in Minneapolis's Chain of Lakes district. The 1971 IDS Center is the tall black-capped skyscraper in middle left, while the 1992 Postmodernist Capella Tower, with its distinctive halo-like roof, is in the center. During summer months, joggers, picnickers, boaters, swimmers, and dog walkers crowd around the public shores on the lakefront. In the winter, the lake is quieter, but there are still occasional ice-skating or cross-country ski events. Meanwhile, the name of the lake itself has become a flashpoint for a long-neglected public debate over Minnesota's historical legacy. Originally named for U.S. Senator John C. Calhoun—who was one of the most famous defenders of 19th-century slavery—in 2017 the Hennepin County Board approved a decision to rename the lake Bde Maka Ska, which translates to "White Earth Lake" in the Dakota tongue.

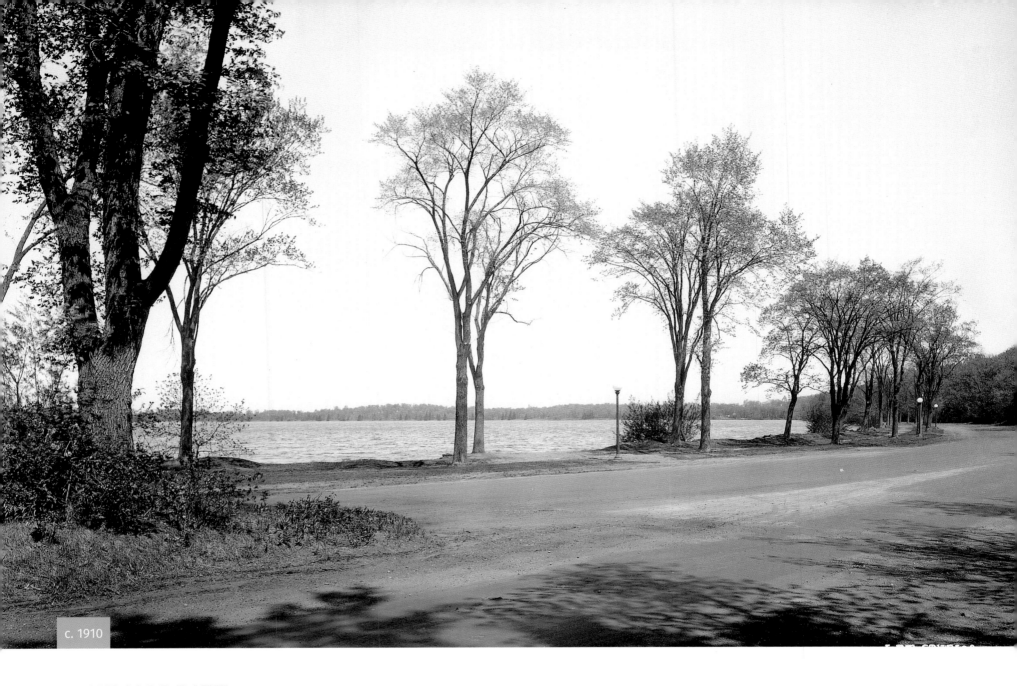

c. 1910

LAKE HARRIET

Still a prime Twin Cities attraction

ABOVE: Just to the south of Lake Calhoun, Lake Harriet is the most southwest of the city's chain of lakes. The lake is bordered on the north by a well-known cemetery and an educational rose garden that dates to 1907. Lake Harriet was named for the wife of the first commander of Fort Snelling, and marks the transition from the more urban neighborhoods of south Minneapolis to the well-off suburban communities in the city's southwestern reaches. The original Lake Harriet streetcar line that ran along here continued for another 10 miles until it reached the shores of vast Lake Minnetonka, where the streetcar company ran an amusement park.

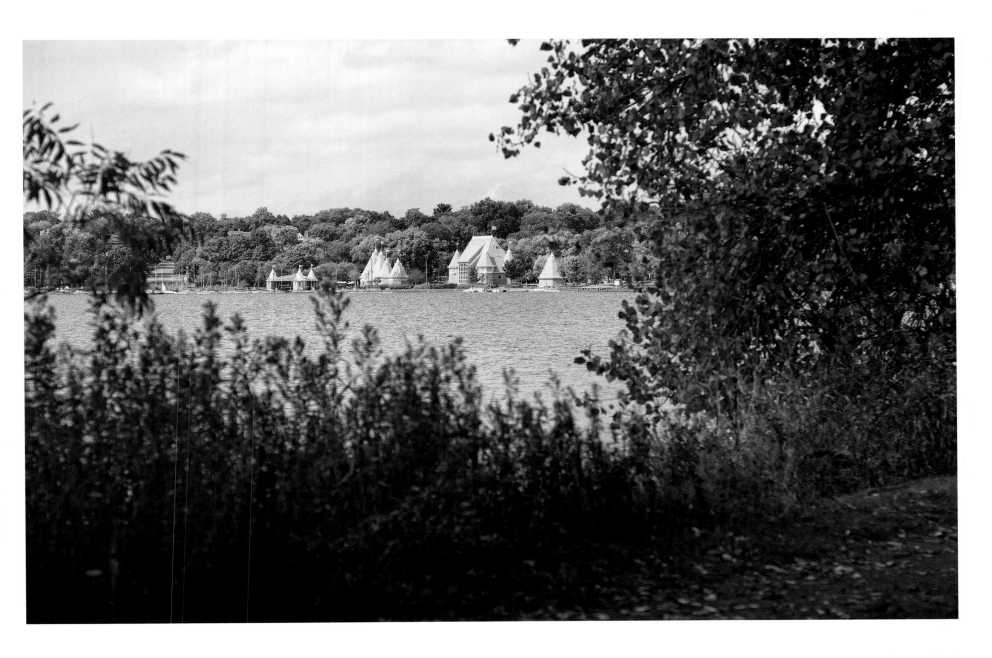

ABOVE: Today Lake Harriet remains a prime Twin Cities attraction; a magnet for families and tourists and anyone seeking communion with the water. During nice days, sailboats dot the lake and dock at the marina next to a small waterfront café. The large bandshell, pictured along the far shore, is a popular spot for civic concerts open to the public. Just past the bandshell, the last remnant of the Twin Cities' once-comprehensive streetcar system runs along the lake's western shore, offering weekend rides through the summertime. Around the shoreline, joggers and strollers fill the paths with activity, and the expanded rose garden complex on the lake's northeast corner remains a prime spot for wedding photos.

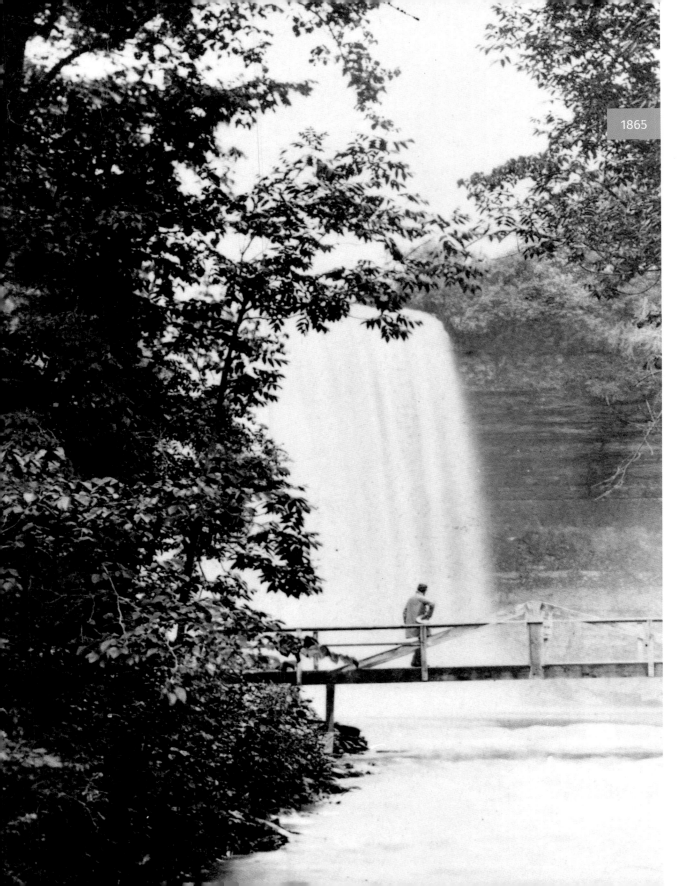

1865

MINNEHAHA FALLS
A Minnesota landmark

LEFT: Just upriver from Fort Snelling, Minnehaha Falls had long been a focal point for white settlers in Minnesota, famously capturing the imagination of poet Henry Wadsworth Longfellow, who made it the central feature of a well-known epic, *The Song of Hiawatha*. (Longfellow himself had never been to the waterfall.) From the very first, the waterfall became an iconic image of Minnesota. Shown here in 1865, within 20 years the surrounding land had become Minnesota's first official public park, the cornerstone of the nascent Minneapolis parks system. Minnehaha, a Dakota word which translates to "falling water," has since been a Minneapolis icon. The waterfall itself, where Minnehaha Creek connects Lake Minnetonka to the Mississippi River, is a 50-foot drop over a bowl-like cliff. Early 20th-century parks planners went to great lengths to ensure that the waterfall was always flowing, engineering a system of channels to feed the creek and maintain water levels. In times of need, for example during the visit of President Lyndon Johnson, city leaders managed to boost the waterfall's volume to better impress their guests.

RIGHT: Then, as now, Minnehaha Park is the most popular park in the Twin Cities, attracting millions of locals and tourists annually. The massive park complex includes dozens of picnic shelters, a popular café, and a large dog park that sits along the shores of the Mississippi at the base of the river gorge. In the wintertime, the waterfall freezes and becomes a challenge for adventurous souls who (illegally) climb along the ice.

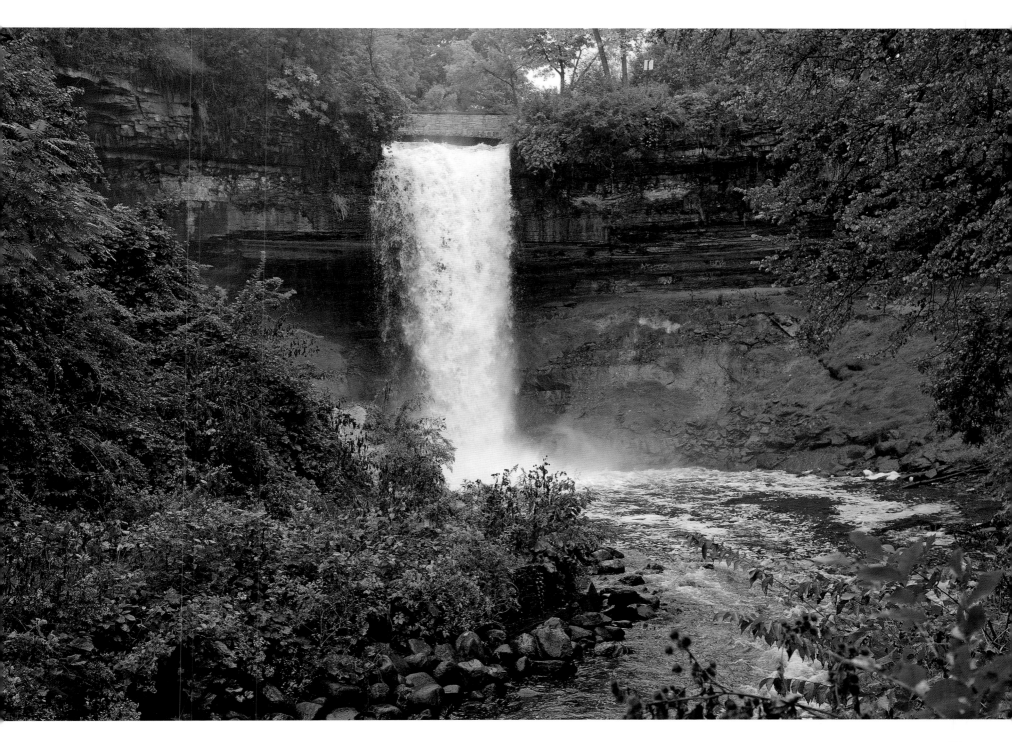

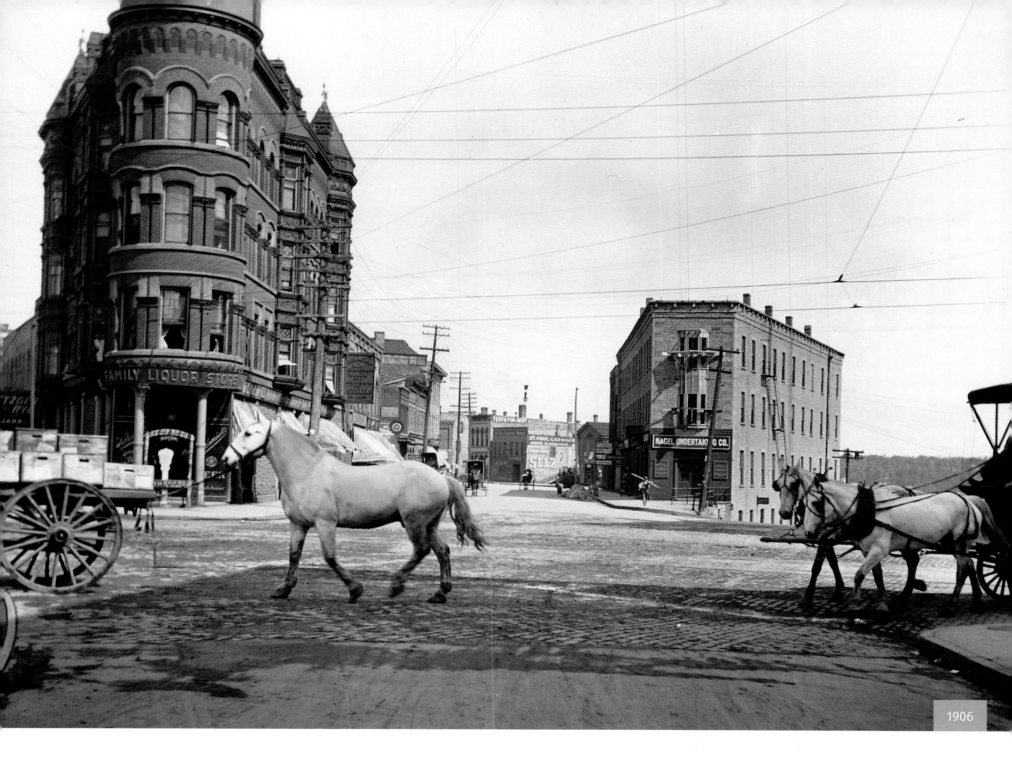

1906

SEVEN CORNERS

A hub of activity where Fourth, Main, West Seventh, Third, and Eagle met

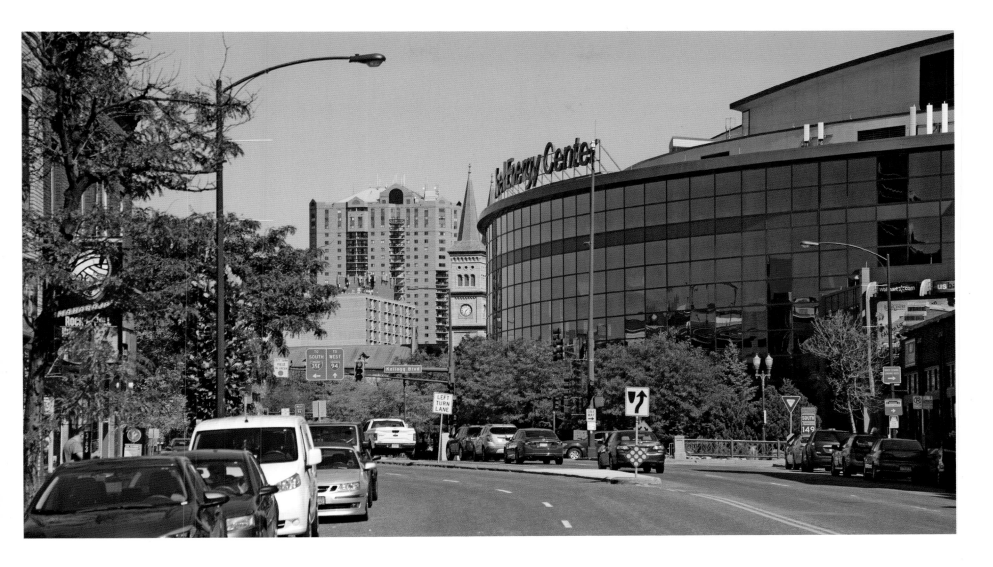

LEFT: Sitting at the west edge of downtown, St. Paul's Seven Corners intersection was the heart of the city for a century, where six key streets came together. Just up the bluff sat the mansions of Summit Avenue, and another street led straight down to the upper riverboat landing and the surrounding "river flats" communities, full of Italian and European immigrants. Pictured here in 1906, the neighborhood was home to some of the city's most thriving businesses and industries, and acted as a gateway connecting downtown to the Fort Road, which led to Fort Snelling. This view shows Eagle Street and Third Street (now Kellogg Boulevard) as they run down the bluff toward the river.

ABOVE: Today the seven corners has been altered almost to the point of non-recognition. After the city widened streets like Kellogg Boulevard and West Seventh Street to accommodate cars, much of the old building stock was removed for extra pavement. While some of the historic buildings remain along West Seventh Street, most of the rest of the intersection has become space for institutions, parking, hotels, and downtown office buildings. The massive Xcel Energy Center hockey arena, built in 2000 to replace the old Civic Center, dominates the picture, as it does the intersection. As a result, the street is home to a thriving nightlife scene, and crowds of fans and concert goers. The twin towers at the far left of the Xcel arena belong to the Catholic Church of the Assumption.

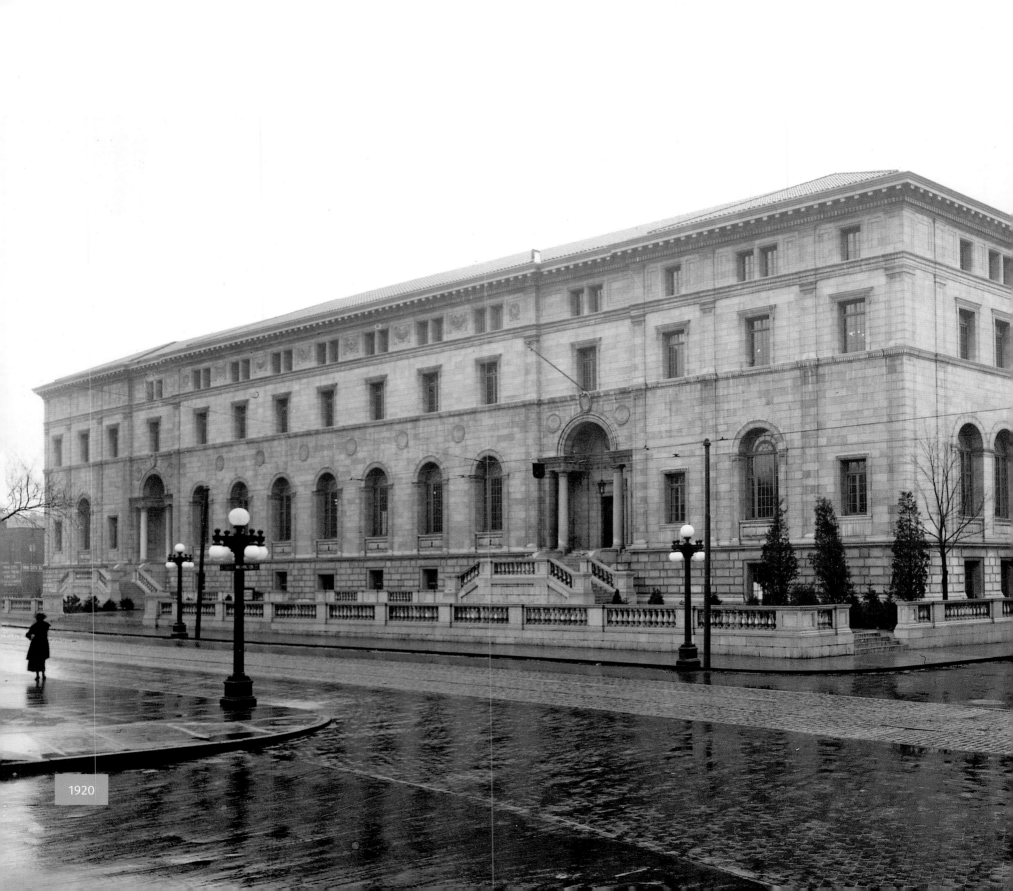

1920

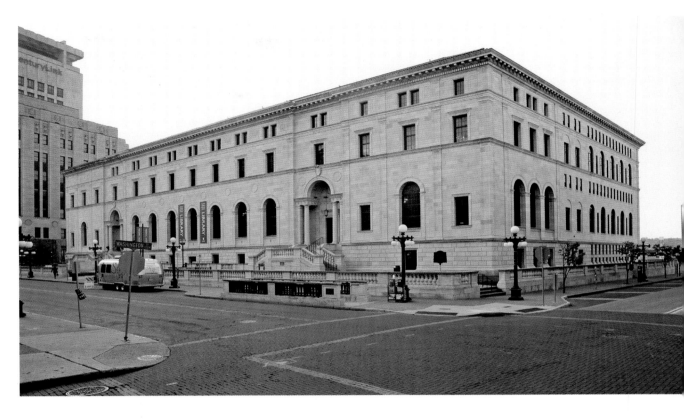

ST. PAUL CENTRAL LIBRARY
A landmark institution on the south side of Rice Park

LEFT: The St. Paul Central Library building at 90 West Fourth Street dates to 1917, three years before this photo was taken. It was built at the tail end of the city's boom in Beaux-Arts architecture. Bankrolled by railroad magnate James J. Hill, the library served as a shining white downtown landmark on the edge of Rice Park. Half the building was occupied by a business library, endowed by Hill as an archive for commercial and trade history. The interior was designed with marble staircases and a pair of elaborate wood-ceilinged reading rooms.

ABOVE: The building has been used continuously as a business and community library since its founding, and has remained a landmark institution on the south side of Rice Park. After undergoing a thorough renovation in 2016, the library celebrated its centennial anniversary in 2017, looking better than ever. Still the central branch of the city's library system, the old card catalogs have been replaced with internet terminals that receive heavy use by people from all walks of St. Paul life. In 2014 the building was renamed the George Latimer Central Library, after one of St. Paul's most popular mayors, while the business library has been christened in honor of James J. Hill. Just outside the door, the leafy enclave of Rice Park awaits.

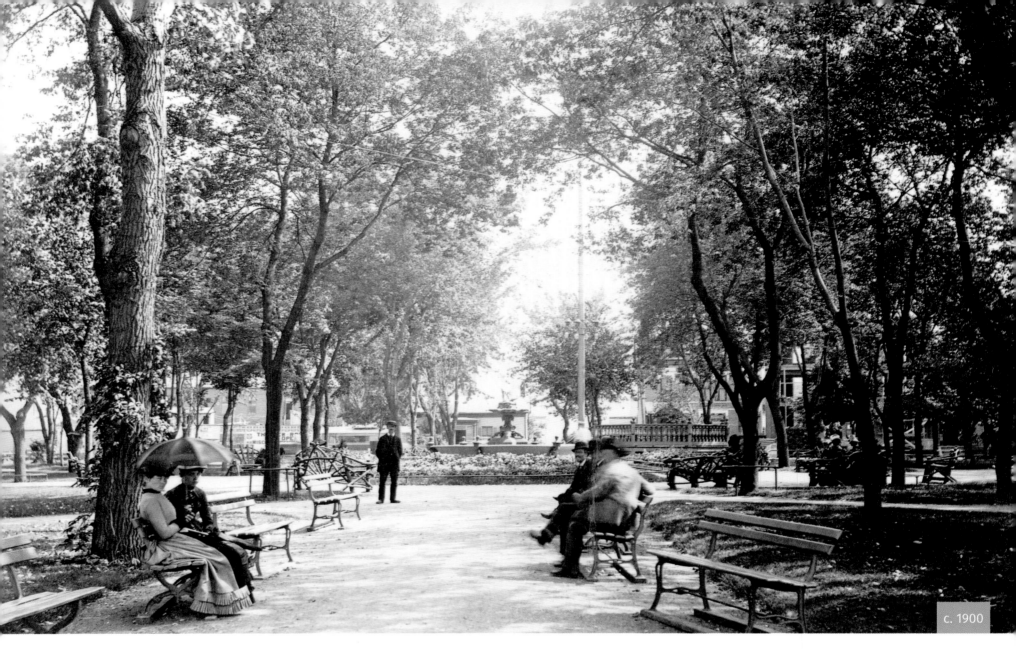

c. 1900

RICE PARK

An oasis of calm in bustling St. Paul

ABOVE: Rice Park was named for Henry Rice, one of the first speculators and civic leaders who settled in the city in the 1850s. Back then, when the city population numbered only a few thousand, the park was used by those living nearby for cattle grazing and drying laundry. Electric lights were installed in the park in 1883 for a visit by President Chester A. Arthur. In the early 1900s, when this photo was taken, the park had reached its pre-war zenith, with the Central Library, St. Paul Hotel, and Federal Court House flanking it on three sides. Then as now, the trees, benches and central fountain provided an oasis for strollers, couples, and businessmen passing through the bustling city.

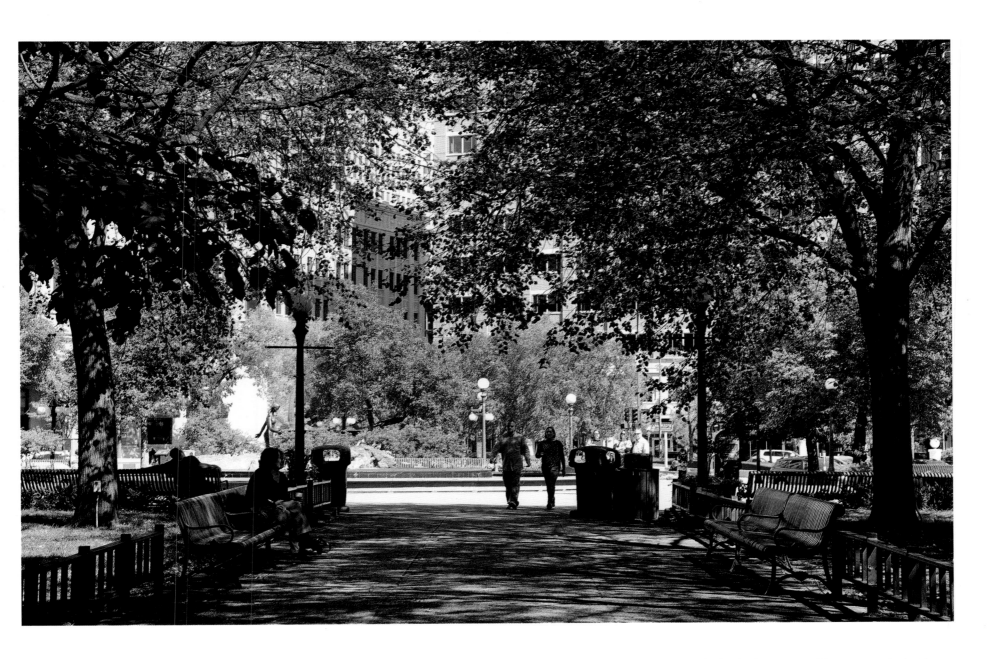

ABOVE: Rice Park remains a vital public space on the west end of downtown. Yet for much of the 20th century, the park did not receive the care or attention it needed, and fell into general disrepair. In 1965, around the same time that the old Court House (now the Landmark Center) was saved, renovations began and a new circular fountain was installed at the center of the park. The statue at the center of the fountain, named *The Source*, features a young woman playing in the water and is meant to depict the beginning of the Mississippi River. The Ordway Concert Hall now sits on the west side of the park. During warm months, food trucks line the square's edges while people enjoy fresh food on nearby benches.

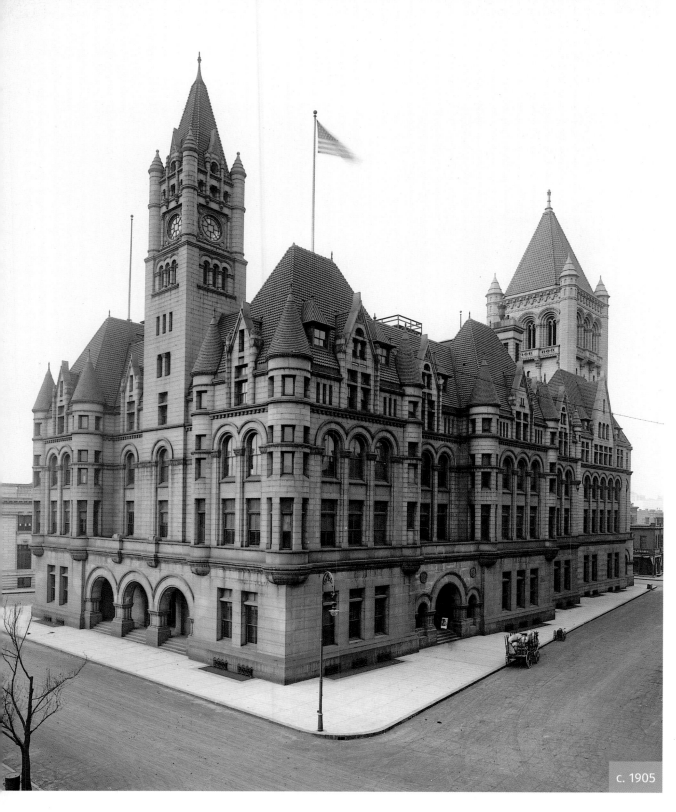

c. 1905

POST OFFICE & FEDERAL COURT HOUSE / LANDMARK CENTER

Threat of demolition helped galvanize St. Paul's earliest preservation efforts

LEFT: Towering over Rice Park, the Neo-Romanesque old U.S. Post Office and Federal Court House building was completed in 1902, just a few years before this photo was taken. For half a century it operated as a government administration building, serving as the headquarters for Federal trials that included attempts to rein in organized crime and bootleggers during the 1930s. Its iconic clock tower rose high over old St. Paul while its interior featured a huge five-story atrium. Presidents Truman and Eisenhower campaigned here and the notorious criminals Ma Barker and Alvin Karpis were tried here.

RIGHT AND BELOW: By the late 1960s, the building had become run-down and was declared surplus property by the federal administrators. It was slated for demolition, destined to become a parking lot, but the impending loss galvanized St. Paul's earliest historic preservation efforts. With help from the county, the building was saved, and today it serves as a cultural and event center. The old offices remain home to at least five museums and cultural organizations of different sizes. Now dubbed the Landmark Center, the remodeled building is the focal point of St. Paul's historic Rice Park district. During the winter carnival, an outdoor ice rink is constructed at its base, and it serves as the final destination for many of the city's annual parades.

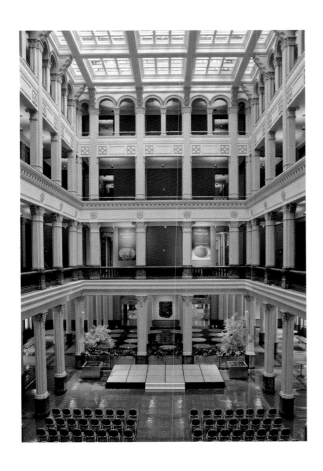

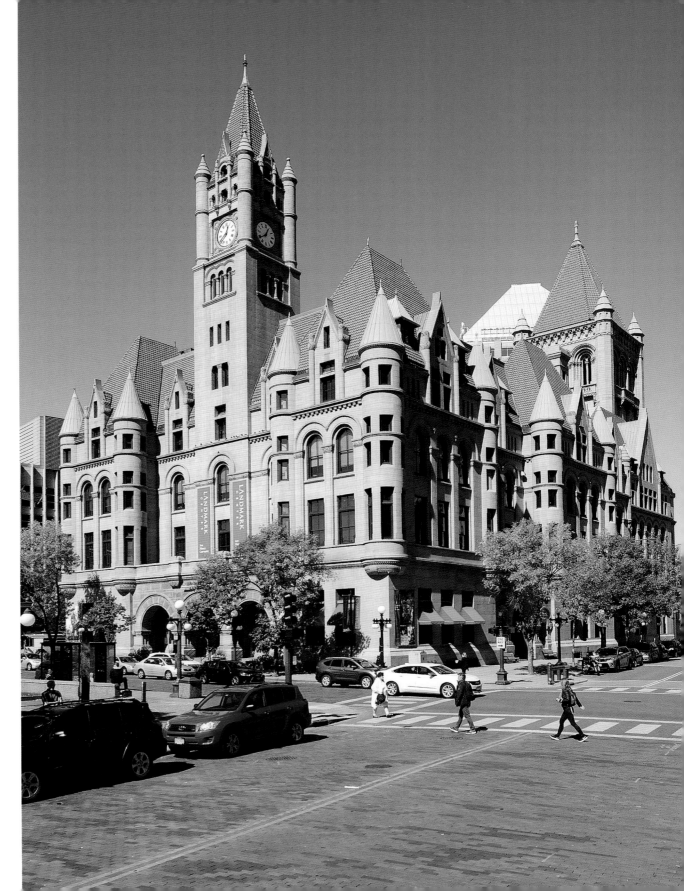

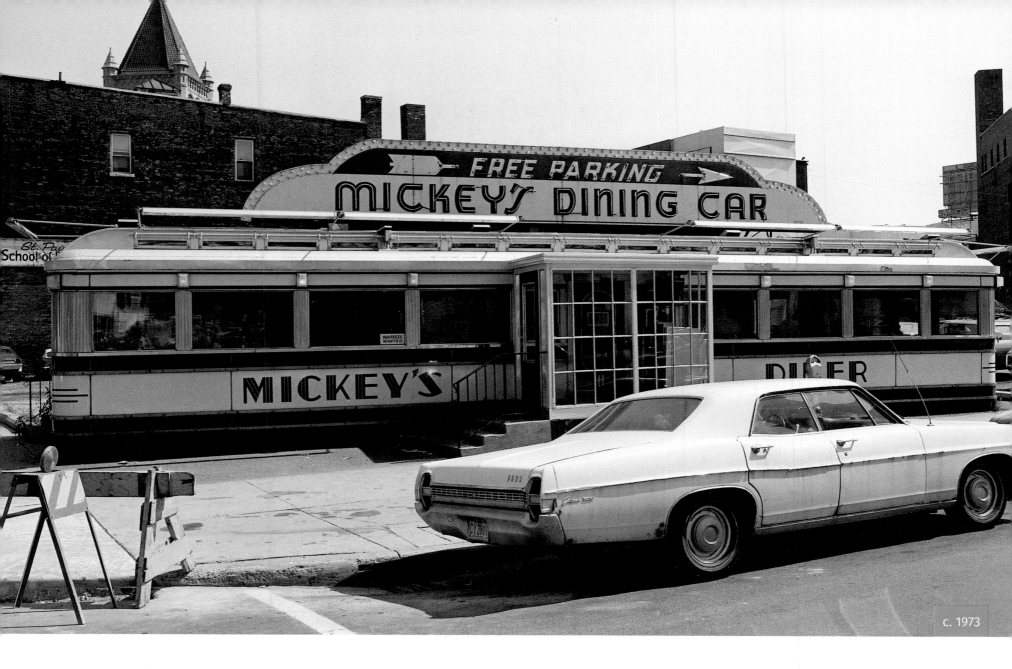

c. 1973

MICKEY'S DINER

This local institution is still open day and night

ABOVE: Originally constructed in New Jersey in 1937, Mickey's Diner is a classic rail-car café that opened on the corner of St. Peter and Seventh Street to serve food to the working people of the city, 24 hours a day, seven days a week. Famous for their breakfasts, beans, burgers, and mulligan stew, Mickey's gradually assumed landmark status in the city, offering simple, quick food at cheap prices at all hours of the day and night. Since opening, it has only closed a handful of times for maintenance purposes. In the early 1970s, when this photo was taken, the diner was bordered by historic brick buildings, and the north tower of the Landmark Center is visible at the top left of the frame.

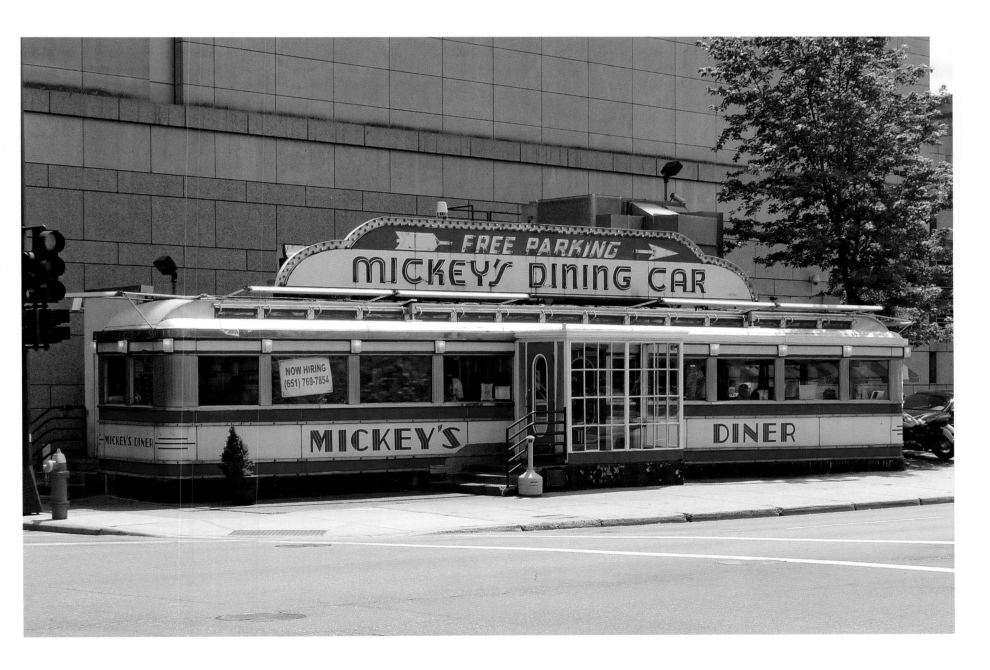

ABOVE: Today neither the menu nor its neon sign have changed. Mickey's still serves the hungry and humble people of St. Paul at all hours of the day. The diner has been used as a film set a number of times and is a popular spot for a snack after an event or a night on the town. While its landscape has shifted quite a bit over the decades—the old buildings immediately behind it were first razed for surface parking, before becoming the massive blank wall of an office building complex—the diner has remained a rock of stability in a changing downtown.

SECOND AND THIRD STATE CAPITOLS

The third state capitol still dominates the view

BELOW: Minnesota's second state capitol, the dark building with the elongated dome on the left, was built in 1881 on the corner of 10th and Cedar Street. It operated for less than 25 years as the center of state government during the late 19th and early 20th centuries. The red brick building was taxed by the rapid growth of the state's population and economy, and government needs quickly outgrew its confines. Just a few years later, the vastly larger and more expensive third state capitol, visible at the center of the frame, was constructed a half-mile to the north and was completed in 1905.

RIGHT: The second state capitol was demolished in 1937 and today the city block where it once sat houses a massive windowless complex, home to a music school and a theater company producing local history plays. Looking up Cedar Street today, few of the historic buildings remain, though the steeple of the Church of St. Louis is still visible, and the third state capitol continues to take center stage. The surrounding area has become the core of office buildings connected with second-story skyways that cater to the nine-to-five crowd. Meanwhile, the I-94 freeway was built in the 1960s below grade, two blocks to the north, separating downtown from the state capitol area. The beige building on the left is the former Dayton's building, designed in 1961 by Victor Gruen (who also designed the Southdale Mall). In 2013, a light rail line was completed that connects downtown St. Paul to downtown Minneapolis, running into the heart of the city along Cedar Street.

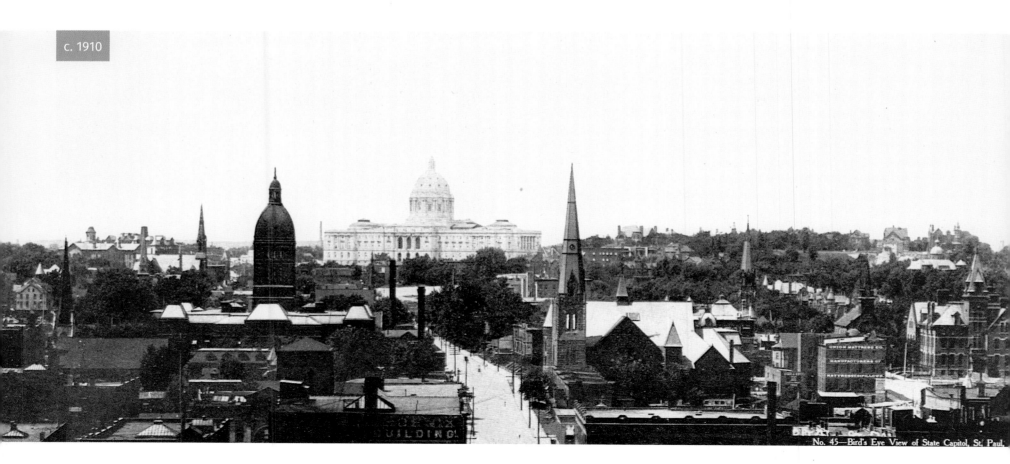

c. 1910

No. 45—Bird's Eye View of State Capitol, St. Paul.

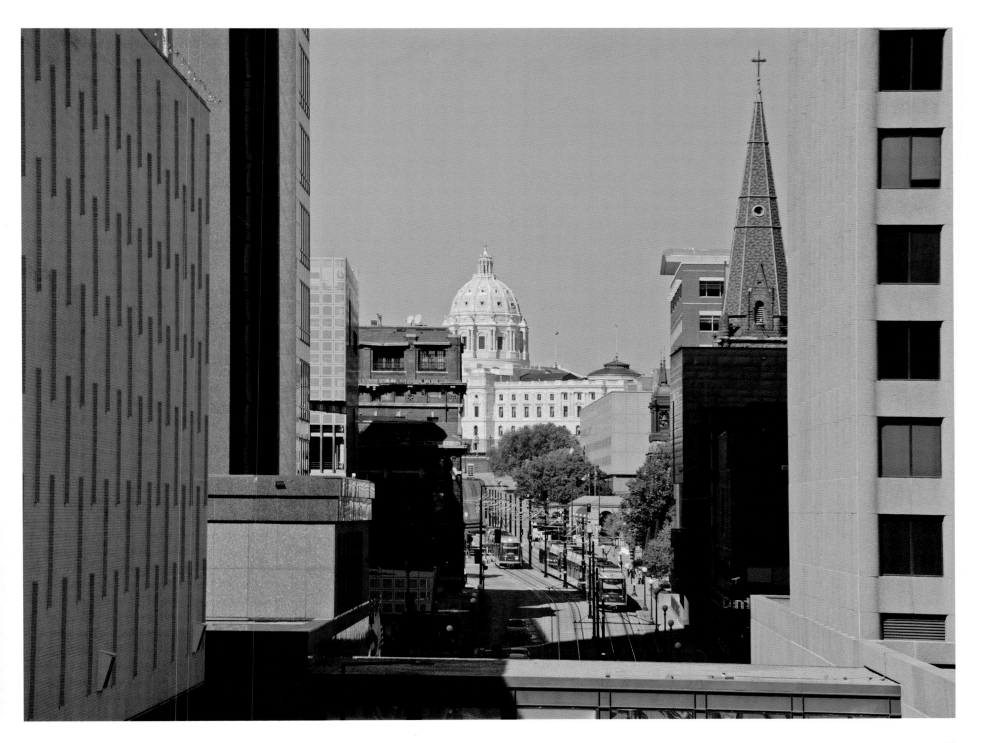

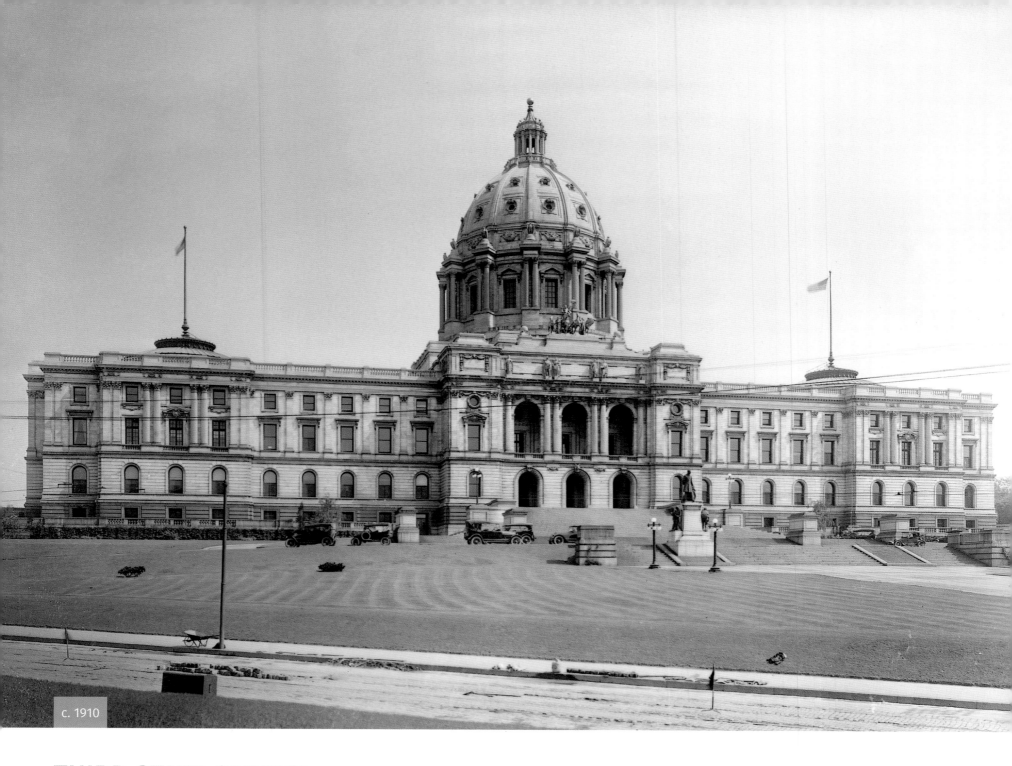

c. 1910

THIRD STATE CAPITOL

Features the world's second-largest freestanding marble dome

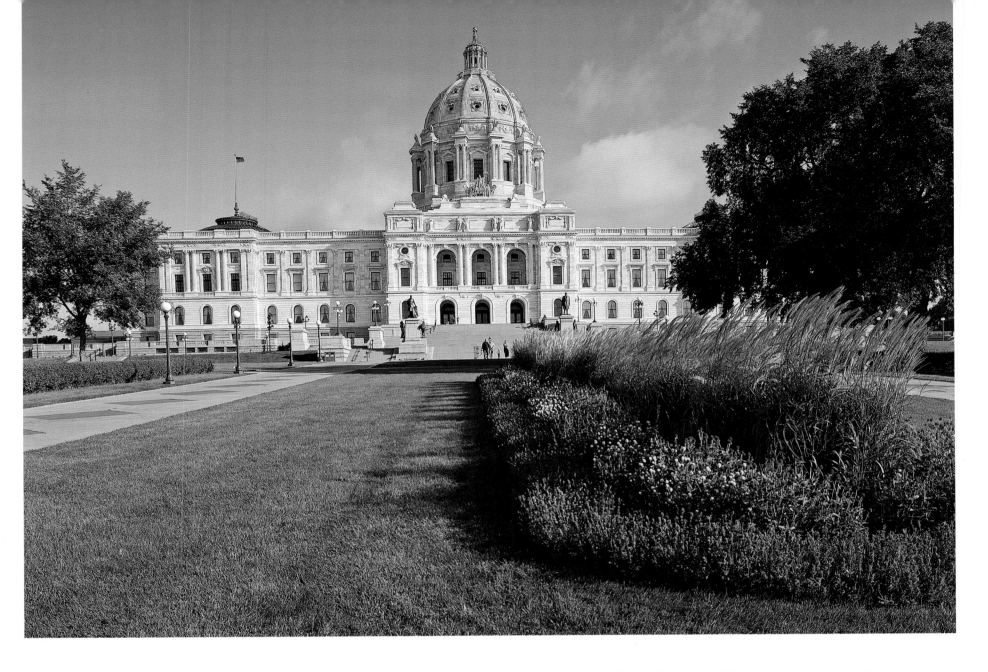

LEFT: The third Minnesota state capitol building was designed by Cass Gilbert, who also built the U.S. Supreme Court building in Washington, D.C. and Manhattan's famous Woolworth Building. The classically-inspired Beaux-Arts design was completed in 1905 and features the world's second-largest freestanding marble dome, after St. Peter's in Rome. The details of the design, both inside and out, are full of early Minnesotan pioneer imagery. The golden statue, the Quadriga, which is prominently displayed on the top of the building, represents civilization and prosperity harnessing the natural elements.

ABOVE: The capitol's interior houses the Minnesota state house, senate, and supreme court chambers, along with many elaborate offices for political leadership and staff. During each year's session, from January to May, the capitol buzzes with politicians, lobbyists, and advocates negotiating budgets and laws. After years of neglect and wear, the state government approved an ambitious plan for remodeling and repairing the capitol building, which were completed in 2017. Since it was built, the old neighborhoods surrounding the building have been demolished in favor of government office complexes and parking lots, as well as a central open mall that is home to over a dozen memorials, and serves as a staging point for both public demonstrations and civic events throughout the year.

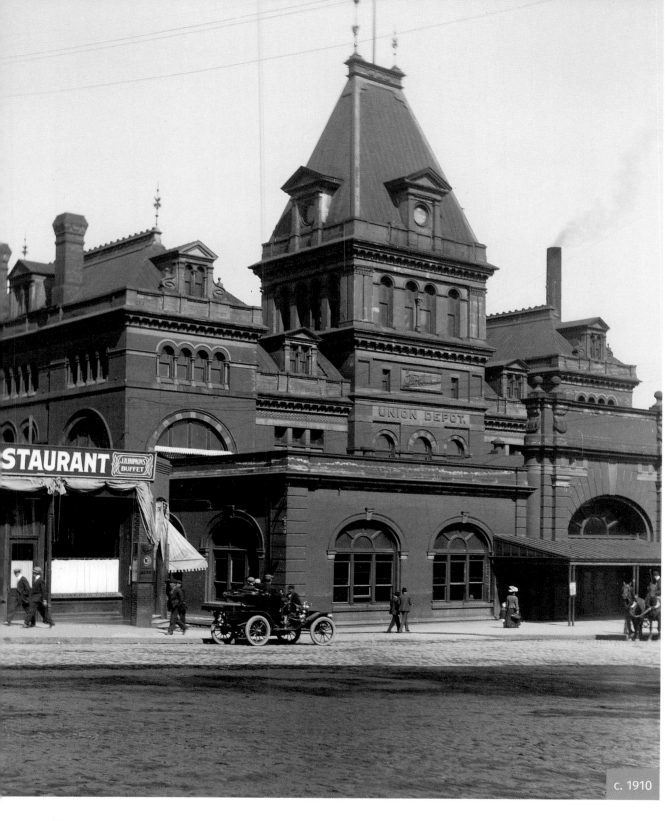

STAURANT J.H.HOPKINS BUFFET

UNION DEPOT

c. 1910

ST. PAUL UNION DEPOT
Rail service returned to the depot in 2014

LEFT: By the late 1870s, St. Paul had become a key national railroad hub, and demand for passenger rail service was booming. The first St. Paul Union Depot was built in 1881 and combined the services of several different railroads into one central location. By the 1890s, over 150 trains were departing and arriving at the depot every day. The station was at the heart of a booming downtown, located at the center of the railroads and their warehouses, the river, and the merchant offices of the central business district. Shown here around 1910, the building burned to the ground in a fire in 1915, and, within a few years, was replaced by an imposing Neoclassical structure with a polished pink marble lobby and massive columns bracing the steps leading toward the Lowertown neighborhood.

RIGHT: Today's Union Depot building, which was completed in 1923, has been restored and is back in use as a train and bus station. Yet for decades the building was largely mothballed. With cuts to rail service and the formation of Amtrak in 1971, passenger rail moved five miles west into an industrial area and the depot fell into disuse. In 2014, with help from federal and local grants, the old train station was meticulously restored and trains returned to the depot. The walls that had sealed up the massive waiting room were taken down, and today it is full of public art, a café, and, at any given moment, dozens of people waiting for bus or train services. Notably, the restoration revived the original 1923 paint colors and reopened the waiting-room skylights for the first time in half a century.

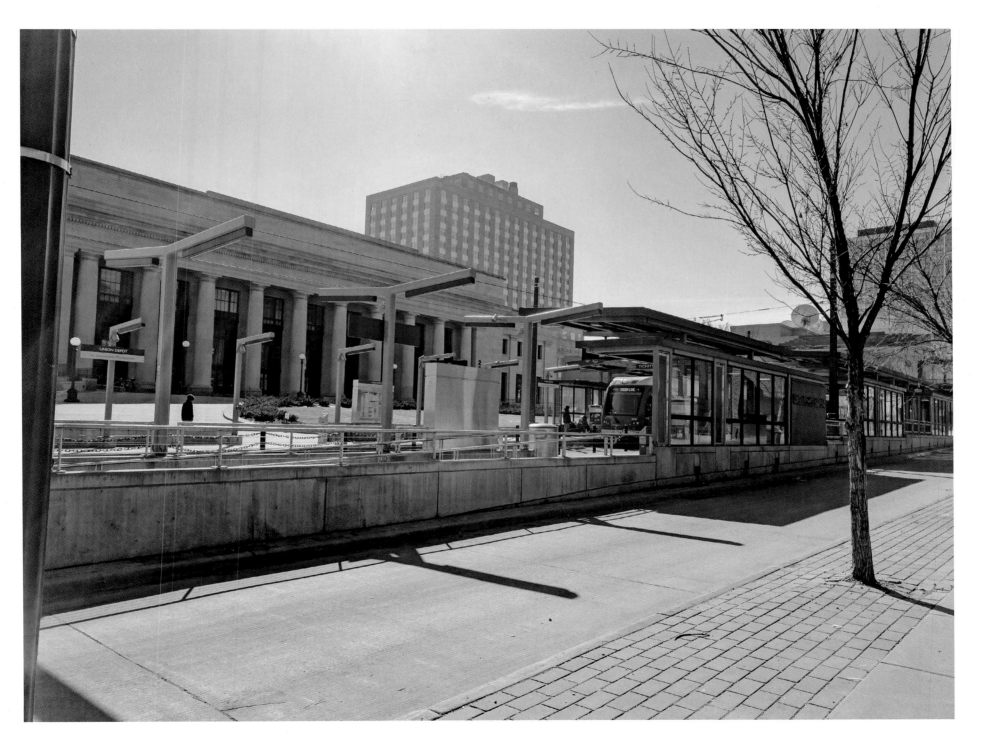

1948

ST. PAUL FARMERS' MARKET
The oldest continuously running market in the Twin Cities

LEFT: St. Paul's Farmers' Market has moved around quite a bit over its more than 150-year history, but has always been in downtown St. Paul. Its longest tenure—from 1902 to 1982—was at Tenth and Wall Streets. In 1948, when this photograph was taken, the area was still an industrial warehousing center, full of factories and dry-good storage facilities that were taking advantage of access to nearby railroads.

ABOVE AND RIGHT: In 1982 the Farmers' Market moved into its current space at Fifth and Wall Streets, reusing and re-creating the corrugated metal overhangs for a bustling food market on warm weekends. The farmers, many of whom are related to Hmong refugees from Southeast Asia, sell fruits and vegetables from May to November. Its Lowertown location has been a historic district since the early 1980s, and many of its turn-of-the century buildings have been preserved. The surrounding neighborhood has transformed into a booming arts and entertainment district, with most of the old warehouses being converted into residential space. Just across Broadway Street, an old factory was replaced by CHS Field, home of the St. Paul Saints, an unaffiliated baseball team that plays each summer.

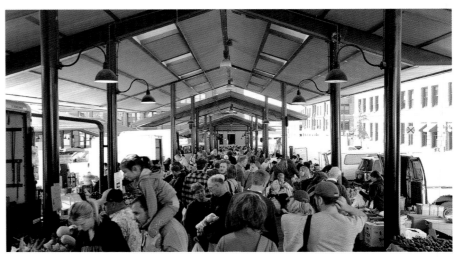

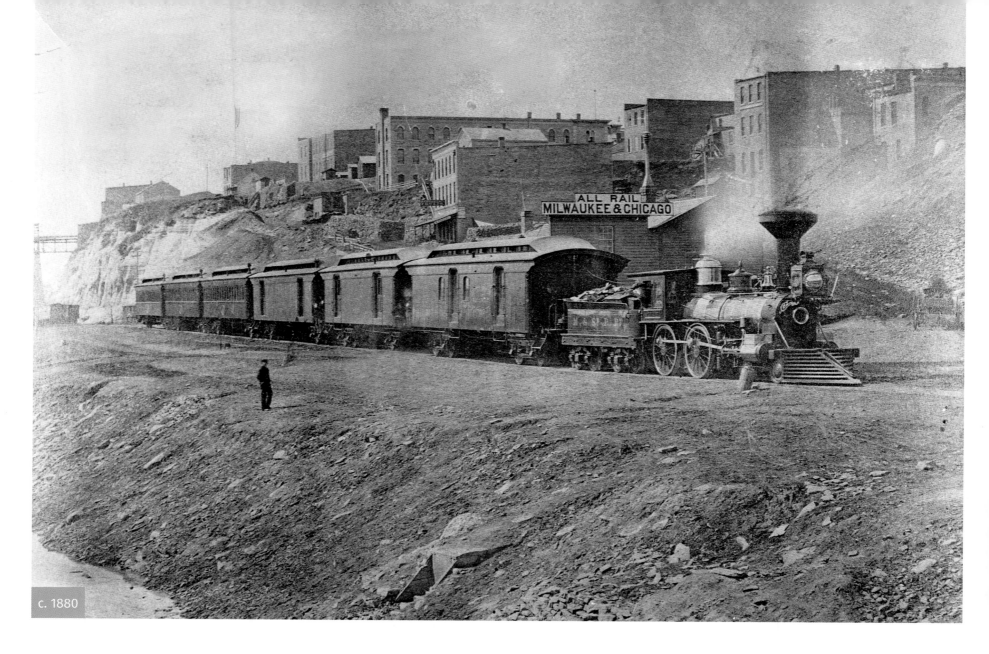

c. 1880

ALL RAIL
MILWAUKEE & CHICAGO

ST. PAUL LOWER LANDING RAILROAD
Trains still run along the old route

ABOVE: The first trains arrived in St. Paul in the mid-1870s and by 1880 St. Paul was a booming railroad town; the logistical hub for the entire northwest. The old "lower landing," which once filled with steamboats, now had to share space with the new railroads, and quickly the old fringes of downtown St. Paul began to transform into warehouses and smoky rail yards. The transformation led to an exodus from many of the old Victorian residential enclaves surrounding old downtown. Visible rising up from the tracks in this photo is old Second Street, which was lined on both sides with taverns, shops, hotels, and the occasional brothel. The famous limestone cliffs of downtown St. Paul are visible here, with the Wabasha Street bridge far left. In this photograph, likely from the early 1880s, it was the only river crossing in the city.

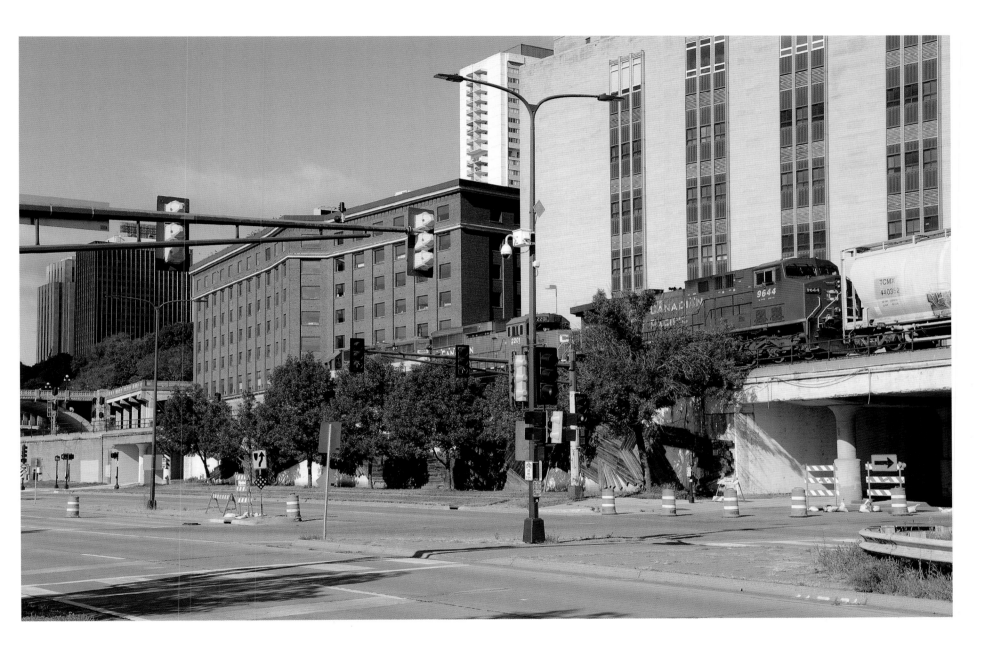

ABOVE: Then as now, flooding is a recurring problem in this part of the city. Shepard Road, pictured in the foreground, floods on a regular basis, but most of the rail tracks and city buildings have been either elevated or protected by levees. Visible on the far right is the former St. Paul Post Office and Custom House, a massive Art Deco building, constructed in 1934 and recently converted into an apartment and hotel complex.

The railroad still runs along its old route, entering the downtown 1923 Union Depot building just to the left of this picture. The Robert Street Bridge is visible to the far left of the frame, meeting the bluffs as it intersects Kellogg Boulevard, formerly Third Street.

ROBERT STREET BRIDGE

The primary link between downtown and the West Side

c. 1890

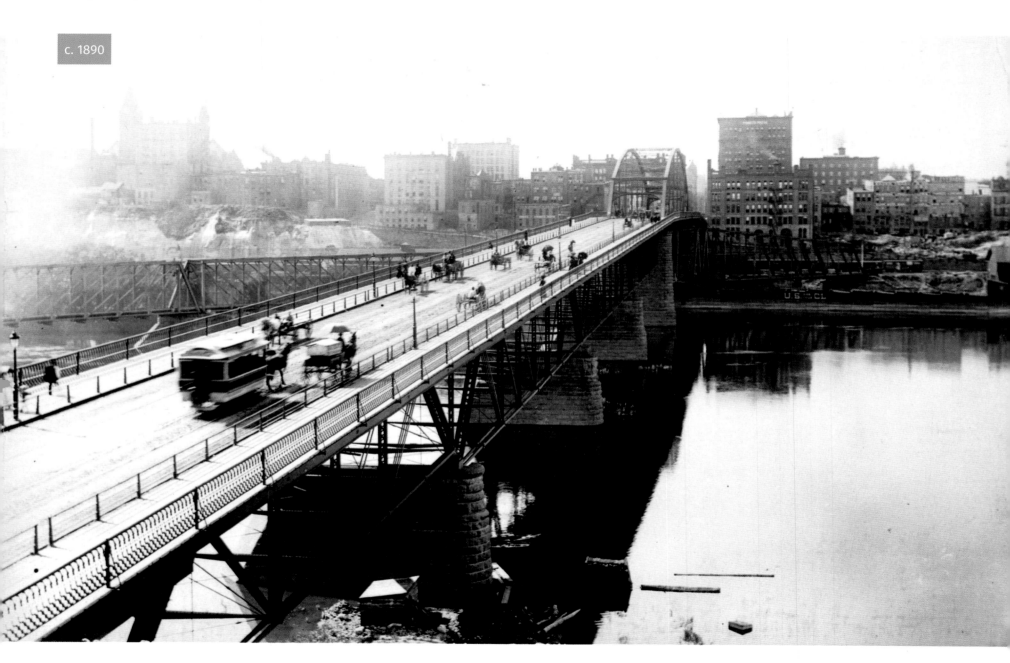

LEFT: Built in 1886, the Robert Street Bridge was the second to cross the Mississippi in downtown St. Paul. The original bridge was vaulted over an earlier railroad bridge (which still exists) that brought train traffic over the Mississippi. This image, which dates to around 1890, was taken from the West Side Flats, and shows the bridge looking north toward downtown. The then-new 12-story Pioneer Press building is visible just to the right of the bridge, rising up over the downtown skyline. At the time, it was St. Paul's tallest structure, and made innovative use of steel and an elevator that rose above a sklylit central atrium. Note the horse-drawn streetcar crossing at the center left, a transportation technology that was in use for only a few years, between 1887 and 1891.

BELOW: The original bridge lasted for around 40 years before being replaced by a larger concrete bridge with limestone arches in 1926. The bridge is still heavily used by automobile and pedestrian traffic. One design detail: the concrete was scored to make it look as if it had been formed from individual stones. The bridge offers excellent views of the river traffic below, and is the primary conduit between downtown and the West Side neighborhood. This image, taken from the levee walkway on the West Side Flats, shows the river barge traffic in the foreground. The neon red "1st" sign of the First Bank building is visible along the skyline, rising over the 1970s-era Kellogg Square apartment building. The red brick top of the Pioneer Press building is still visible just to the right. (Four stories were added to the building in 1910.) The staircase and docks of downtown's lower landing are visible on the far riverbank.

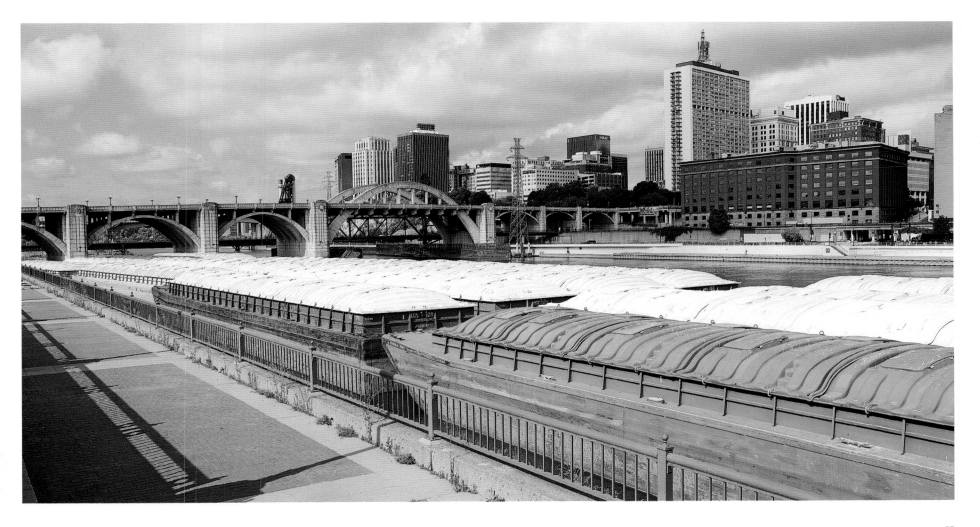

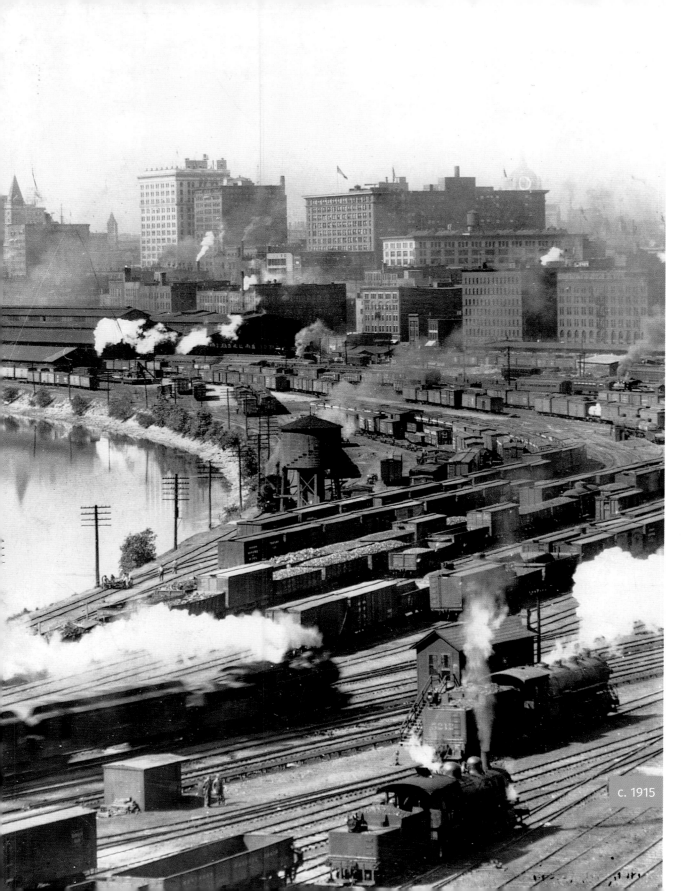

c. 1915

ST. PAUL RAIL YARDS

The rail yards filled the space between the Mississippi and downtown St. Paul

LEFT: This image captures both the Minnesota winter and the industrial activity of early 20th-century St. Paul. Here are the massive rail yards that once occupied the space between the Mississippi and downtown St. Paul. During this era, the riverfront was not a place for recreation, but used solely for industry, and it must have been an incredibly dirty place to be. This photo is taken from the Mounds Park bluffs, so called because they are home to a series of Indian burial mounds that are at least two thousand years old. The sacred Dakota site of Wakan Tipi, or "spirit cave," is located in the park along the base of the bluffs. The long train sheds at the left edge of the image were connected to the original St. Paul Union Depot building, torn down and replaced by the present Neoclassical building in 1923. In the background, warehouses stretch from downtown along the tracks to the industrial areas to the east. The tall white Merchant's Bank Building rises above the Pioneer Building on the left while the dome of the then-new Cathedral of St. Paul is faintly visible in the background on the right.

RIGHT: Then as now, this rail corridor is one of the most heavily trafficked in the country, and 20 percent of the national rail freight goes along this bend in the Mississippi River between Chicago and the northwestern United States. The Merchant's Bank and Pioneer buildings can still be seen in front of the First National Bank on the left, along with many of the 19th-century warehouses that are part of the official Lowertown Historic District. However, the 1990s-era Galtier Plaza condo and office tower at the center of the frame overshadows much of the neighborhood. At the edge of downtown, the Highway 52/Lafayette Bridge runs across the river, separating the central city from the East Side. Joining the rail tracks in the foreground are a widened U.S. Highway 61, a biking and walking trail that offers recreational access to the riverfront. The state capitol dome rises on the far right.

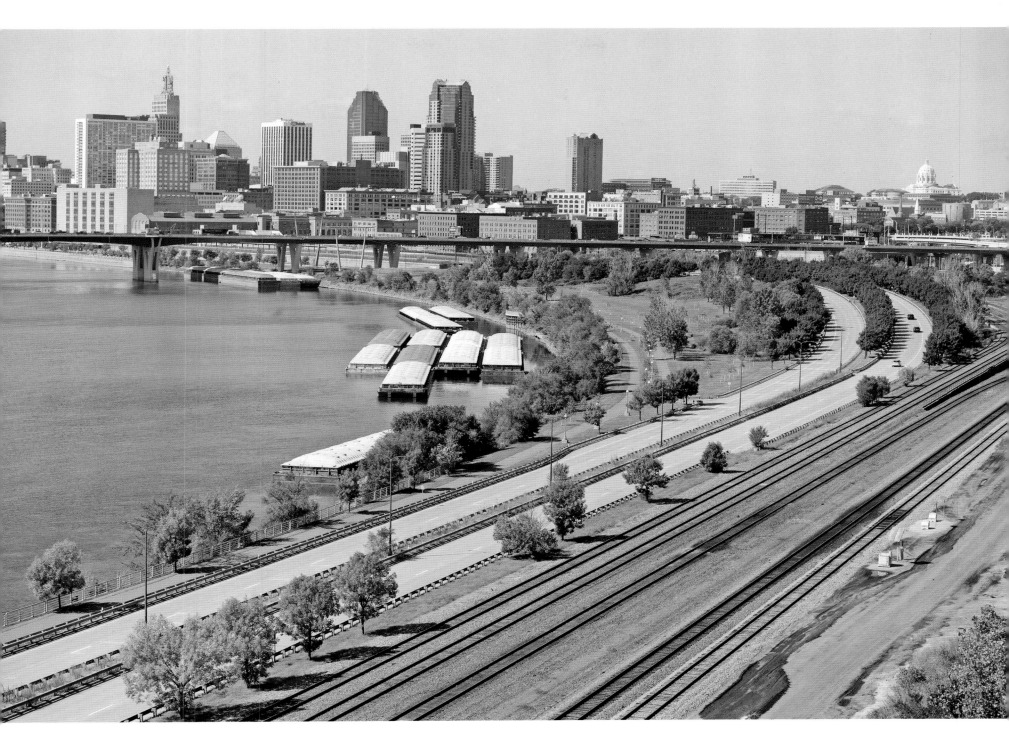

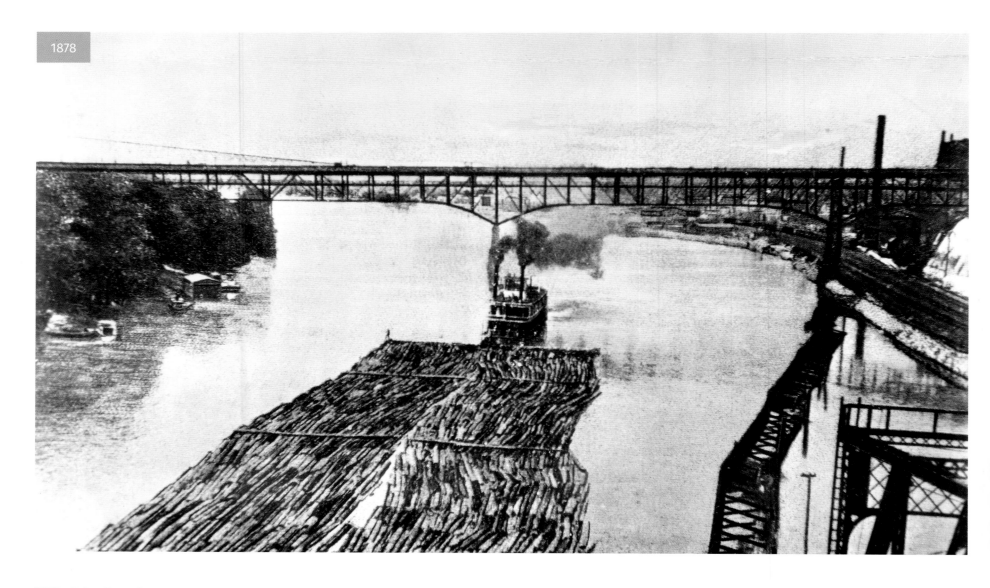

TRANSPORTATION ON THE MISSISSIPPI

How natural resources made their way to and from Minnesota

ABOVE: Since the first steamboat made its way upriver in 1825 until the railroad era, the Mississippi was the key to shipping and commercial trade in the Twin Cities. During the steamboat era, the river was how natural resources made their way to and from Minnesota, as is the case here where logs from the northern forests are being shipped downriver for milling. This photo dates to 1878, when the lumber industry was one of the largest in the state. At the time, the Wabasha Street Bridge, which ran up toward downtown, was the only regular river crossing in St. Paul. Harriet Island is visible on the riverbank to the left, and the upper steel buttress of a railroad bridge is visible at the right bottom corner of the frame.

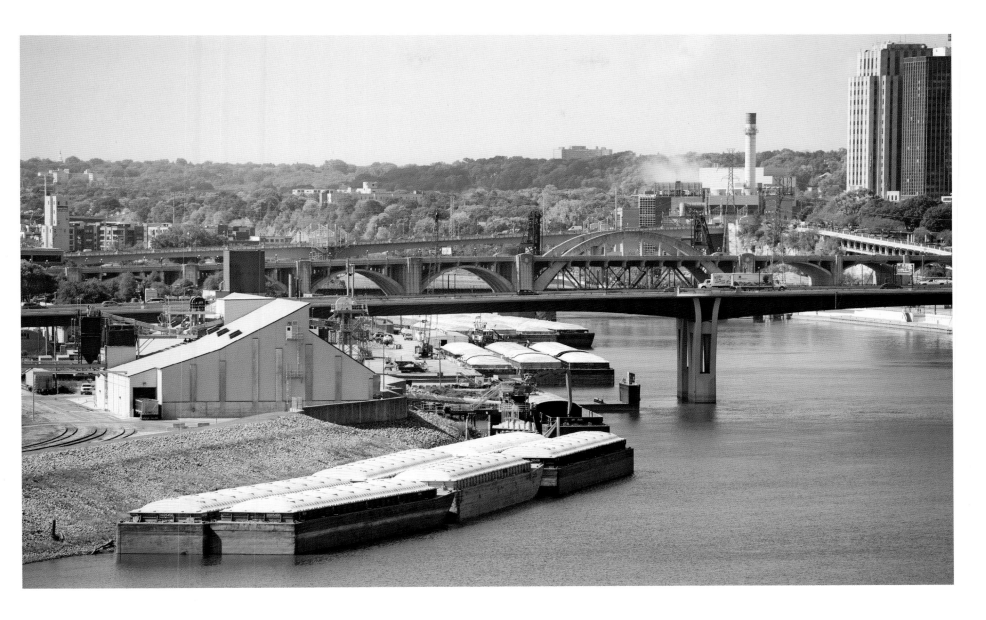

ABOVE: By the 1910s farmers were clamoring for shipping alternatives to the railroads, which had a monopoly on the trade—and therefore the price—of grain. At that time, the upper Mississippi had been dredged only to shallow depths, thanks to the U.S. Army Corps of Engineers' series of locks and dams that allowed river shipping between St. Paul and St. Louis. The river was later dredged to a deeper 6-foot depth with a series of underwater "wing dams" constructed to ensure adequate flow. Today, during the navigation season of roughly April to November, river barges are active in St. Paul, and the massive barges, hauling mostly grain, aggregate, or scrap metal, can be seen docked along the river as they wait to be bundled and shipped downstream. The white building at left of the frame stores grain to be loaded into the barges for shipping. The Highway 52/Lafayette, Robert Street and Wabasha Street bridges are all visible in the frame, while the smokestack of the city's innovative district heating natural gas plant rises just to the left of city hall.

CASTLE ROYAL
The former speakeasy is now open for gangster tours

BELOW: Many of the Mississippi bluffs that rise up around downtown St. Paul are made from sandstone, which allows them to be easily hollowed out as caves. The Castle Royal was built in 1933, when this photograph was taken, and occupied a set of man-made caves that had been used as a mushroom-growing operation in the late 1800s. By the 1930s, the Castle Royal nightclub became a hot spot for organized crime, including St. Paul's notorious Ma Barker gang. During Prohibition, St. Paul was a gangster haven with lax enforcement of outlaws, as long as they remained on good behavior while within city limits. The elaborate bluff-embedded speakeasy, with exits out the backside of the cave, formed a convenient hideout in St. Paul's West Side neighborhood.

1933

BELOW: Today the club remains at the base of the river bluff, now covered in trees. The elaborate building is used for events, weddings, and a monthly swing dance, with dancers dressed in Jazz Age fashions. Visitors can take the popular gangster or ghost tours, where they can visit the caves and see the occasional bullet hole in the walls.

A coffee shop sits just outside the doorway, while St. Paul's stately Cherokee Heights neighborhood sits above on the top of the bluff, enjoying panoramic views of the valley below.

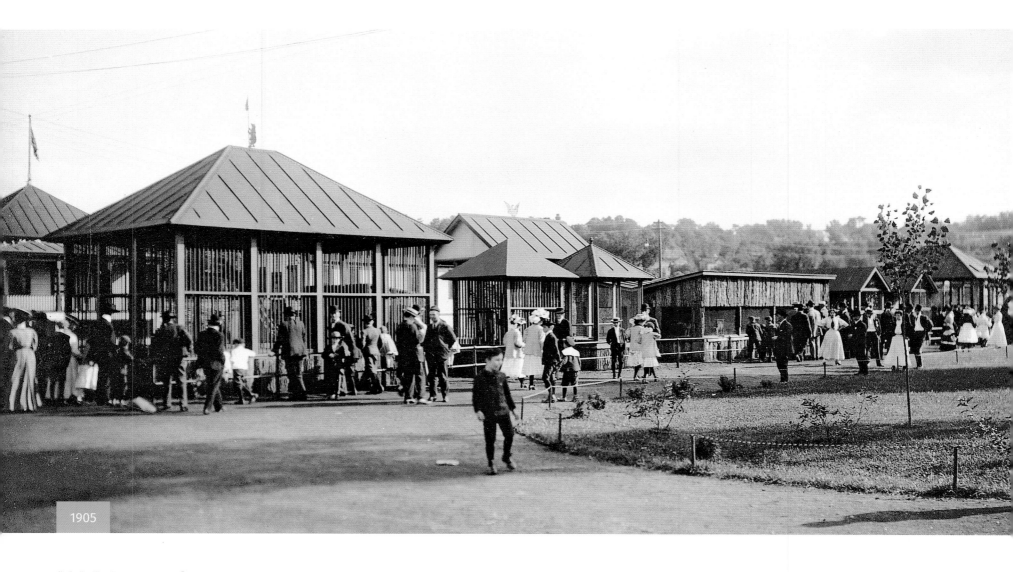

1905

HARRIET ISLAND
Site of the city's first public health project

ABOVE: In the late 19th century, the West Side river flats, just across the Mississippi from downtown St. Paul, were a thriving working-class immigrant neighborhood, home to the city's first communities of Jews, Lebanese, Germans, Swiss and many others. Originally called Wakan Island (Dakota for "spirit island"), Harriet Island was named for Harriet Bishop, an 1850s St. Paul schoolteacher and missionary, who kept a meticulous journal of her time in the unruly city. The island was connected to the flats by a narrow footbridge, and became the site for the city's first public health project when a wealthy doctor named Justus Ohage built a public bathhouse there, designed to serve the many flats residents who lacked basic amenities like running water or indoor plumbing. Harriet Island grew to include a playground, refreshments pavilions, tennis courts, walking trails, and a zoo. This photo dates to 1905, when the island was a very popular place for recreation, including swimming in the industrial Mississippi waters.

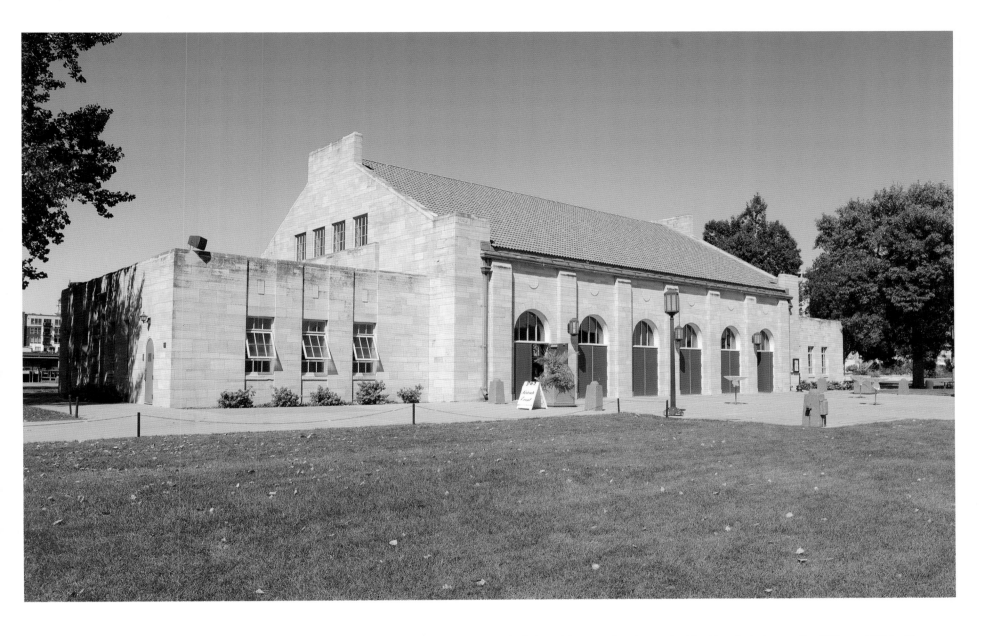

ABOVE: The popularity of Harriet Island waned in the early 20th century and the bathhouses were shut in 1919 due to recurring floods and pollution from the Mississippi River. The large structure shown here, the Clarence W. Wigington Pavilion, was built in 1941 to draw visitors back to the park. Originally known as the Harriet Island Pavilion, it was renamed for its architect, the first African-American municipal architect in the country. It was one of many civic structures designed and built by Wigington when he worked for the city between the 1920s and 1940s. The channel separating the island from the mainland was filled in after the river flats neighborhood was demolished during the 1960s for an industrial park. Today the site is home to a large regional park and hosts events throughout the summertime like the annual Irish Fair. The boat landing along the waterfront is the docking place for tourist steamboats, and a marina full of houseboats floats just downstream.

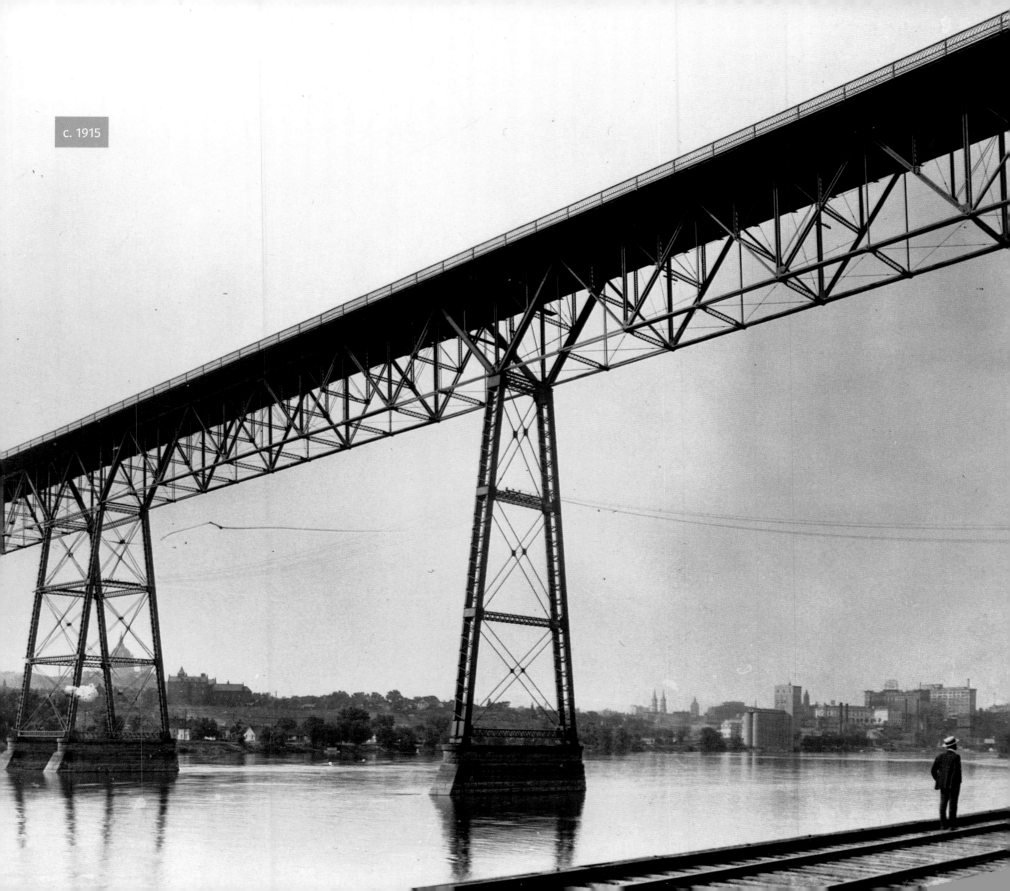

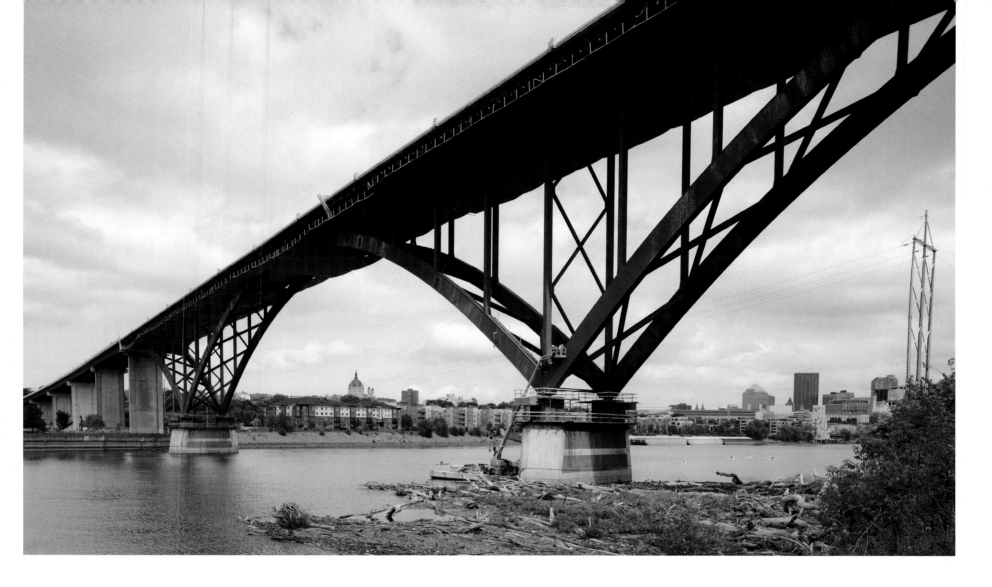

HIGH BRIDGE
Still the highest bridge in St. Paul

LEFT: The most structurally daring of the Twin Cities' river bridges, St. Paul's Smith Avenue High Bridge connects the historic West Seventh and West Side areas of the city to each other. Built in 1888 out of girders shipped up the river from Pittsburgh, the original bridge spanned a half-mile from bluff top to bluff top, reaching a height of 150 feet above the river flats below. Notably, part of the bridge was knocked down in a 1905 tornado, suggesting that the original engineers might not have done a great job assembling the components. The view here was taken around 1915 from the flats neighborhood of Lilydale, which once boasted dozens of flood-prone homes along the west bank of the Mississippi.

ABOVE: The West Side neighborhood of St. Paul, named for being on the west side of the river, was originally a separate city, but was annexed into St. Paul in the 1870s. The original bridge was replaced in the 1980s with a new arch bridge. It is shown here while undergoing maintenance. The old railroad tracks have been abandoned, and the flood-prone homes and structures of Lilydale were demolished during the 1950s. Today, the Lilydale area underneath the High Bridge serves as a park and recreational trail, offering a forested escape from the surrounding city at the base of the limestone bluffs. Various St. Paul landmarks from the 1915 photo are still visible in the distance here, including the dome of the Cathedral of St. Paul on the left and the towers of downtown, like the Ecolab building and the World Trade Center, on the right.

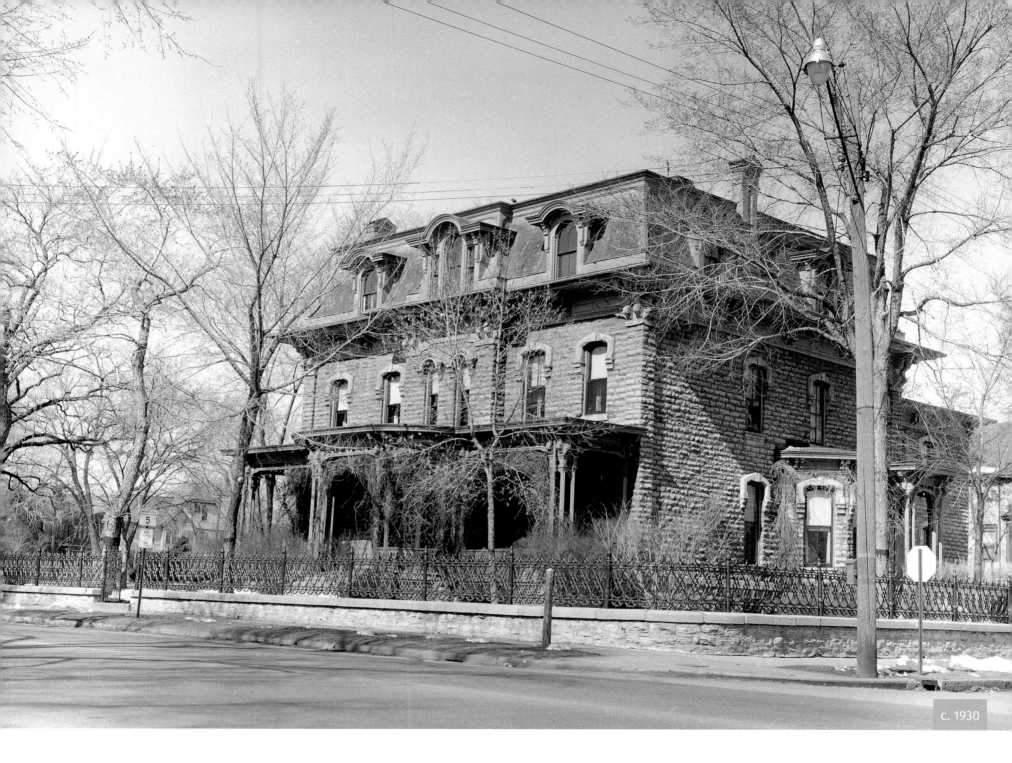

c. 1930

RAMSEY HOUSE

Now a museum giving a glimpse into life in the 1870s

108

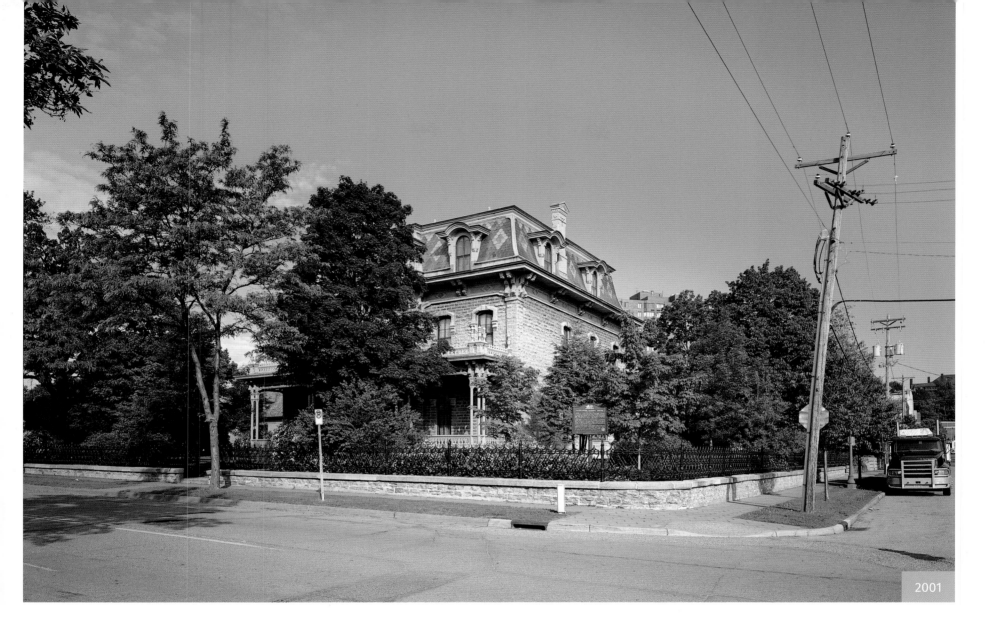

2001

LEFT: The 1872 home of the state's first governor, Alexander Ramsey, still sits near the historic Irvine Park neighborhood in the shadow of downtown. The house looked over Irvine Park itself, a public square where cows would have grazed in the late 1800s. The French Renaissance-style home is built from the distinctive Platteville limestone, which was used in many 19th-century construction projects through the Twin Cities. The Ramsey House remained home to Ramsey descendants until the 1960s, when it was deeded to the Minnesota Historical Society for preservation.

ABOVE AND RIGHT: Today the house is open to tours that give an insight into family and servant life in the 1870s. The house serves as a symbolic entrance for the nearby historic Irvine Park neighborhood. The 1870s Victorian-era neighborhood was saved from the wrecking ball by preservationists in the 1970s, and remains the Twin Cities' finest example of an early bourgeois district. Homes dating from the 1850s to 1880s surround the quaint square in the shadow of downtown, and it remains a popular place for wedding photos and strolling.

2017

ST. ANTHONY HILL / CATHEDRAL HILL
Offering unparalleled views of downtown St. Paul

BELOW: In the mid-1880s, figuring out a way to get a new electric streetcar up the hill and out of downtown was a real challenge. By 1890 streetcars were running all the way to Minneapolis, crossing the Mississippi River at the new Lake Street–Marshall Avenue bridge. As a result, residential development boomed in the western half of the city. Yet the steep 16 percent grade at the St. Anthony Hill leading into downtown was a dangerous chokepoint for travelers. By the early 1900s, when this photo was taken, engineers had begun planning a tunnel that would level out the streetcar journey. A tunnel opened in 1907, and helped streetcars ascend and descend the steep bluff with far less effort. When this photograph was taken, the hill itself was lined with homes that climbed the incline of the river bluff. Looking toward downtown, the twin spires of the Church of the Assumption, built by German immigrants in 1875, is visible to the left of the telephone pole.

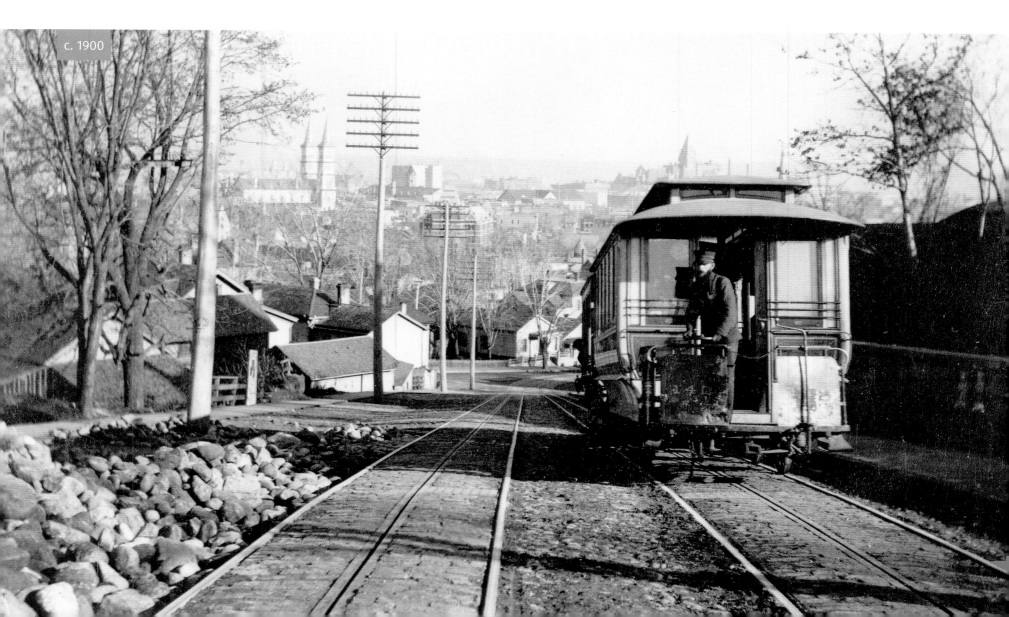

c. 1900

BELOW: Nobody calls it St. Anthony Hill anymore; the bluff is now known as Cathedral Hill for its most notable landmark: the Cathedral of St. Paul. Coinciding with the construction of the streetcar tunnel, the cathedral and the improved streetcar line fueled a building boom in the western reaches of St. Paul. When the streetcars were mothballed in 1954, the old Selby Avenue tunnel was sealed up. It still sits underneath the Cathedral Hill neighborhood, though the Interstate 35E freeway trench was built at its base during the 1970s, separating the Summit Hill neighborhood from downtown proper. Since 2012 the Red Bull Crashed Ice race, a downhill extreme ice-skating sporting event, has been held on this site each winter. The site is also noteworthy for offering stunning views of the downtown St. Paul skyline, its many Modernist and Postmodernist office towers crowding around the remaining 19th-century landmarks. In this image, the World Trade Center skyscraper can be seen on the left, next to the Church of the Assumption. The red-topped Landmark Center tower is visible poking over the modern skyline at the right.

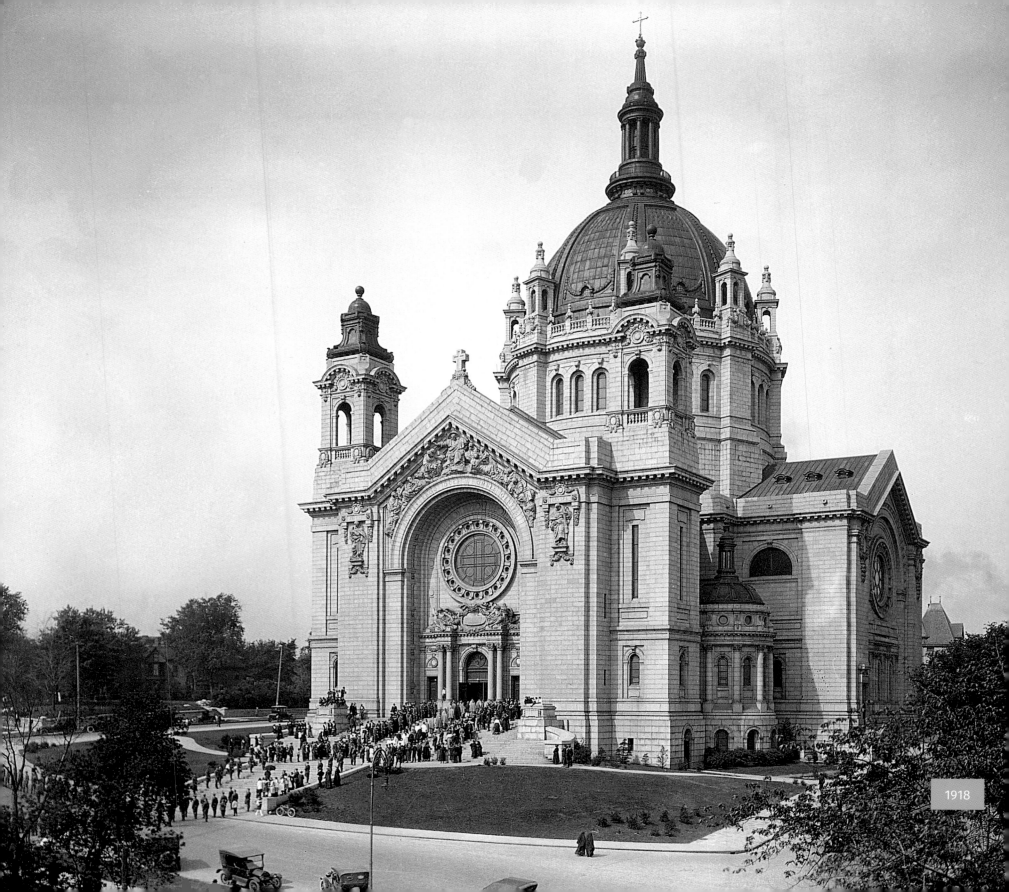

1918

CATHEDRAL OF ST. PAUL

The copper-clad dome
is visible for miles

LEFT: St. Paul's most recognizable building towers
over the city from high on the Summit Avenue bluffs.
At the behest of his Roman Catholic wife, the railroad
tycoon James J. Hill bankrolled the Cathedral of St. Paul
and built his own Gilded Age mansion just across the
street from it on the edge of the bluff. The cathedral's
impressive exterior, topped by a copper dome and built
from marble quarried in nearby St. Cloud, is matched
by its interior, with pews in the inner sanctum that seat
3,000 people in style. This photo was taken in 1918,
when the building was brand new.

RIGHT: After undergoing renovations in the year 2000,
which restored the copper dome to its original dark
brown hue, the building remains an iconic symbol of
the city. Some of the surrounding apartment homes
have been cleared away from its entrance, which was
renamed John Ireland Boulevard in honor of the bishop
who called the cathedral home for decades during
the early 20th century. Tours of the cathedral and the
nearby James J. Hill House are open to the public.

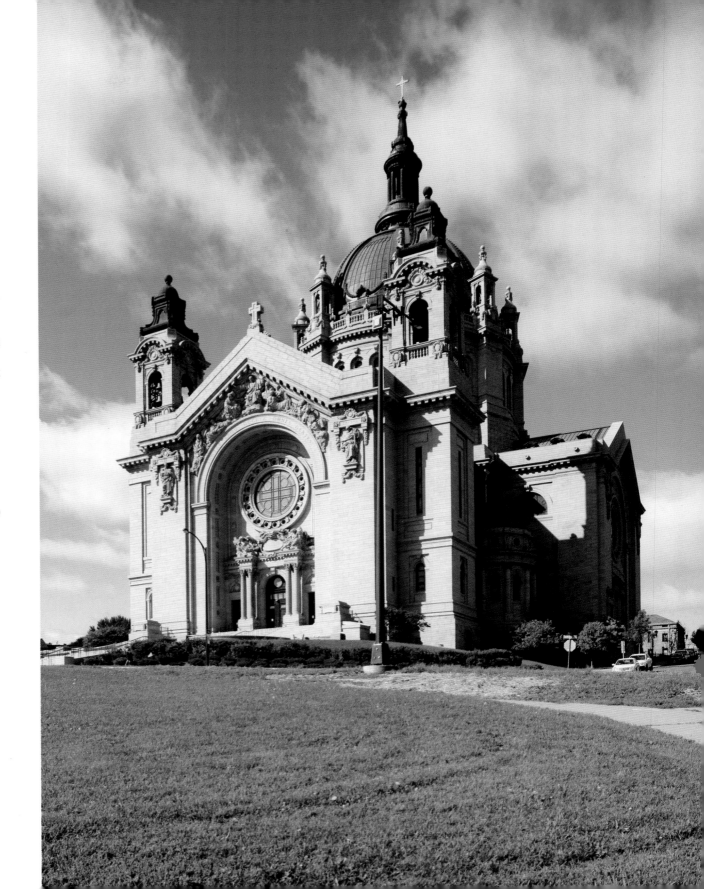

1925

COMMODORE HOTEL
Former residents include F. Scott and Zelda Fitzgerald

LEFT: Since the early 1880s, when the streetcars began running west up the bluffs out of downtown, ascending through the now-mothballed Selby Avenue tunnel, the Cathedral Hill area has been one of St. Paul's most coveted addresses. When the Commodore Hotel building opened in the 1920s, it was as a high-end residential hotel that catered to out-of-town guests looking to make an impression. The ground floor housed a speakeasy that attracted the St. Paul elite, most notably F. Scott and Zelda Fitzgerald, Nobel Prize-winning St. Paul writer (and Summit Avenue resident) Sinclair Lewis, as well as several notable gangsters. The Fitzgeralds were famously kicked out of the hotel for their raucous partying. This photo dates to 1925, at the peak of the flapper era.

ABOVE: The Commodore Hotel building is still a landmark near the corner of Summit and Western Avenues, its red neon sign providing a delightful contrast to the looming Victorian mansions. In the 1970s a gas explosion forced the hotel to shut down, though the building was saved and eventually remodeled as condominiums. The ground floor club, featuring an elaborate Art Deco bar detailed in gilded trim that dates back to a post-Prohibition 1934 remodel, operated as a famous spot for nightlife during the 1980s and 90s. After a long hiatus, the Commodore recently reopened as a restaurant and cocktail bar, serving Jazz Age drinks and food.

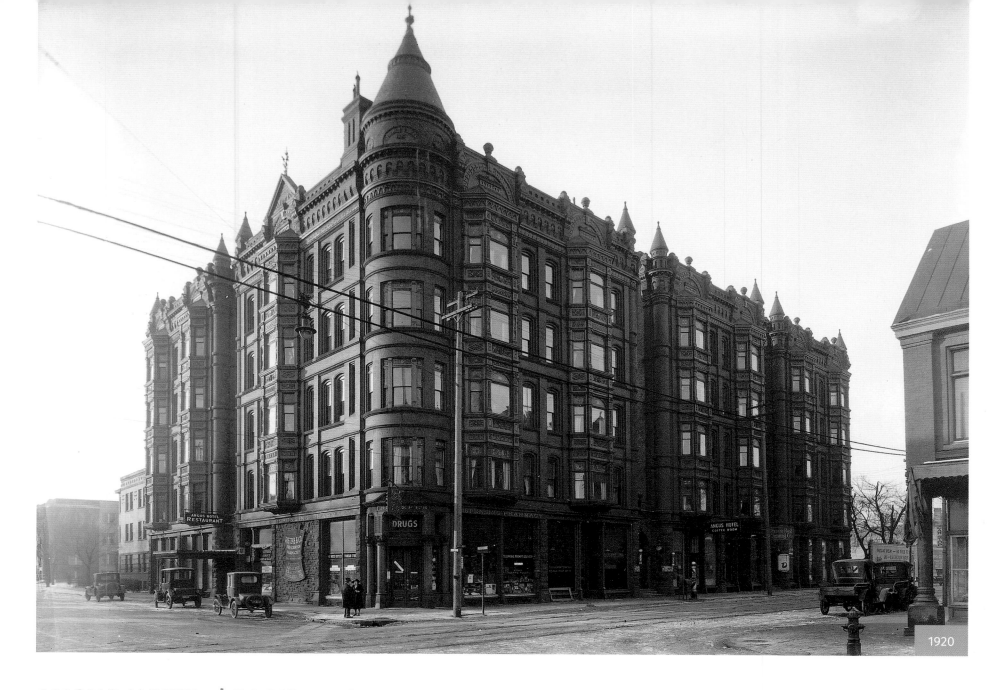

1920

ANGUS HOTEL / BLAIR ARCADE

Now a mixed-use building with shops, cafés, and condominiums

ABOVE: Like the nearby Commodore Hotel, the Frank P. Blair building was originally designed as a residential hotel for short- or medium-term dwelling in the upscale Cathedral Hill neighborhood. Dating to 1887, the Italianate-style building served as the Albion Hotel from 1893 until it changed ownership and was renamed the Angus in 1911. After World War II, the area began to decline and the Selby Avenue corridor experienced disinvestment. It is shown here in 1920, with Rietzke's Pharmacy between the hotel's restaurant on the left and its coffee room on the right.

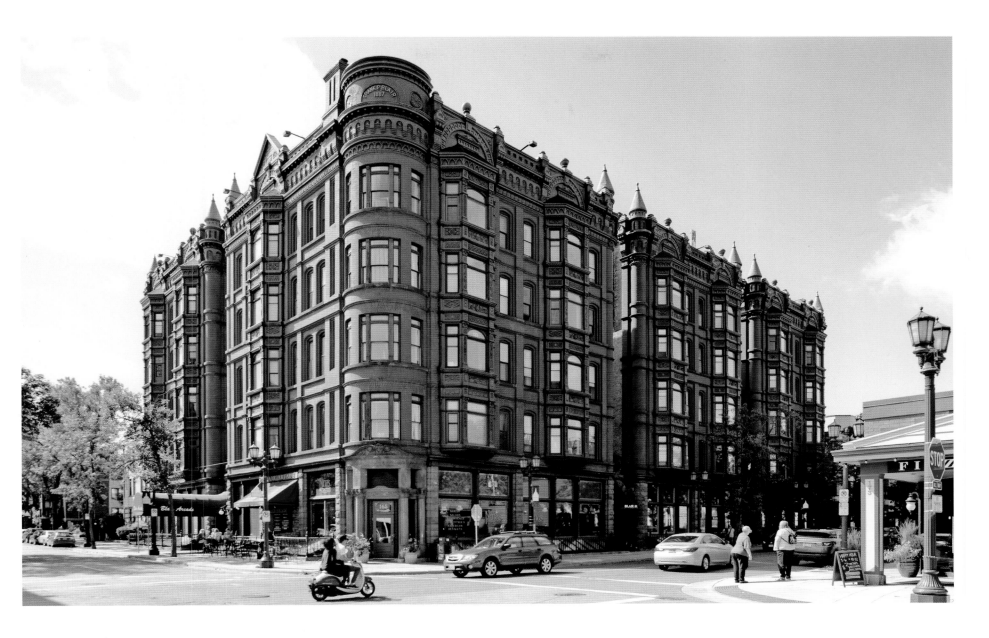

ABOVE: The Angus closed in 1971, but the preservation movement, close proximity to downtown, and unique architecture prompted a renaissance in the Selby and Cathedral Hill neighborhoods. Across the street, W.A. Frost, a prominent high-end restaurant, opened up in a former general store. In 1985 the former Angus Hotel reopened as Blair Arcade, a mixed-use building. Today it is home to a ground-floor café, a bookstore, and a beauty salon that all share the interior sky-lit arcade. The café is named for Nina Clifford, a famous madam who ran an underground brothel along the downtown St. Paul riverfront during the 1890s. These days, though, after a few decades of decline, the neighborhood around the Blair Arcade has undergone a vivid renaissance. Today Selby and Western are a hot spot for area restaurants, with almost a dozen popular eateries occupying the old brick buildings of Cathedral Hill.

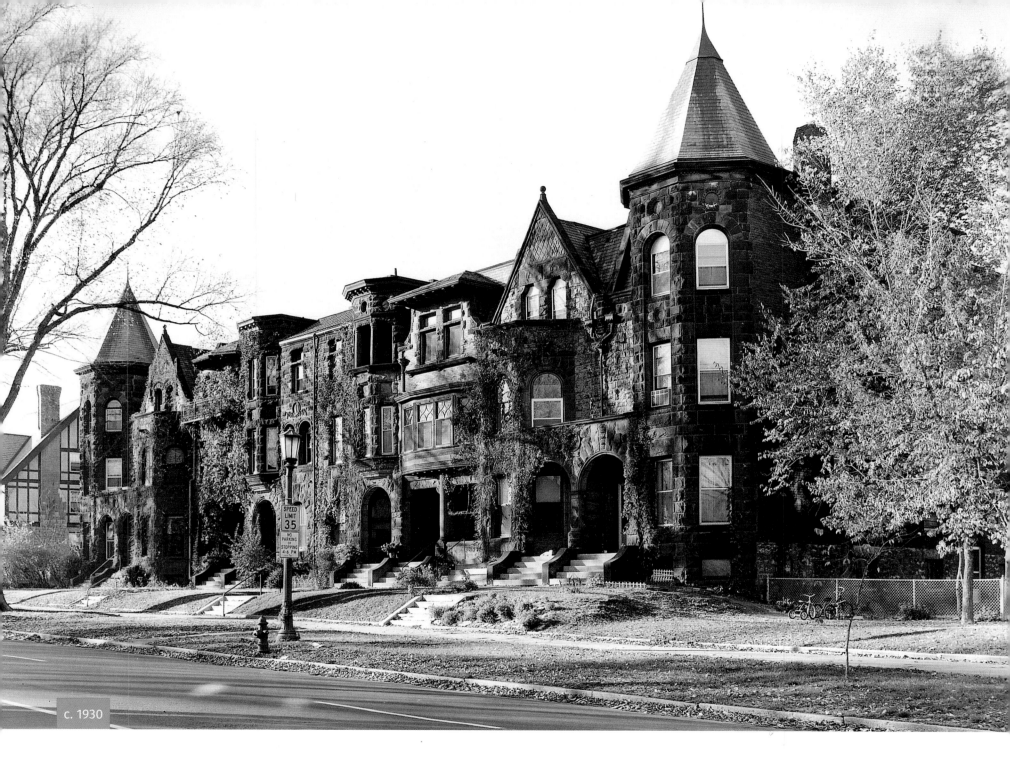

c. 1930

SUMMIT TERRACE

The childhood home of F. Scott Fitzgerald

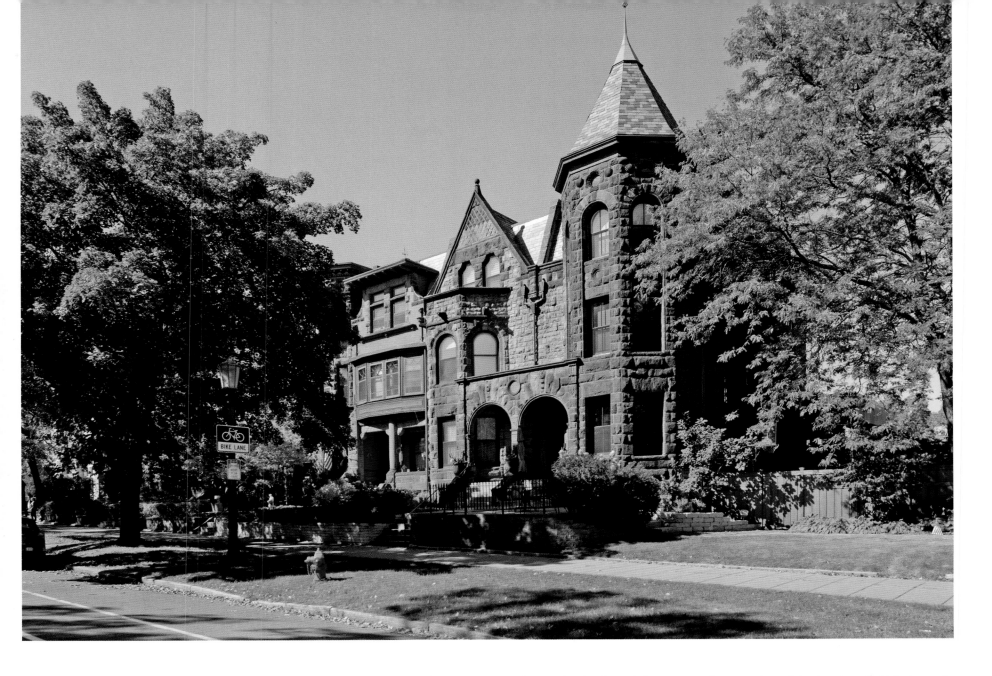

LEFT: Summit Avenue's historic mansions and row houses offer a unique collection of turn-of-the-century architecture. The Summit Terrace building, comprising eight attached townhouses, dates to 1889 and is a good example of high-end Victorian row houses that, today, are a rarity in the Twin Cities' urban landscape. One of the apartments was the childhood home of F. Scott Fitzgerald for a few years, St. Paul's most famous writer. While living there as a young man, he wrote the manuscript of his first novel, *This Side of Paradise*, and some of Fitzgerald's early short stories are set in 1920s St. Paul. An interesting side note: across the street, the home of St. Paul's other second Nobel laureate, Sinclair Lewis, sits only a block away.

ABOVE: Today the Summit Avenue mansions remain well-kept and are in high demand. While some still serve as single-family homes, others are used by institutions, bed and breakfasts, or divided up for apartments. A half-mile to the east, at the apex of the street, a well-known private club, the University Club, occupies a prime piece of real estate and continues to function as a private dining and tennis club for the city's elite. Summit's most famous resident these days is probably writer and public radio host Garrison Keillor, who lives on the edge of the bluff closer to the Cathedral of St. Paul.

VICTORIA CROSSING

The corner of Grand and Victoria is still a thriving retail destination

BELOW: Victoria Crossing, just two blocks south of posh Summit Avenue, flourished when streetcar service began serving the area in the 1880s. Formed where Grand and Victoria meet, Victoria Crossing was a key shopping district, and home to multiple small shops with apartments above. Grand Avenue's mixed-use buildings date to the late 19th century and grow more modern as you move west along the street. Before World War II, Grand Avenue was the center of the city's automobile repair and sales industries, and the street had many mechanics and gas stations along its route. The Grand Avenue State Bank occupies the northwest corner of the intersection in this view.

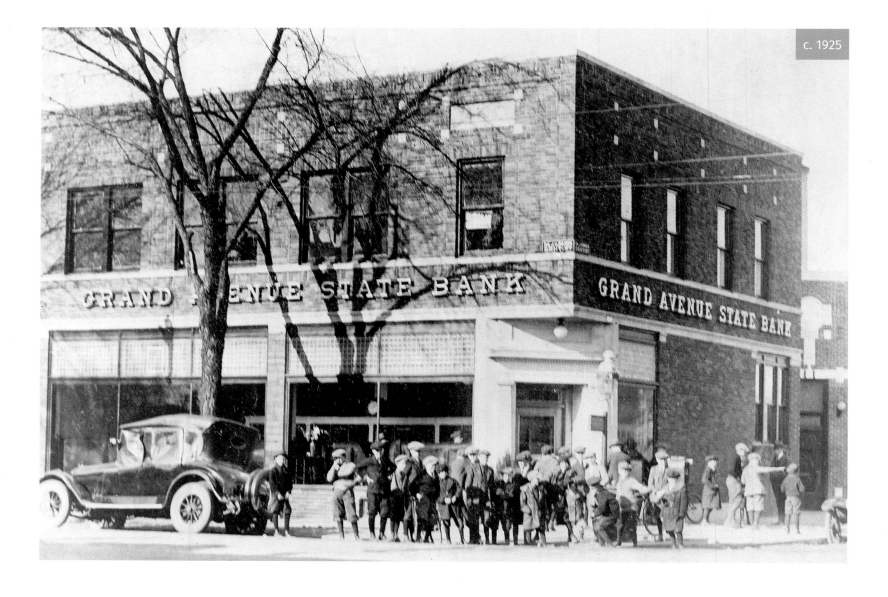

c. 1925

BELOW: As the Twin Cites grew, Grand evolved again into a mixed-use retail destination. The annual Grand Old Days festival began in 1973 with a day-long pedestrian-only parade, and many of the large old houses became home to small businesses selling boutique wares. The street continues to thrive as a retail destination featuring brand-name clothing, cafés, and other craft goods in and among the century-old homes and apartments.

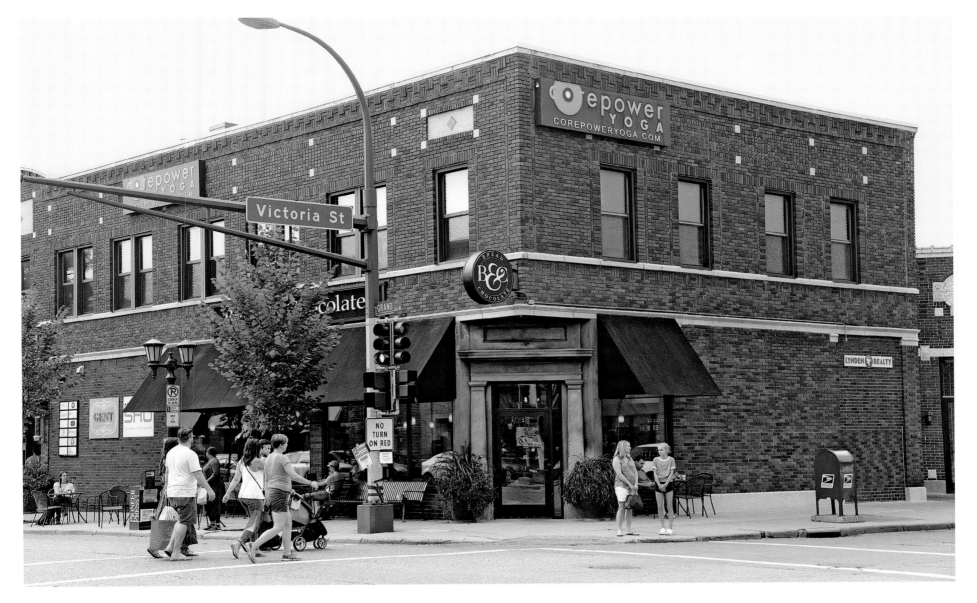

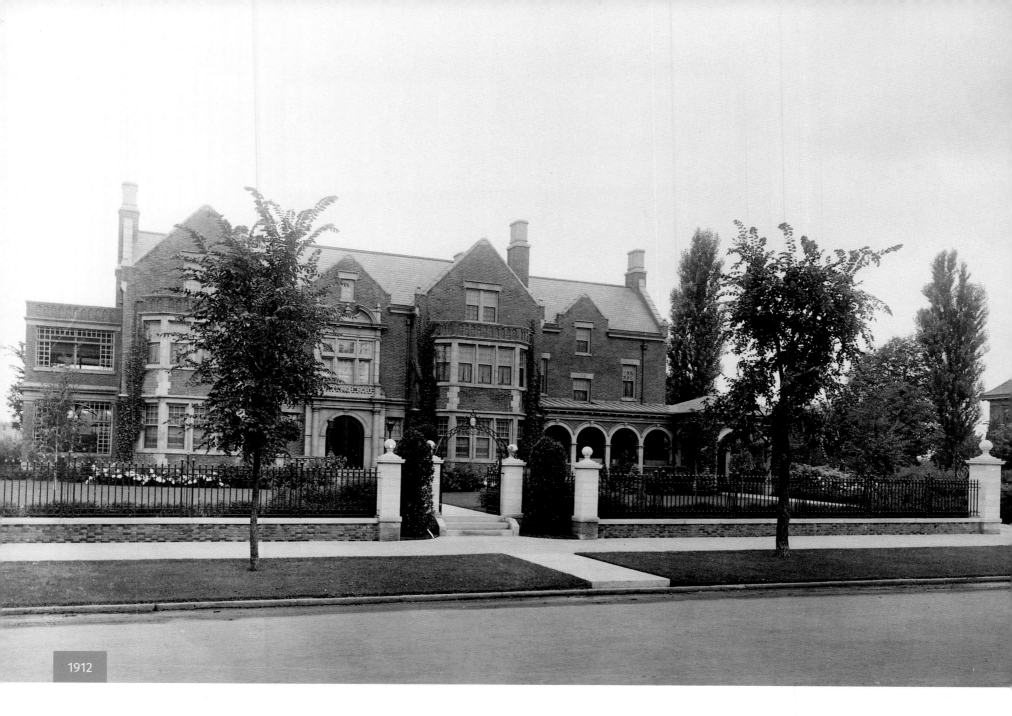

1912

GOVERNOR'S MANSION
The official home of the state's first family

ABOVE: Seen here in 1912, when it was brand new, this English Tudor-style mansion was built on one of the last remaining prime plots along Summit Avenue, a block east of Lexington Parkway. Constructed for a lumber baron named Horace Hills Irvine, and designed by local architect William Channing Whitney, the 14,000-square-foot house boasted 20 rooms, 10 bathrooms, nine fireplaces, and two large porches behind its well-gated grounds.

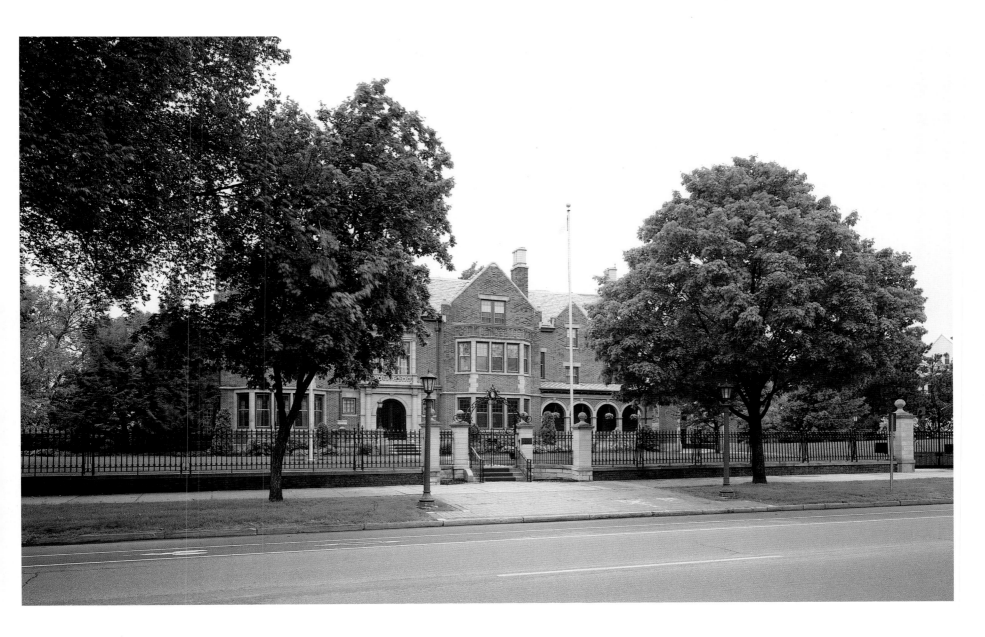

ABOVE: By the 1960s, like many of the large houses of Summit Avenue, the mansion had become expensive, and Irvine's two youngest daughters donated the home to the state for use as its official governor's residence. After a series of changes to tax law and expensive renovations, Governor Karl Rolvaag moved into the home in 1966, and since then the house has been the official and ceremonial home for the state's first family. In the early 2000s, governor and former professional wrestler Jesse Ventura famously shut down the mansion as a gesture of frustration with budget limitations, though earlier that year his son had gotten into trouble for hosting parties in the mansion that had damaged the public building. Through the years the mansion has been the site of numerous protests and demonstrations, and every Halloween hundreds of trick-or-treaters line up at the gates to receive gubernatorial candy.

1898

SUMMIT AVENUE

A prime address for mansions, churches, and institutions

ABOVE: First platted in the 1850s, Summit Avenue marks the edge of the bluff overlooking downtown from the southwest. As St. Paul grew westward along with the railroads and streetcars, Summit became the prime address for mansions, churches, synagogues, and well-regarded institutions. From its eastern curve at steep Ramsey Hill, the wide tree-lined boulevard stretches straight west to the Mississippi River. In the 19th century it was a popular street for promenading, and in the 1900s it was an ideal route for the first wave of bicyclists to come to St. Paul. The western half of Summit Avenue, shown here in 1898, transforms into a wide boulevard. The University of St. Thomas, founded in 1885 by Bishop John Ireland, sat on its western end, and a rocky bluff-top park overlooks the Mississippi River gorge below.

ABOVE: Today Summit remains a popular place for joggers, bicyclists, and dog walkers, and its wide lanes are perfect for cruising in a convertible or getting back and forth to Minneapolis at a stately pace. The state-owned Governor's Residence sits in a converted mansion near Lexington Parkway, and its well-kept row of Victorian and early 20th-century homes offer some of the finest historic architecture in the country. At the corner of Snelling Avenue, where this photo was taken, Macalester College sits on the south (left) side of the street, while the University of St. Thomas, now with 6,000 students, is about a mile to the west.

MACALESTER COLLEGE

Old Main dates to 1887 and is the college's oldest building

BELOW: When Macalester College was founded back in 1874 by a Presbyterian missionary, the school was located in Minneapolis. But in 1885 the college moved to largely undeveloped land in the western reaches of St. Paul, where it built its first building. The liberal arts school, named for a Philadelphia philanthropist, is one of many small colleges in St. Paul. Located on the corner of Grand and Snelling, the college grew steadily, thanks in part to a massive donation from the heirs to the *Reader's Digest* fortune. Shown here is the Romanesque Revival-style Old Main building. The original left wing of the building was built in 1884, while the larger right wing dates to 1887.

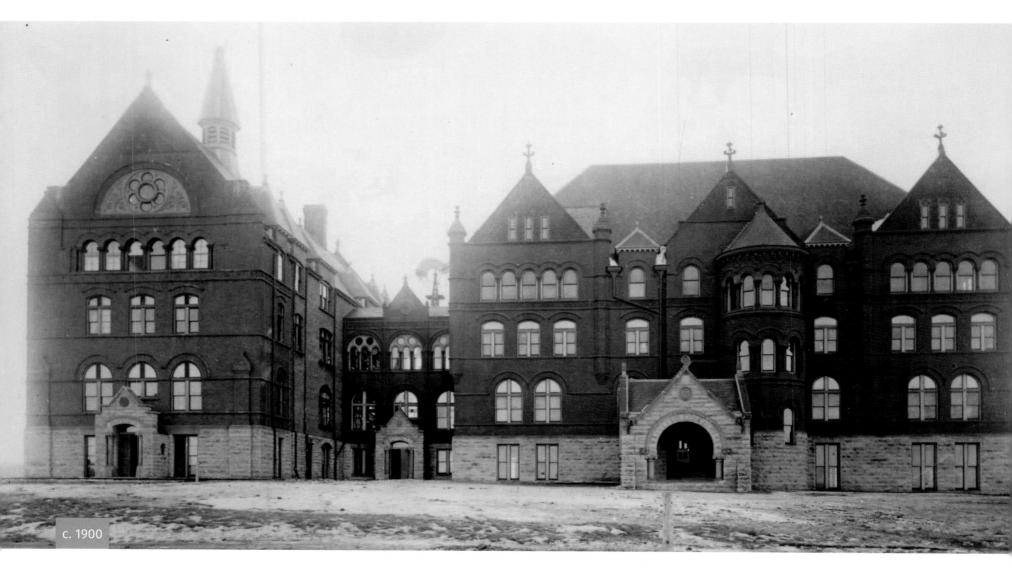

c. 1900

BELOW AND RIGHT: During the late 19th century, following Macalester's lead, the surrounding neighborhood, known today as Macalester-Groveland, grew up around the school and the new streetcar that connected the area to both downtowns. Today Macalester has more than 2,000 undergraduates from 49 U.S. states and 88 countries. The Old Main building, shown at the far right of the photo below, remains the center of the Macalester campus, which has grown to include a hexagonal Modernist chapel, a windmill, and dozens of other buildings between Summit and St. Clair Avenues. The older wing of the Old Main complex was torn down in the 1980s and replaced with a new college library that mimics the original Romanesque style, albeit in a Postmodernist guise.

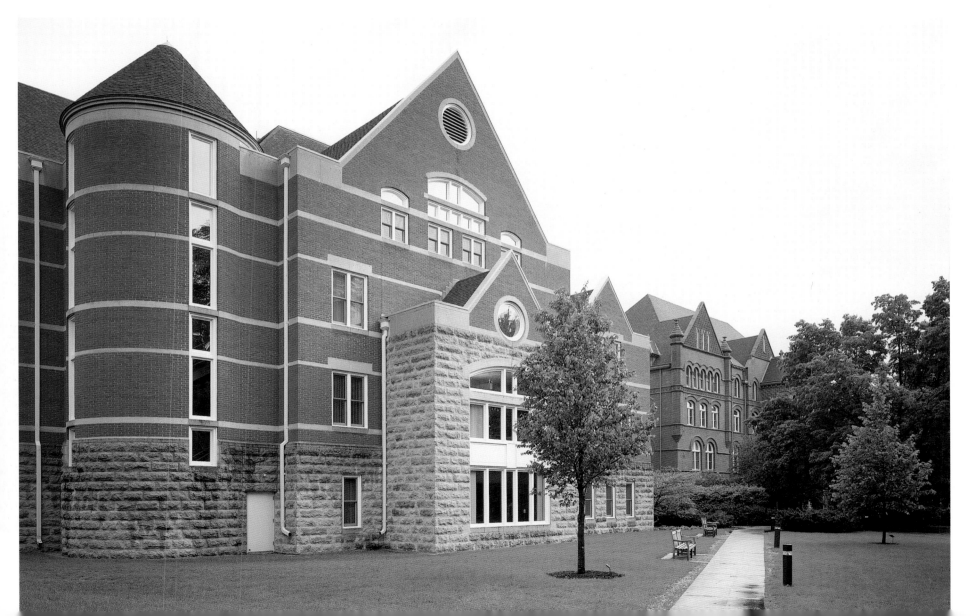

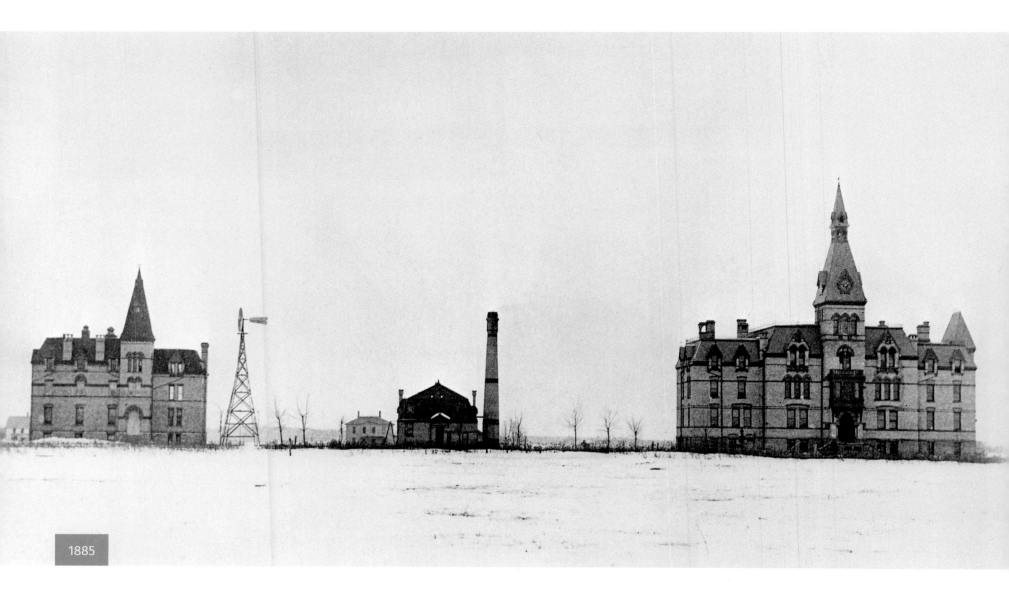

1885

HAMLINE UNIVERSITY
The oldest university in Minnesota

ABOVE: Dating to 1854, Hamline University is the oldest in the state, predating statehood by four years. The school was originally founded in Red Wing, a city about 70 miles south along the Mississippi River. Both the school and the surrounding neighborhood bear the name of the university's founder, Bishop Leonidas Lent

Hamline. The school moved to its current site, on North Snelling Avenue, in 1880 when the streetcars were expanding between the Twin Cities. The Old Main building at the right of the frame dates to 1884 and sits on a mall at the heart of campus. This photograph was taken one year after it was built.

ABOVE: Following the university's move to the edge of the city in 1880, St. Paul rapidly grew to surround the campus with railroads, homes, and industry. The Old Main building remains at the center of campus, shown here opposite a statue of school founder Bishop Hamline, who stands at the center of a campus square. Today Hamline draws about 5,000 graduate and undergraduate students with a focus on service learning. After a merger with the William Mitchell Law School on nearby Summit Avenue, there is a wide range of post-secondary education. The campus also features an early example of a Carnegie library, donated by the Pennsylvania philanthropist in 1916.

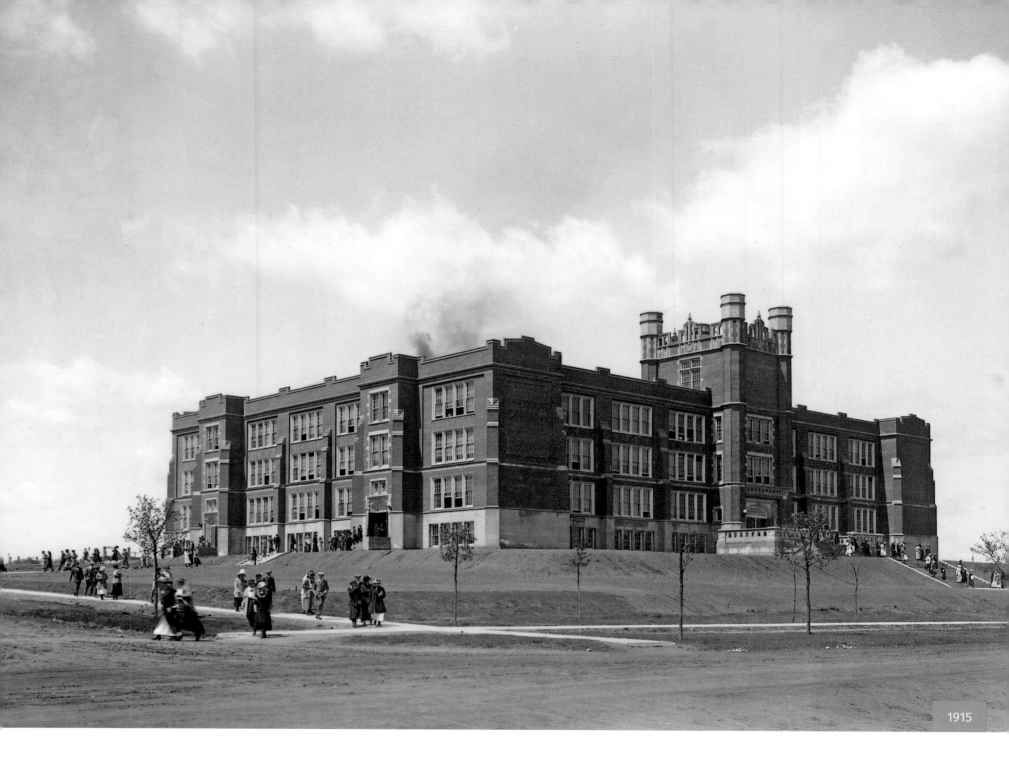

1915

ST. PAUL CENTRAL HIGH SCHOOL
The oldest high school in Minnesota

LEFT: The city's largest high school is located in the heart of the Lexington-Hamline neighborhood, just off Lexington Parkway. The school was founded in 1866, when lessons were taught in two rooms of the Franklin School building, located at Broadway and Tenth Streets. The school relocated twice before settling into the Gothic Revival-style building shown here at Marshall Avenue and Lexington Parkway in 1912. The school educated thousands of city youth from the nearby Frogtown, Rondo, and Summit-University neighborhoods. The small football stadium and ballfields next door were a popular site for community gatherings. When this photo was taken, the building was only three years old.

ABOVE: In the mid-1960s, Interstate 94 was constructed just to the north of the site, the wide trench cutting off the school from much of the surrounding neighborhood. The current building dates to the late 1970s, and local architectural historian Larry Millet describes the building thus: "the nadir of modern school architecture ... a building so resolutely grim and uninviting that it suggests education can only be viewed as a form of incarceration." Surprisingly, the infrastructure of the old building is literally entombed by the new structure. Some of the old walls are still visible inside. The school district recently curated a placemaking project to liven up the public spaces and plazas outside the school, and on the sidewalks around Marshall Avenue.

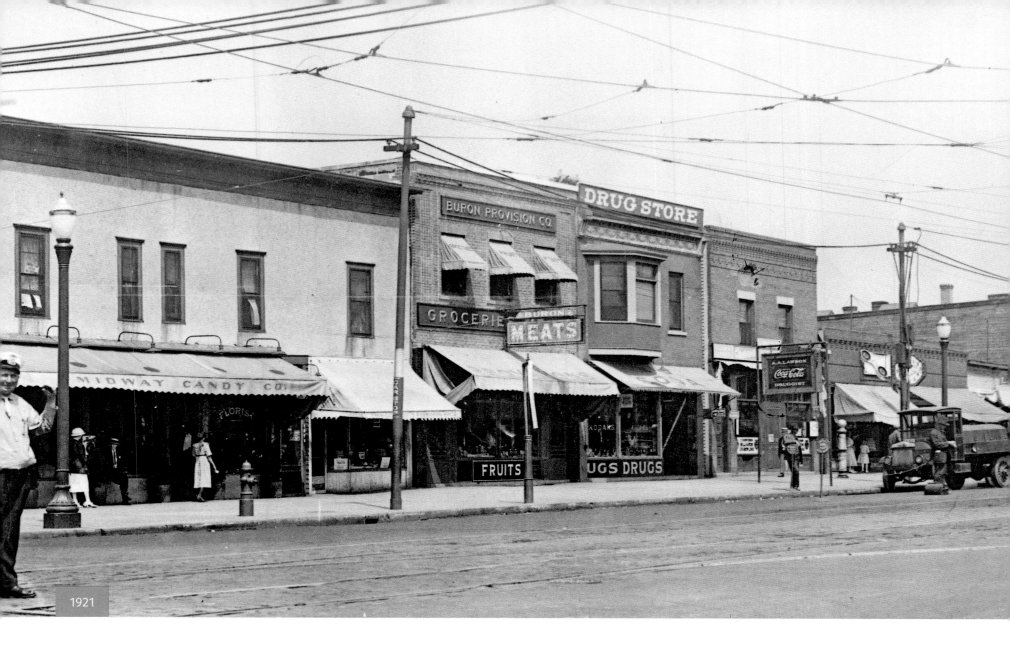

1921

SNELLING AND UNIVERSITY
Still one of the most bustling corners in St. Paul

ABOVE: University Avenue was constructed near the route of Territorial Road, along one of the region's oldest paths, and connected downtown St. Paul to the University of Minnesota to the west. Since the very beginning, it was the city's de facto main street, and the intersection with Snelling Avenue is one of the busiest in the metro area. The street marks the heart of the industrial and residential Midway area, so called because of its place midway between the two downtowns. In the early 20th century, the row of buildings on the north side of the street faced the headquarters of the regional streetcar system, the massive set of barns where the thousands of streetcars for the local Twin Cities Rapid Transit were housed, constructed, and repaired. A uniformed streetcar conductor waves at the far left of the photograph, taken in 1921.

ABOVE: Today the row of shops, offices, and bars still sit on the north side of University, and the Snelling intersection remains one of the most bustling corners in St. Paul. After streetcars were mothballed in the mid-1950s, the site became a large strip mall and parking lot. Currently, it is the site of the under-construction soccer stadium for the Minnesota United soccer team. Meanwhile, the Green Line light rail travels down University Avenue between the two downtowns.

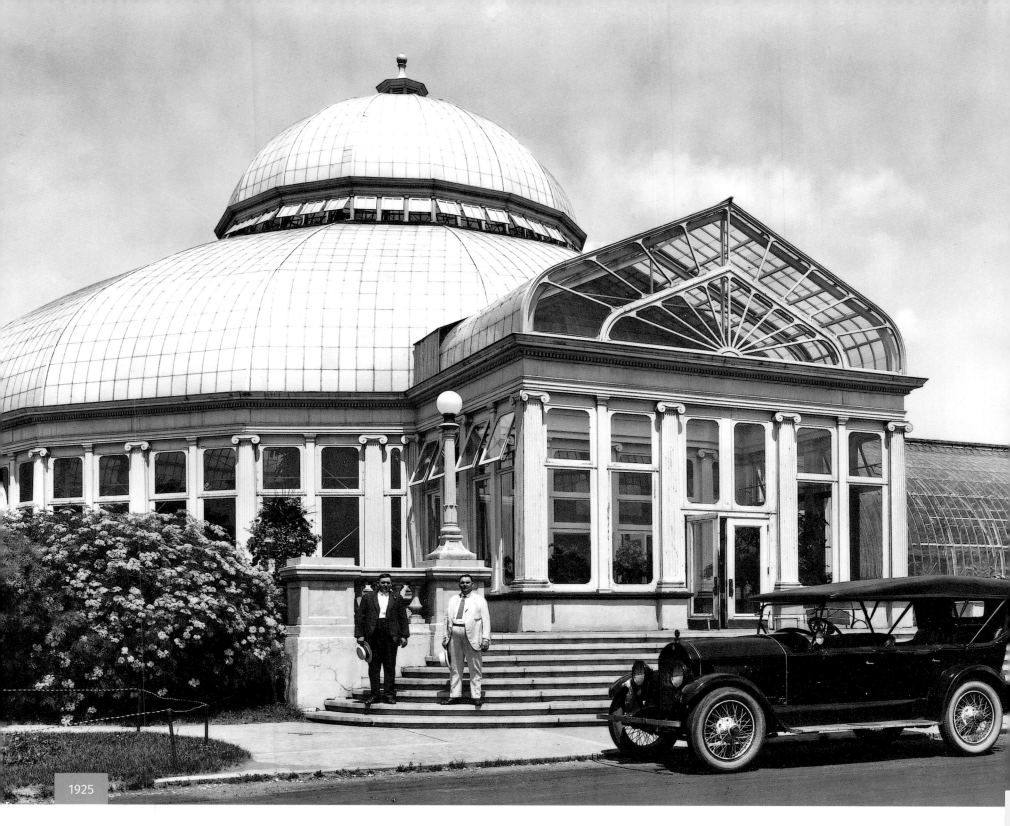

1925

134

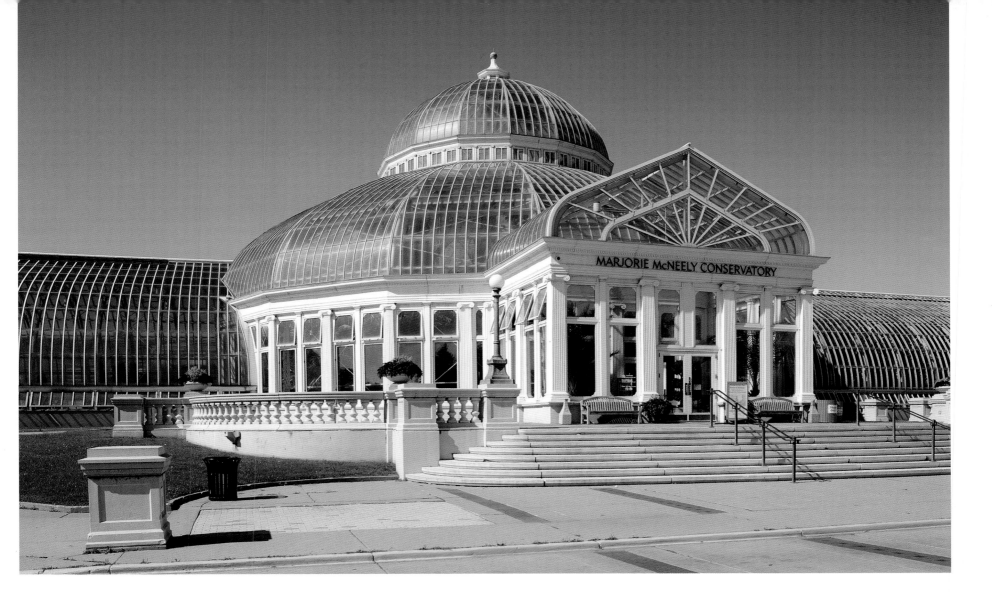

COMO CONSERVATORY

The jewel in the crown of Como Park

LEFT: Originally a series of resort hotels, Lake Como and the large park that surrounds it sit at the center of St. Paul, and have long defined the surrounding neighborhoods. The park's landmark grand conservatory building dates to 1915. The brainchild of an ambitious parks commissioner, the building's glass-and-steel conservatories are full of plants and flowers from all over the world. The conservatory is surrounded by a vast network of paths and trees that connect the lake, golf course, and surrounding grounds. One of the city's first electric streetcars ran through the park, connecting it to both downtowns and the Minneapolis chain of lakes.

ABOVE: Today the building has been painstakingly remodeled and expanded to include a zoo, amusement park, and a Japanese garden in honor of St. Paul's sister city of Nagasaki. In 1988 a century-old wooden carousel, which once sat at the nearby state fairgrounds, was rescued from auction and it is now housed near the conservatory entrance, offering rides during the summertime. A nearby golf course serves as a cross-country ski trail during the wintertime, and on the lakeside a bandshell pavilion and café operates all year long. All in all, the park annually draws over two million visitors. In 2002 it was renamed the Marjorie McNeely Conservatory, following a generous donation from the Donald McNeely family.

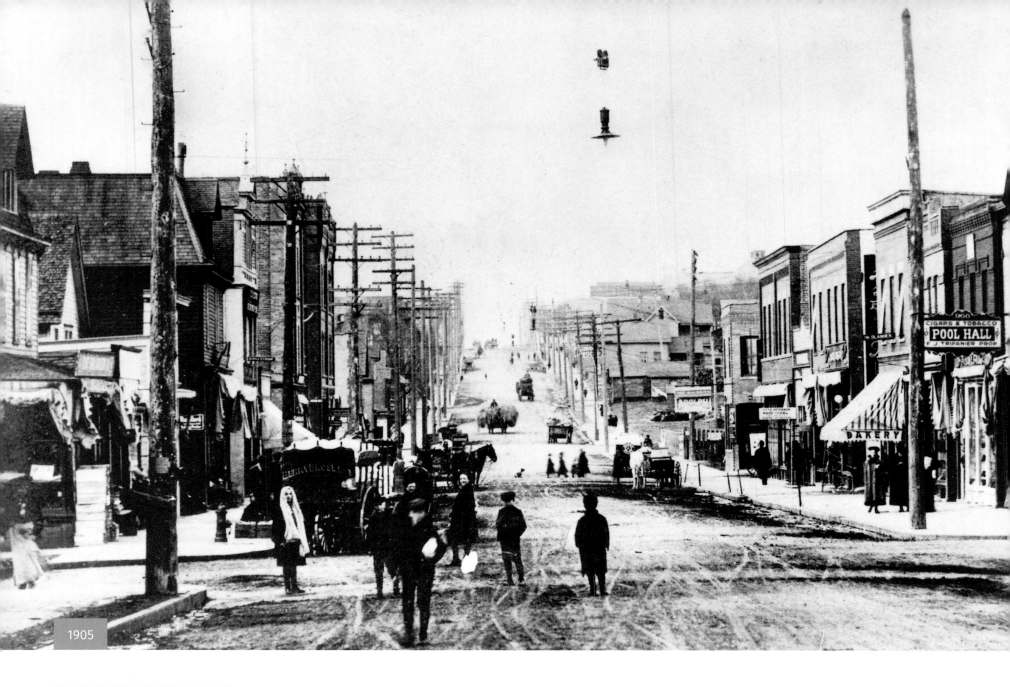

1905

PAYNE AVENUE

The most well-preserved street of historic buildings in the Twin Cities

ABOVE: One of the main streets of the city's large East Side neighborhood, the mixed-use commercial buildings of Payne Avenue grew up alongside the streetcar that once ran down its center. Originating in Railroad Island, named because it was surrounded by railroad tracks in the 1870s, Payne Avenue climbs up the Arlington Hills and was lined with shops catering to the local German, Scandinavian, and Italian immigrants. Throughout the 20th century, the East Side was known for its many factories and industries that employed thousands of workers, including the Minnesota Mining and Manufacturing Company (now 3M) and Hamm's Brewery.

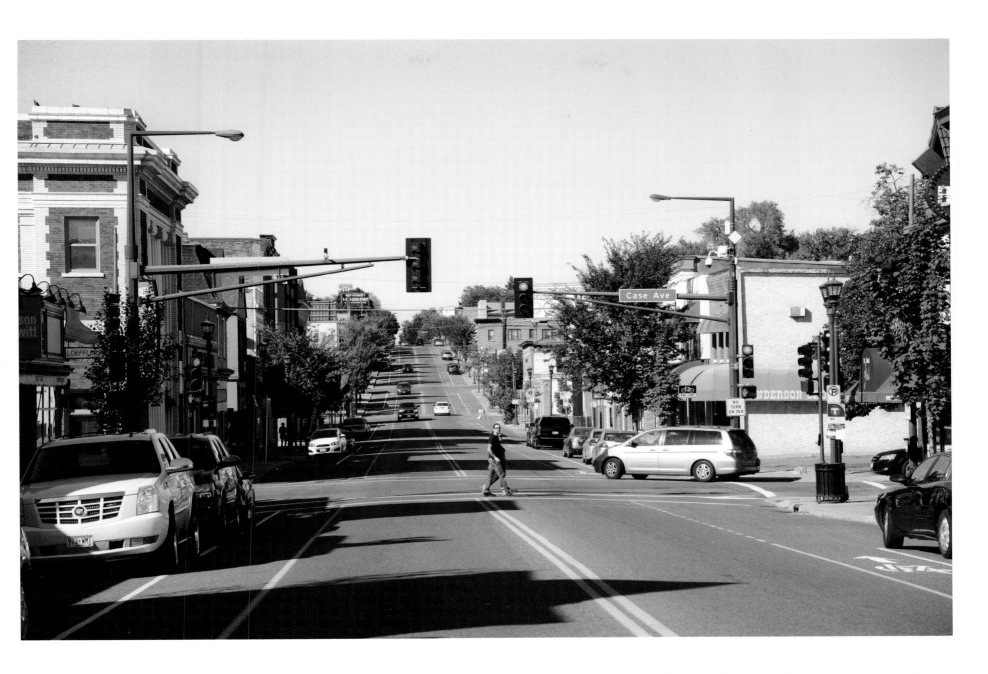

ABOVE: Today Payne Avenue remains the Twin Cities' street with the most contiguous and preserved collection of historic buildings. Anderson's Shoes, a century-old shoe store, still sits at the corner of Payne and Case, visible with the blue awning. Many parts of the street are experiencing a food renaissance with a half-dozen new restaurants opening up in the historic buildings, as old bars and shops are restored or rebranded for the 21st century. Other buildings remain largely empty, like the Payne Avenue State Bank (visible with the white pillars at the left side of the frame) waiting for the right mix of investment and East Side entrepreneurialism.

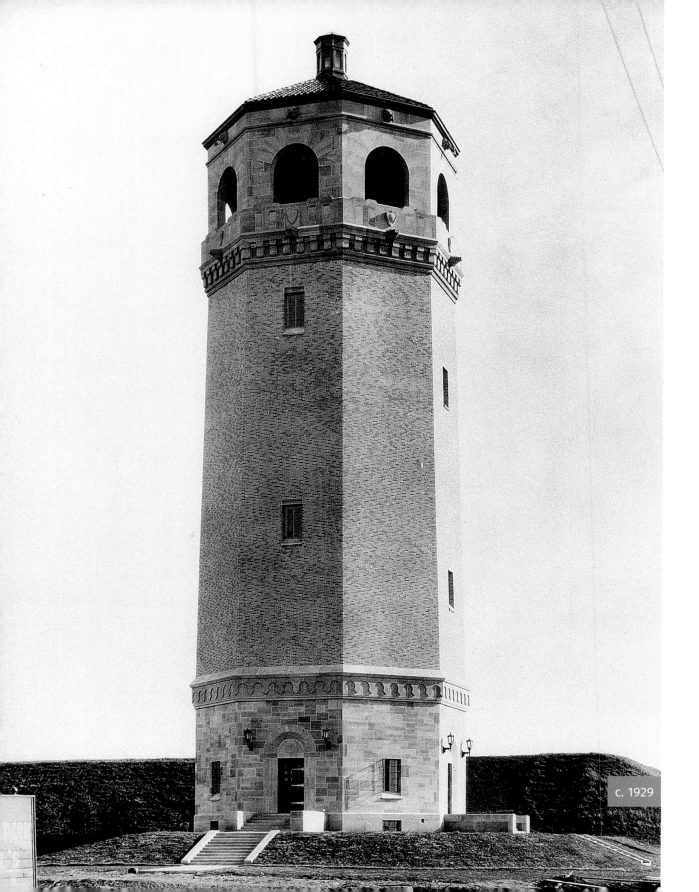

c. 1929

HIGHLAND WATER TOWER

Designed by Cap Wigington, the first African-American municipal architect in the nation

LEFT: Completed in 1928, this distinctive octagonal water tower was constructed to serve the rapidly growing Highland neighborhood. In 1923 Henry Ford built a cutting-edge automobile factory along the river in the Highland area, and the apartments and homes built around it housed workers from the plant. The water tower was one of many buildings designed by city architect Clarence W. "Cap" Wigington, the first African-American municipal architect in the nation, who worked in St. Paul for over 20 years. Wigington designed a number of public buildings that remain standing today, as well as three different elaborate Winter Carnival ice palaces, that do not. This photo dates to the earliest days of the water tower in the late 1920s.

RIGHT: The water tower is open to the public twice a year, in spring and fall, and offers panoramic views of the surrounding Highland neighborhood and the river valley below. Just to the east, a large park and golf course offers recreational opportunities and greenery for people in the area. Though the Ford factory closed in 2015, the former industrial land is being cleaned up and a new mixed-use neighborhood is planned for the riverside site. The sign in the foreground is for the neighboring Charles M. Schulz Highland Arena. The arena opened in 1973 and is named for the creator of the *Peanuts* comic strip, who grew up in St. Paul and was an avid hockey fan.

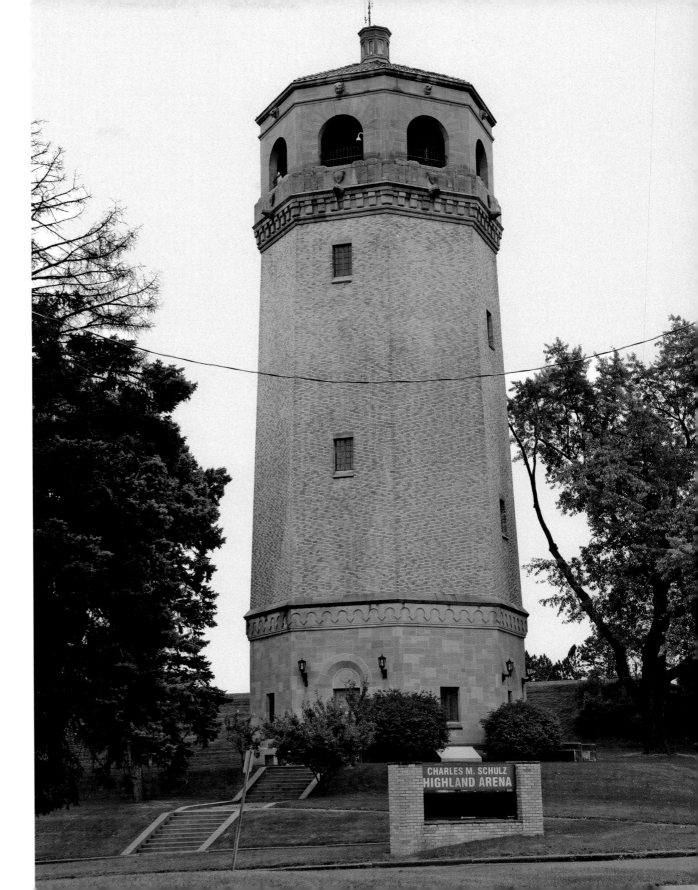

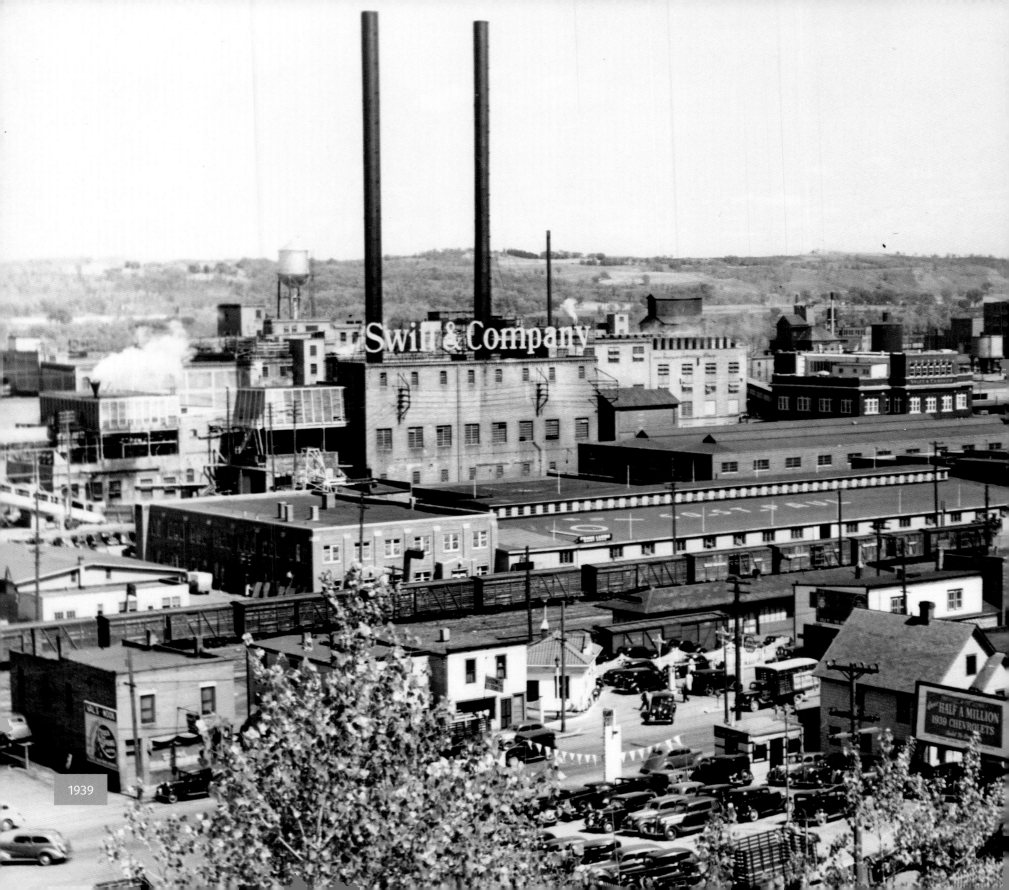

1939

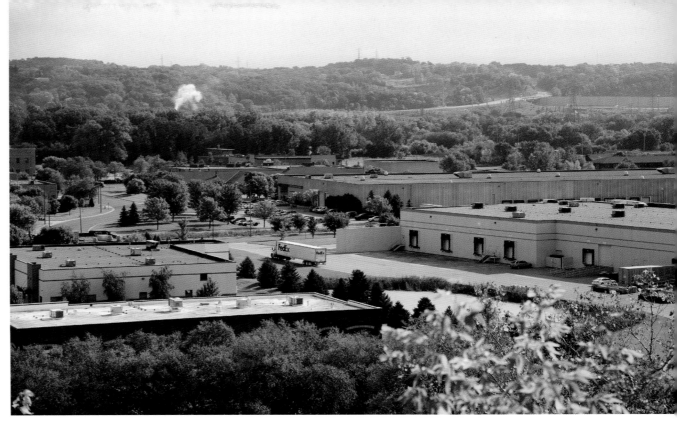

SOUTH ST. PAUL
Once home to two of the world's largest meatpacking enterprises

LEFT: In the 1860s, this area and the nearby flats, located just downstream from St. Paul, were the site of the last remaining Dakota village in the Twin Cities region, a small settlement called Kaposia run by a chief named Little Crow. Little Crow's village was forced to evacuate, along with the rest of the Dakota people in the state, following the conflict of 1862, which saw whites and Dakota people kill each other in a series of skirmishes. By the 1920s it had become the river flats in South St. Paul, and it was home to two of the world's largest meatpacking enterprises. Both the Armour and Swift companies, and the St. Paul Union Stockyards, relied on the railroad and river connections to create an industrial facility that churned out meat at unprecedented rates at all hours of the day and night. The facilities each employed thousands of workers that took the streetcar back and forth, or went up the river bluff past an endless line of bars, and into the surrounding city of South St. Paul.

ABOVE: The Swift plant closed in 1969 and next-door Armour followed suit 10 years later. By then, the South St. Paul infrastructure was getting old and industry practices began favoring multiple smaller plants rather than large centralized facilities. While far less odorous than they used to be, today the South St. Paul flats are a sleepy light-industrial area along the Mississippi River, which even features a bike path on top of the levee. The only remnants of the old stockyards are a pair of 25-foot brick towers that once bookended the packing plant gates.

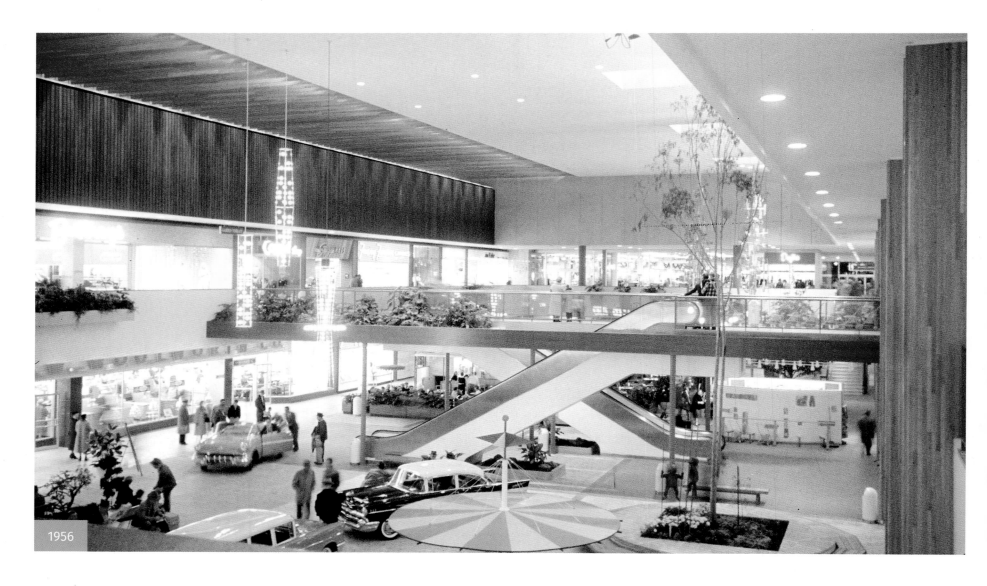

1956

SOUTHDALE MALL
The first indoor shopping mall in the world

ABOVE: When it was built in 1956, the Southdale Mall in suburban Edina was the first indoor shopping mall in the world. Designed by Victor Gruen, an Austrian Modernist architect, the mall was intended to ameliorate the winter weather and pioneer a new automobile-centered retail model on the edge of the city. Gruen, a idealistic socialist, also intended the new space to function like a European town square, offering much- needed public space in growing suburbs that lacked them. The initial designs featured a complex set of amenities, which included benches and fountains, designed to encourage public interactions and civic engagement. This photo dates to the first year of the mall.

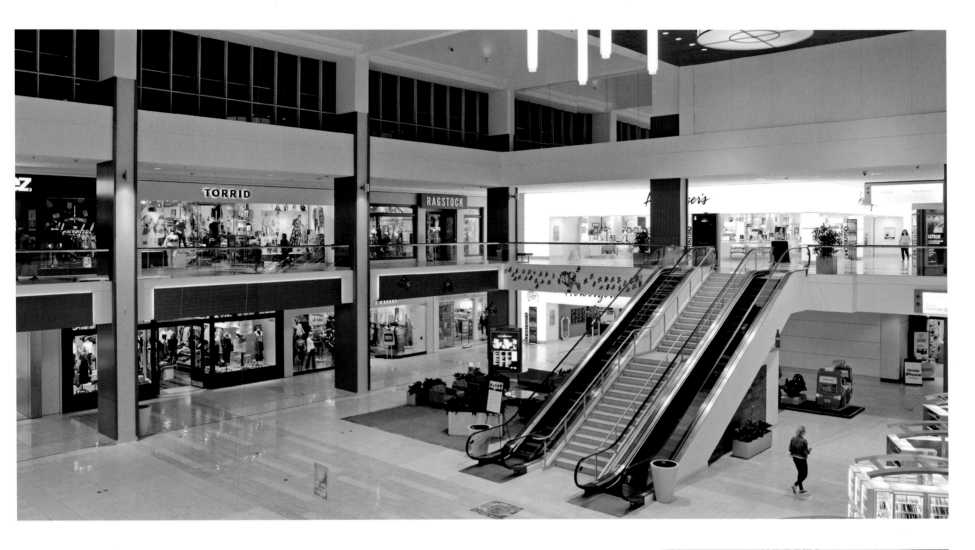

ABOVE AND RIGHT: At first glance, Southdale Mall has completely changed and there's little left of the original design. But at root, the mall is functioning almost exactly as it did in the 1950s, and remains one of the most successful shopping malls in the Twin Cities. The fully-enclosed Southdale Mall design proved to be immensely influential, and similar projects spread around the Twin Cities and the world, forever transforming how Americans shopped. The latest series of remodeling efforts reintroduced some elements of mid-century Modernist designs, like the hanging sculpture seen in the photo on the right. Outside the walls of the shopping center, the larger Southdale region has become a popular mixed-use area surrounded by wide roads and freeways, and the city of Edina is planning ways to fill in some of the mall's parking lots with new apartment and office buildings.

INDEX

OTHER TITLES IN THE SERIES

ISBN 9781910904060

ISBN 9781911216452

ISBN 9781911595007

ISBN 9781910904121

ISBN 9781910904053

ISBN 9781911216063

ISBN 9781910904800

ISBN 9781911216483

ISBN 9781911595571

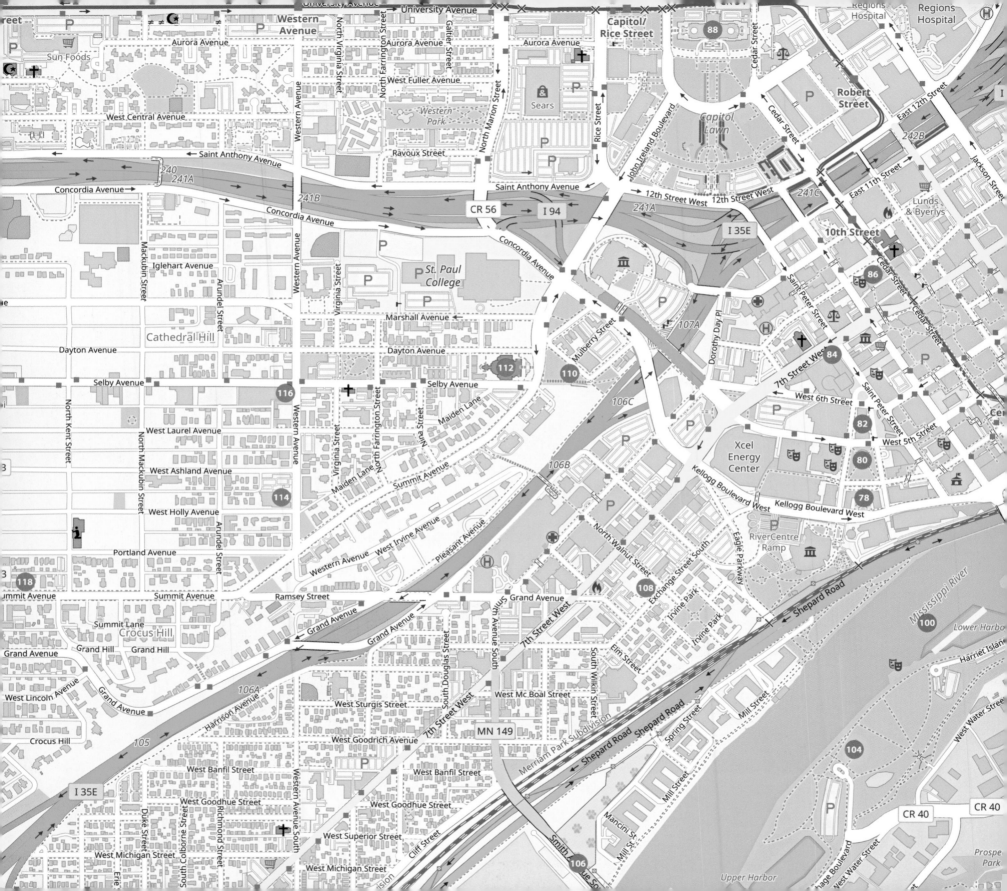